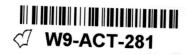

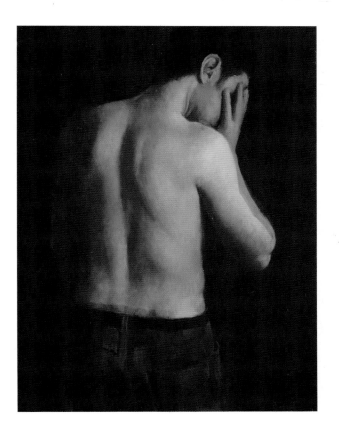

Color *for* Painters

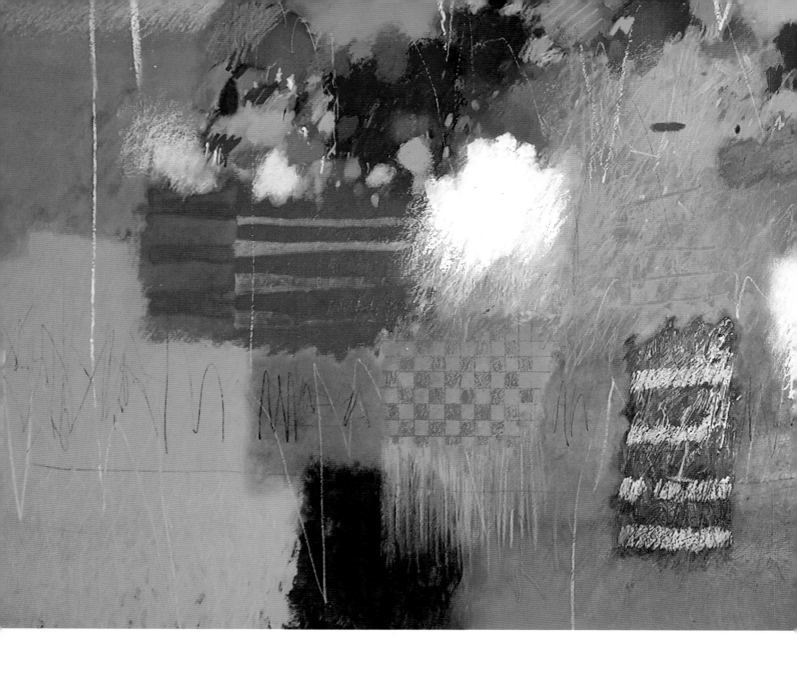

Color *for* Painters

A GUIDE TO TRADITIONS AND PRACTICE

Al Gury

Watson-Guptill Publications | New York

Page 1: **Luis Borrero**, *Ryan's Back*, 2005, oil on board, 17 x 14 inches (43.1 x 35.5 cm). Private collection. Courtesy of the artist

Pages 2–3: **Moe Brooker**, *Everything Is On Its Way to Somewhere*, 2004, oil and mixed media on panel, 48 x 96 inches (121.9 x 243.8 cm). Courtesy of Sande Webster Gallery. Collection of the Kimmel Center for the Performing Arts

Page 6: **Jon Redmond**, *Purple Onion*, 2009, oil on board, 10 x 10 inches (25.4 x 25.4 cm). Courtesy of the artist

Page 30: **Joan Becker**, *Pencil Sharpener*, 2009, gouache and charcoal on watercolor paper, 29 x 41½ inches (73.6 x 105.4 cm). Courtesy of Gross McCleaf Gallery

Page 64: **Carlo Russo**, *Yarns (study in complements)*, 2009, oil on linen, 23 x 28 inches (58.4 x 71.1 cm). Courtesy of the artist

Page 114: **Thomas Eakins**, *William Rush Carving His Allegorical Figure of the Schuylkill River*, 1876–1877, oil on canvas mounted on Masonite, 20⅛ x 26⅛ inches (51.1 x 66.3 cm). Philadelphia Museum of Art: Gift of Mrs. Thomas Eakins and Miss Mary Adeline Williams, 1929. Photo: Graydon Wood

Page 160: **Jean-Baptiste-Siméon Chardin**, *The Attributes of the Arts and their Rewards*, 1766, oil on canvas, 44½ x 57¼ inches (113 x 145.4 cm). Minneapolis Institute of Arts, Minneapolis, Minnesota, USA. The William Hood Dunwoody Fund. Photo: Erich Lessing / Art Resource, NY

Copyright © 2010 by Albert F. Gury

Design by: Christopher Cannon / Isotope 221

All rights reserved.

Published in the United States by Watson-Guptill Publications
an imprint of the Crown Publishing Group
a division of Random House, Inc., New York
www.crownpublishing.com
www.watsonguptill.com

WATSON-GUPTILL is a registered trademark and the WG and Horse designs are trademarks of Random House, Inc.

Library of Congress Cataloging-in-Publication Data
Gury, Al.
 Color for painters : a guide to traditions and practice / Al Gury. — 1st ed.
 p. cm.
 Includes index.
 ISBN 978-0-8230-9930-6 (pbk.)
 1. Color in art. 2. Color (Philosophy) 3. Painting—Technique. I. Title.
 ND1489.G87 2010
 752--dc22

 2010000199

Printed in China

10 9 8 7 6 5 4 3 2 1

First Edition

This book is dedicated to my students,
past, present, and future,
and to the memory of Arthur DeCosta

Acknowledgments

I would like to thank my assistant, Tom Raggio, for his faith in this book and for his hard and precise work. I thank the many friends who support me in my life and work, especially Linda Robinson, Miriam Kotzin, and Joseph Danciger.

Candace Raney, Alisa Palazzo, and Autumn Kindelspire at Random House are a joy to work with, and I thank them for their guidance and patience. Thanks to James Lynes for his support and time spent reading and advising me on my text.

In particular, I wish to thank Winsor & Newton in England. The company's support in providing beautiful images from their museum and factory—and the hard work of Paul Robinson on my behalf—is much appreciated.

Thanks to Jack Frisk for his support and friendship. Thanks again to Peter Groesbeck, who has once more provided beautiful and precise photography for many of the images in this book.

Finally, I wish to thank all the students, museum staff, and colleagues who supplied the beautiful images for this book. Their support and friendship have been invaluable.

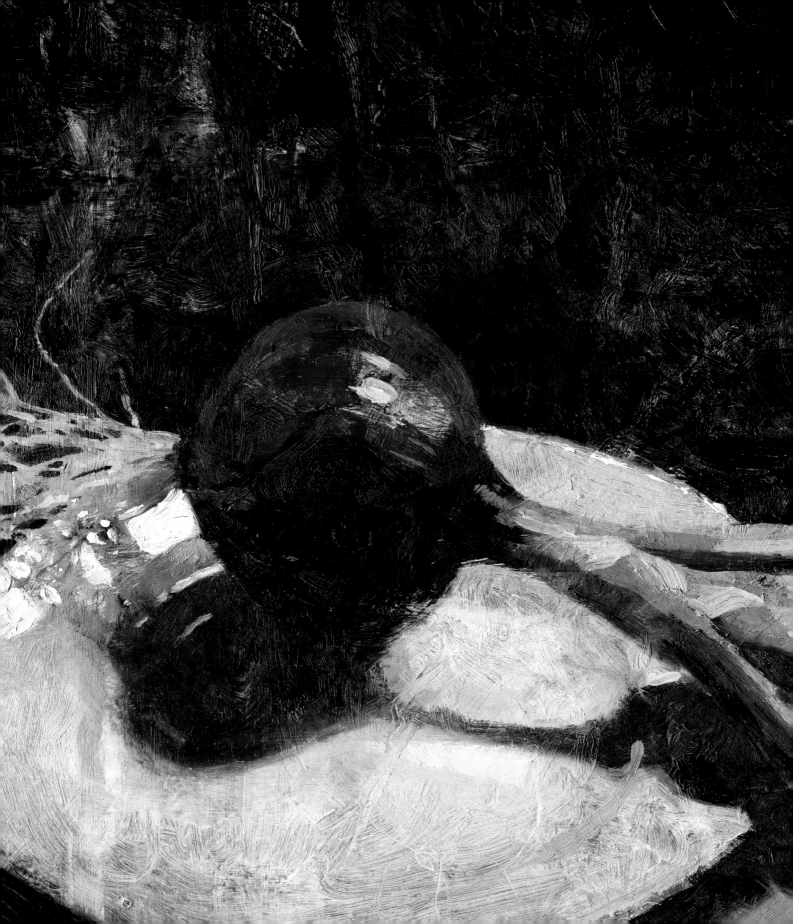

Contents

INTRODUCTION

Color, for many people, is the most the most exciting and interesting aspect of painting. It can also be the most confusing and frustrating element of painting practice. *Color for Painters* is intended to help students, painters, teachers, and even general readers to better understand color in oil painting and to help clarify the myths, mysteries, and misunderstandings of color.

Color for Painters is meant to be a practical manual rather than an exhaustive academic work on the topic. The text and illustrations are meant to present basic types of color (and their background and use) rather than to examine every historic artist's work or discuss specific problems in painting, such as how to paint the color of trees or faces. Teaching color is a daunting task, and this book is also designed to help instructors present color concepts in a clear, practical, and usable manner to their students.

I've based *Color for Painters* on over thirty years of experience in teaching color for painters and on my search for the clearest and most practical ways for students to understand color in oil painting. The book is also the result of practical wisdom and information passed down through generations of teachers and painters to be shared by all. The oral transmission of this body of wisdom and the many demonstrations by generations of instructors at the Pennsylvania Academy of the Fine Arts have been an invaluable help to me, both as a teacher and as a painter. Arthur DeCosta, in particular, was a great guide through the chaos and beauty of color and its development in painting history.

This work presents the major basic color concepts in oil painting during the past five hundred years as well as examples of the core techniques and aesthetics of color in oil painting history. It is intended to be used both as a textbook and a studio manual as well as an introduction to painting history and the work of many artists who exemplify color approaches.

Color for Painters, in many ways, is excellent for beginners but will also be illuminating for many experienced painters; I've found that many individuals who have painted for years have very little context and history of the craft of color in their training. Still, this book isn't an exhaustive survey of artists or a scholarly work of history. Many fine painters and examples have been left out, not because they are unimportant but rather so that I can focus on clearly understandable examples of aesthetics and approaches. Basic theories of color and its history are presented in a narrative manner, much as they would be in the classroom, while others are listed in the further reading section.

The spirit of this book is one of painters sharing their knowledge and experience with others. This is the spirit and atmosphere I found when I first entered the school

of the Pennsylvania Academy of the Fine Arts as a student and encountered the many instructors and painters who shared the hard-earned wisdom from their careers as artists with their students. The emphasis has been on what would be most useful for the practicing painter and those interested in painting. Altogether, *Color for Painters* is a clear and practical manual for students, artists, and the lover of painting.

For a painter, coming to understand color and its uses in painting can be very frightening. Many students and artists I know struggle desperately with making color work well in their paintings. They're often frustrated by not clearly understanding what the "wild beast" of color does and not having ways of organizing the experience of the colors they see. The frustration can be so strong that some even contemplate giving up painting or avoiding color in their art altogether. As a beginning art student, I actually felt that I would never be a colorist or really understand color in painting. The reality was that I hadn't yet been taught in a sensible way or had enough guided practice.

Much of the training in color for art students involves either unguided exploration or the learning of abstract theories that are interesting but not directly usable in the many forms of the practice of painting. In many cases, the only training some students get in color, however excellent and well taught, is formal exercise in two-dimensional design classes in college or art school—and this is not easily translatable into an actual painting. This is a good beginning but only a prelude to the practice of painting.

Much of the history of color and its practice is also shrouded in the concept of the "secrets of the old masters" and left to speculation; however, there are many documents available not only on the theories of color throughout history but on the techniques and color practices of these great painters. Modern technology has made it even more possible to understand pigments and the materials used in paintings throughout history. So, simple, clear explanations of how color works in painting and ways of organizing the experience of color are presented in this book. *Color for Painters* will help make sense of the "wild beast" of color in a time of flux in an art world filled with many approaches to color in painting.

TAKING COLOR FOR GRANTED

by ROBERT COZZOLINO, *curator of modern art, Pennsylvania Academy of the Fine Arts*

Among the most daunting tasks a writer can face when confronting paintings is how to describe color so that a reader might come close to experiencing its presence. Artists know that it is not enough to say that a chair in a painting is blue. *Blue* is nearly meaningless in its lack of specificity, although most readers by now have a particular blue in their minds. But the default blue you carry in your head is unlikely to match mine, nor is it bound to mirror what composes the imaginary chair mentioned above. More precise or even empathetic language is needed to coax the memory of a particular blue out of your past experience that will rhyme with what I see in paint. Is it better to say that the chair is phthalo blue or that it is the color of a clear summer sky at midday (two completely different blues)? Language is a hard substitute for seeing. There are no easy solutions to conjuring color with words. As a result, art historians not content with naming colors often attempt poetry or multisensory analogies when aiming to give the reader a better sense of a perceived hue.

Despite these excruciating nuances and wondrous variations, color can easily be taken for granted, its complexity and personal associations glossed over in favor of generalities. Throughout art history and across cultures, visual artists have examined and employed color from an extraordinary range of viewpoints and with diverse aims. Some have attempted to replicate their optical experience of color exactly as it appeared before them, a task that seems straightforward but is maddeningly difficult. Others have deployed color to disrupt expectations and challenge tastes, and in the process, they have confronted societal prejudices and cultural taboos. Numerous artists have attempted to convey their spiritual experiences of color by emphasizing its identity with sensation or association with states of altered consciousness. Even those artists who have claimed to purge color from their work eventually realize that, despite their removals, color is a constant.

Ivan Albright, *From Yesterday's Day*, 1971–1972, oil on canvas, 8½ x 15¼ inches (21.5 x 38.7 cm). Bridges Collection

Ivan Albright, *The Image After*, 1972, oil on canvas, 9½ x 15¼ inches (24.5 x 38.7 cm). Bridges Collection

Consider two artists who, in different ways, have gone to extraordinary lengths to make color's mysteries and contingencies integral to their work. The first, Ivan Albright (1897–1983), was convinced of the spiritual power and psychological impact of color. He devoted much of his long career to investigating how perception affects the experience of color and, in turn, how that affects the viewer's relationship to a work of art. As a young artist freshly out of art school, he wondered, "To what extent do sight, hearing and feeling change the color aspect [in a work of art]?"[1] In numerous notebooks kept from the 1920s through the last year of his life, Albright inscribed his findings from experiments and his philosophical queries about color and used their pages for test patches for palettes. Among the phenomena that fascinated Albright most were afterimages. He often spent time staring at solid color and then looking away at a sheet of white paper in an attempt to discern the chromatic echo, or color of the residual image still perceived on the retina.

Albright's experiments culminated in a pair of paintings that record the color afterimages of objects in a still life (page 11, top image) and then, in an extreme test of perceptual endurance, the color afterimages of the afterimages (page 11, bottom image). He considered taking it even further but conceded to physical and psychological exhaustion. The paintings are extremely personal in their subject and form. As still lifes, they document materials that Albright's father, Adam Emory Albright, took with him when he left home to attend art school in Chicago, including a tintype of Ivan's mother.

Ivan Albright was, famously, a "mirror" twin, and his brother, Malvin, often lived in his shadow, never as well known and working in a style that was never as psychologically probing. Here, color and its doubles, or complements, become metaphorical self-portraits, enacting and alluding to biography, the role of family in craft traditions, and the role of color to throw differences into perspective. Albright believed that afterimages were superimposing themselves over everything all of the time, therefore affecting, often unconsciously, our complete understanding of the world.

I suspect that most readers of this book will approach it with hopes of expanding their understanding and use of color in the studio. Many will expect to transform their palette's range and increase their confidence with using color. Whether artist or art historian, art enthusiast or teacher, or all of the above, a vast number of readers will expect to learn what combinations, ratios, and technical methods led to the brilliantly colored images reproduced throughout this text. Eugène Delacroix or Henri Matisse might be obvious examples to use in such a book. Few will associate Robert Ryman with a book on color. Yet Ryman's work imparts important lessons about color that are critical to our understanding of contemporary painting. For many,

Ryman is the painter of white paintings whose output since the late 1950s has focused predominantly on the possibilities of white paint in an artist's practice. However, this popular assumption is inaccurate, simplifying the profound relationship Ryman's paintings and his chosen approach have with their environment.

Take, for example, a piece now in the collection of the Pennsylvania Academy of the Fine Arts in Philadelphia. *Philadelphia Prototype 2002* (page 14) is a critical work in Ryman's career for several reasons. It brings his thorough examination of the interdependence of paint and support, light and color, texture and edge, installation and environment together for a work that consists of ten vinyl panels adhered to the surface of a wall through the adhesive properties of paint alone (page 15). Ryman must reinstall the piece each time it is placed in a new context, taping the panels to the wall and reapplying paint along the edges and onto the walls each time. Once dry, the tape can be removed and the paint holds the panels in place. They fuse with the wall.

Philadelphia Prototype 2002 is about many issues close to the hearts of painters. For our purposes, it is a powerful example of how color is contingent, unexpected, and subtle but can change everything. Ryman's choice of white paint (and a particular one) enhances the interpretation and experience of the piece perhaps more profoundly than in his individual, discrete paintings. In an interview for the series *Art:21*, Ryman reiterated his position on white.

White has a tendency to make things visible. With white, you can see more of a nuance; you can see more. I've said before that if you spill coffee on a white shirt, you can see the coffee very clearly. If you spill it on a dark shirt, you don't see it as well. So it wasn't a matter of white, the color. . . . It was just that white could do things that other colors could not do. If I look at some white panels in my studio, I see the white—but I am not conscious of them being white. They react with the wood, the color, the light, and with the wall itself. They become something other than just the color white. That's the way I think of it. It allows things to be done that ordinarily you couldn't see. [2]

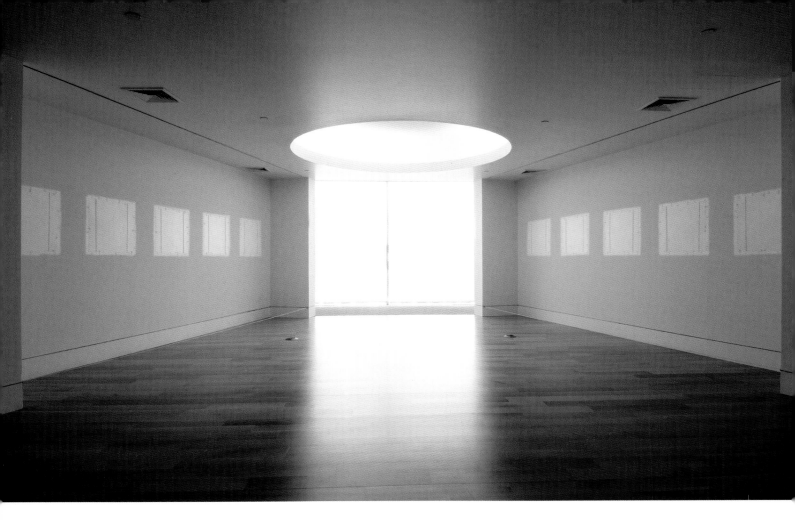

Robert Ryman, *Philadelphia Prototype 2002*, 2002, acrylic on ten buff-colored vinyl sheets and wall, varying dimensions. Pennsylvania Academy of the Fine Arts, Philadelphia. Alexander Harrison Fund, 2005.19. As in stalled by the artist in PAFA's Samuel M. V. Hamilton Building. Photograph by Rick Echelmeyer

Philadelphia Prototype 2002 has been installed in a few different contexts over the course of its life, and in each situation, the appearance of the piece shifted and took on a new character because of light, architecture, and other extraneous factors. Every art object will show a new aspect of itself in varied installation contexts. However, the *Prototype*, due to its form and structure—indeed, its very nature—makes this transformation emphatically part of the experience of the piece. While texture and space are important to the installation, color is consistently the most elusive and yet most present element of *Prototype*'s contingency. In PAFA's Hamilton Building, where it is currently sited, the space fills with natural light from a large window set apart from, but close to, the installation. Light does not strike the piece directly; rather, as a collaborative element of the work, it determines the degree to which the white panels are illuminated and toned. This becomes critical to the changing nature of color in the piece—for the white panels can seem cooler, warmer, more gray, even slightly magenta or yellow ochre, because of the changing weather conditions outside. Other times they glow as though lit from within, their acrylic adhesive strokes highlighted

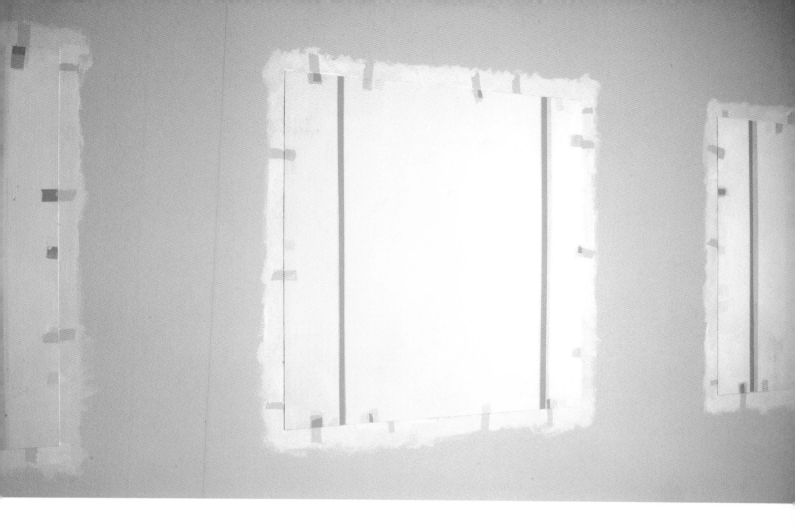

against the wall. Viewers often note that color from their clothing is absorbed by, or reflected in, the panels. This is very subtle and highlights just how critical the choice of white was for the piece.

The subsequent study by Al Gury will include many more examples in which artists have led us to see color anew. In myriad instances throughout art's history, we have been reminded, when we most begin to take color for granted, how much it contributes to the pleasure, meaning, and structure of seeing.

Robert Ryman, detail of *Philadelphia Prototype 2002*. Photograph by Rick Echelmeyer

1. Ivan Albright, notebook dated ca. 1923, Ivan Albright Collection, 1984.6.1:46v. The Art Institute of Chicago, Ryerson and Burnham Libraries.
2. Robert Ryman, interview in *Art:21*, season 4, "Paradox" episode: http://www.pbs.org/art21/artists/ryman/clip2.html. Accessed August 21, 2009.

Overview: *The* History *of* Color

Color has been used creatively and vibrantly in painting for thousands of years. Whether in the encaustic Faiyum portraits of Roman Egypt, Pompeian frescoes and mosaics, Turner's oil paintings of wind and fire, or modern color expressionism in acrylics, color in painting is constantly telling a story of creativity and invention. With over thirty thousand years of artifacts and related research available, today we have a good view of the evolution of theories and practices of color in art.

Ground pigment in storage jars.

Modern art materials haven't changes much since this beautiful cave painting was done. Organic materials were used and pigments, which we call *earth colors*, were made then much as they are now.

Early Beginnings

The earliest forms of paints found in prehistoric cave paintings form the basis of what we still use today, both materially and aesthetically. Colored clays, carbon, and chalk provided the earliest pigments for depicting animals and humans in an elegant mixture of fact and symbol, storytelling and religion. These largely organic materials have proven to be very stable, durable, and reliable. Not surprisingly, these "earth colors" have survived to become the basis for most artists' palettes today.

By the time the peoples of the ancient Near East and the Mediterranean had developed stable cultures, the use of color had blossomed into a wide range of functional, decorative, social, and religious uses. The earth tones were augmented by bright colors distilled from plants as well as from brilliant pigments made from grinding gemstones. The Hebrew bible speaks of materials such as gold and ivory, and a variety of colors and their appropriate religious and social use.

Aristotle and the Classical World

Aristotle, the great Greek philosopher of the fourth century BC, wrote at length on the physical sciences, including the nature of color. *De Coloribus* (*On Colors*) attempts to explain color in the physical sense and also discusses a palette of colors. His writing remained the primary influence on theorists of color and artists alike until the seventeenth century and the development of modern theories and exact scientific method.

The Romans, medieval theologians, and great Renaissance artists such as Leonardo da Vinci all referred heavily to Aristotle in their exploration and explanation of the physical world. Nineteenth-century theorists and painters continued to refer to Aristotle, even if only for reasons of poetry and beauty. Color in the classical world of the Greeks and Romans fulfilled societal or symbolic roles and served decorative and observational purposes. Some colors were ascribed to particular social classes or individuals, while others were associated with particular gods or myths. At the same time, the Greeks and Romans excelled in describing the subtleties of colors in landscapes, portraits, and still lifes through the mediums of fresco, encaustic, and mosaic.

Medieval Europe: The Colors of Faith

Artists' palettes of the classical world—earth colors extended by bright colors made of ground gemstones and distilled plant dyes—remained the staple for the painting of murals, decorations, and book illuminations. Medieval book illuminations, icons and altarpieces, portraits, and the decorative arts all relied on the stable colors of the ancient earth palette and the few expensive bright colors for richness and beauty. Artists and their apprentices continued to make their palette colors through the

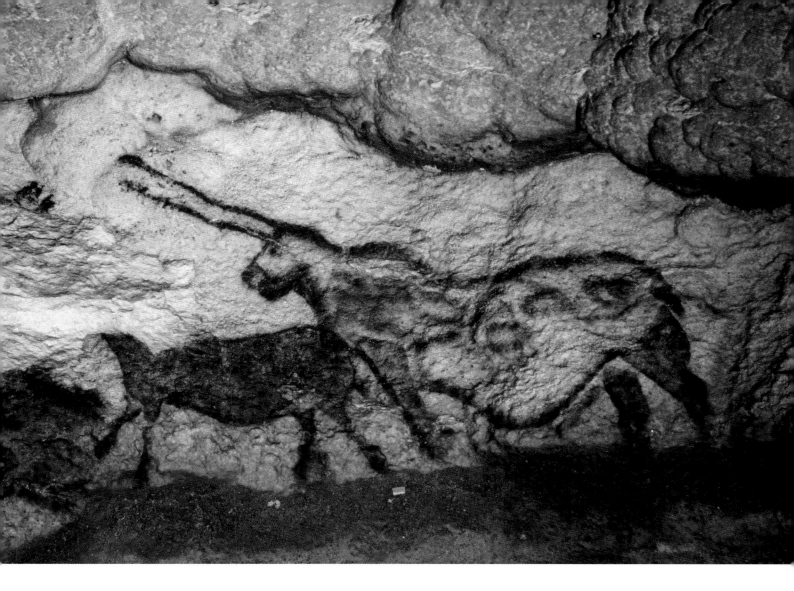

time-honored methods passed down from ancient eras. The physical stability and visual harmony of this "classic" palette has remained largely the basis for works of all historic periods up to today.

Like the artists of the classical world, medieval artisans understood the language of color in signs and symbols. The "colors of faith" spoke to the illiterate and literate alike through stained-glass windows and altarpieces. Done in egg tempera and other water-based mediums, book illuminations and altarpieces presented a spiritual world, glowing with symbolic hues and described by both earth and brilliant colors. As in the ancient world, white was the color of purity and spirit. Blue, often associated with chastity, became the identifying color of the Virgin Mary. Purple and scarlet, both royal colors, were associated with Christ, passion, faith, and martyrdom. Flowers and their colors held a special place as "attributes" of holy figures.

The medieval language of color, written about throughout history, presented an ideal world floating above that of the crude and rough abode of mankind. Even so, lovely, coloristically natural descriptions of flowers, plants, and animals were used to enrich medieval imagery.

A Changing World and the Renaissance

Leonardo da Vinci and the medium of oil painting (thought to have been developed in the fifteenth century) paved the way for a new era of color usage and theories. Color in painting had generally been subject to use in visualizing images that were highly conceptualized and that attempted to perfect and harmonize nature rather than document it.

Leonardo's observations and notes on atmosphere and color helped to open up a new way of seeing nature and depicting it in painting. *Atmospheric color* (the way forms and their colors are affected by the atmosphere and light in which they exist) became the visual watershed for painters of the next five hundred years. As the natural world—rather than just the spiritual world of the medieval period—became more important to Western culture, so followed the theorists and the painters. Leonardo's explorations became a bridge between the concepts of the medieval world and the modern world.

From the fifteenth century through the nineteenth, new theories of how and why color exists proliferated. The old debate between the supremacy of drawing in art versus that of color took on new fervor as painting styles and schools of art proliferated.

By the seventeenth century, painters as diverse as Frans Hals and Nicolas Poussin were both influenced by concepts of dark and light and atmospheric color that descended from Aristotle's ideas and Leonardo da Vinci's explorations. Philosophical and theological content in these paintings now dictated a strong sense of believable form and atmosphere, whether the style of the paintings adhered to a more classical or a naturalistic manner.

Artists' color selections were still very much rooted in the "classic" palette, balanced on the one hand by the earth colors and extended on the other by the brightness of "prismatic" colors. Materials such as ground lapis, malachite, lead, and madder root were still to be replaced in a later era by chemical dyes and other modern materials.

The Baroque and the Birth of Modern Science

Sir Isaac Newton provided the first modern theories of the nature of color. He also presented a modern palette of brilliant primary and secondary colors. During the

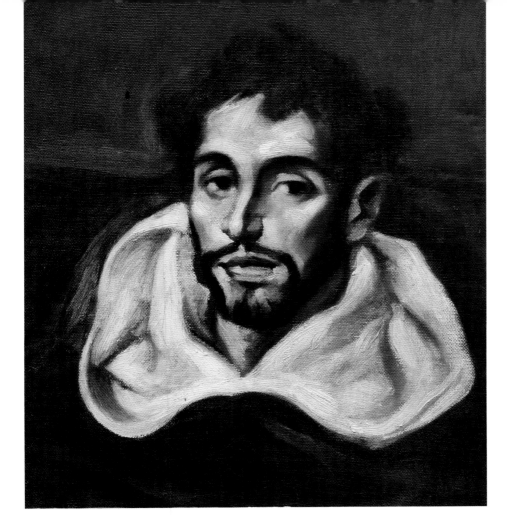

Al Gury, *Portrait of Fray Hortensio Félix Paravicino (after El Greco)*, 1990, oil on canvas, 14 x 12 inches (35.5 x 30.4 cm). Collection of the artist

As discussed more on page 153, copying masterworks is one of the best ways to understand the color and other structures of the painting process in general and of individual works in particular. In my copy of Fray Hortensio (done from a good reproduction), the grisaille underpainting, made of lead white and ivory black, develops the drawing and form on a mid-tone reddish-brown ground. The color is made of one-skin local glazes of burnt sienna, rose, and ultramarine blue. El Greco's general working method, layering, and color effects have been simulated; his original palette colors of lead white, carbon black, lead-tin yellow, orpiment (a yellow), copper resinate (a green), indigo, lapis lazuli, cochineal lake (a rose color), and burnt umber have been replaced by my modern colors.

seventeenth and eighteenth centuries, numerous theories and beautiful illustrations of these concepts abounded. Charts, maps, and constructions of all kinds showed recommended colors for palettes, color systems, and color gradations.

Academies of art, first appearing in Italy in the mid-1500s, had now largely replaced the artists' workshops as the scene of aesthetic debate. Color theorists might easily be scientists or academics rather than painters. Artists themselves followed these debates and new developments in color technology but continued to produce paintings based on the classic colors of time-honored palettes, methods, formal elements of light and shade, and line and form development. Color, and the arrangements of colors in a painting, was dependant on the subject (portrait, landscape, history painting, and so on), as it always had been. Variations depended on the gifts of the painters as well as their orientation toward more atmospheric painting (*open form*) or more linear painting (*closed form*). Rembrandt and his deep tonalities represented open-form color and painting methods, while Hans Holbein represented closed-form painting and its elegant polished line edges.

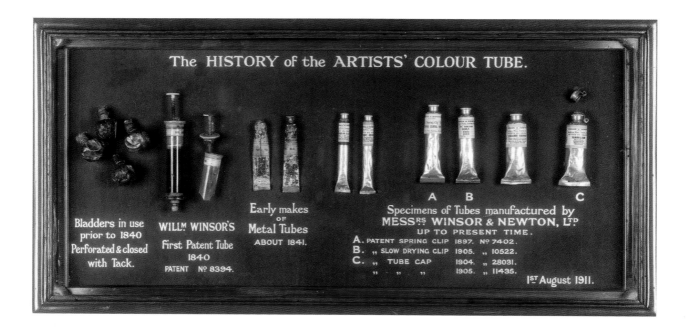

The HISTORY of the ARTISTS' COLOUR TUBE.

Bladders in use
prior to 1840
Perforated & closed
with Tack.

WILL^M WINSOR'S
First Patent Tube
1840
PATENT N⁰ 8394.

Early makes
OF
Metal Tubes
ABOUT 1841.

Specimens of Tubes manufactured by
MESS^{RS} WINSOR & NEWTON, L^{TD}
UP TO PRESENT TIME.
A. PATENT SPRING CLIP 1897. N⁰ 7402.
B. „ SLOW DRYING CLIP 1905. „ 10522.
C. „ TUBE CAP 1904. „ 28031.
 „ „ „ 1905. „ 11435.
1ST August 1911.

The Eighteenth and Nineteenth Centuries: The Explosion of Colors

The eighteenth century and the beginnings of the industrial revolution saw the development of a new world of artist colors and materials. Developments in the chemical and petroleum industries would, over the next century, introduce not only cheaper substitutes for older, more expensive and fragile colors but also a host of new colors with which artists could experiment. The profession of the "artist's colorman" grew out of the opening of factories to produce large quantities of the new colors along standardized lines of quality and consistency. The Winsor & Newton company in England, founded in 1832, was at the forefront of the development of new materials for artists that were consistent in their high quality and permanence.

The classic palettes continued to be the basis of painting practice, but new colors (such as cadmiums, alizarins, and phthalos) were added to palettes and experimented with. Some painters, like Eugène Delacroix, added so many new pigments to their palettes that as many as forty colors, squeezed directly from the tubes, crowded their mixing surfaces. Gradually, painters found that some colors were too like others and weren't needed. Others, such as mummy (made from ground Egyptian mummies) and asphaltum (made from petroleum), came and went with fashion and increased knowledge of the new paints and their limitations.

An important factor in this development was the prevalence of art supply stores, which provided premade artist materials of high quality, replacing the making of

materials in the studio by the end of the eighteenth century. In many ways, the concept of the "lost secrets of the old masters" derives as much from this switch from the studio to the store as anything else. Artists and art students could now easily purchase a wide array of materials, ranging from the newly developed collapsible oil paint tubes to prepared canvases. The new colors and materials were featured in these stores.

Parallel to this development, painting techniques were now largely taught in academies like the École des Beaux-Arts in Paris rather than in artists' studios. Concepts of color in painting became part of the curriculum of schools and individual teachers. New theories and speculations on color were transmitted through these academic and official channels.

The period from the beginning of the nineteenth century to the start of World War I contained some of the most wide-ranging and experimental developments in aesthetics, artist materials, and color theories of any time in Western history. In 1839, French scientist and man of letters Michel Eugène Chevreul wrote *De la Loi du Contraste Simultané des Couleurs* (*The Principles of Harmony and Contrast of Colors*), based on his studies of color contrast in woven yarns at the Gobelins tapestry factory in Paris. Chevreul observed that adjacent colors intensify the effect of each other and that spots of color could optically mix to provide illusions of other, more subtle colors. For painters, especially of landscape, this concept allowed for the capturing of the complex effects of many colors seeming to be present in the atmosphere and of the forms that they saw. Chevreul's work outlined the manner in which colors affect one another and optically blend and even create afterimages to make new illusions of complex colors.

The older studio formulas for creating form, depth, and atmosphere were readily adapted to the new ideas by some painters. Chevreul's seminal work became the basis for what was to be known as impressionism and started the evolution in painting toward expressionist and modernist color in the last quarter of the nineteenth century. A new approach to both the painting of atmosphere and to color mixing created illusions of color in the work of French painters Claude Monet, Camille Pissarro, Alfred Sisley, and others, which would not have been possible without the writings of Chevreul.

Postimpressionist painter Georges Seurat utilized a pure, almost abstract version of the new concepts of color mixing. As many painters became more interested in the pure properties of color and color expression, the idea of color itself as a subject took root. In an earlier decade, painter Édouard Manet had spoken of the paint itself as an important element in modern work. Postimpressionist, fauvist (from the French *Les Fauves*, or *The Wild Beasts*), and modernist painters explored as many avenues of personal color expression as there were individual painters.

Prior to the invention of the paint tube, and its large-scale manufacture by artists' materials suppliers, hand-mixed colors were stored in small sealed containers or in animal-skin "bladders" (small tied bags). This was suitable for indoor studio work, but the increasing desire of some painters to work *en plein air* in the nineteenth century made the old storage system unwieldy and difficult.

The first tubes, made of glass and operating much like a syringe, were a positive step but were fragile and awkward to use. The true collapsible tin tube with a screw top allowed artists to transport, store, and use paint in an easy and flexible manner—both in the studio and outdoors. The collapsible tube contributed greatly to the growth of outdoor painting in general and impressionism in particular.

It's important to remember that more traditional forms of painting and color usage were not replaced by new movements and styles of painting; rather, they largely coexisted and influenced one another. Tonal, academic, plein air landscape sketches were among the roots of impressionism. The difference is that the fresh outdoor studies done by academic students and painters *were not* considered "finished" by their mentors, whereas they *were* seen as very complete by the new breed of impressionist painters.

Paul Cézanne, Vincent van Gogh, and Paul Gauguin embodied the excitement among painters for the new color possibilities. Just as impressionism was spreading rapidly through Europe and America, modern examples of color expression (such as fauvism) appeared in salons, galleries, and art schools throughout the Western world. Coexisting side by side at the start of World War I, the works of such painters as John Singer Sargent and Thomas Eakins could be seen in the same cities as works by André Derain and Henri Matisse. The modern world of color had exploded.

Paul Cézanne, *Mont Sainte-Victoire*, 1902–1904, oil on canvas, 28¾ x 36³⁄₁₆ inches (73 x 91.9 cm). Philadelphia Museum of Art: The George W. Elkins Collection, 1936. Photo: Graydon Wood

Cézanne is often called the father of abstraction because he broke down his subject into simple shapes and facets that were relatively flat. He approached color both through observation of what nature provided and through his own conceptualizing of geometric shapes and color blocking. In spite of a flatness inherent in his shapes and facets, he created depth and atmosphere through the traditional means of darker and bolder colors advancing and cooler and softer ones receding into the distance, although the similarities in the intensities of the colors keeps the whole image close to the picture plane, or surface of the canvas. Color is organized into simple masses, focusing on the abstraction of form rather than the nuances of variation in nature.

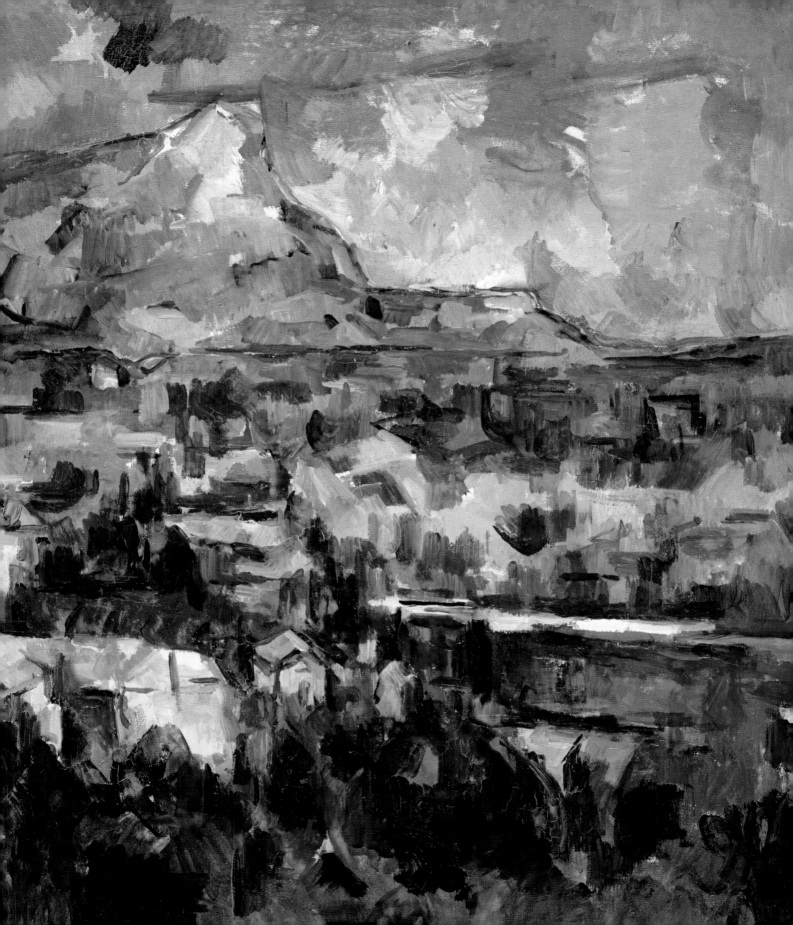

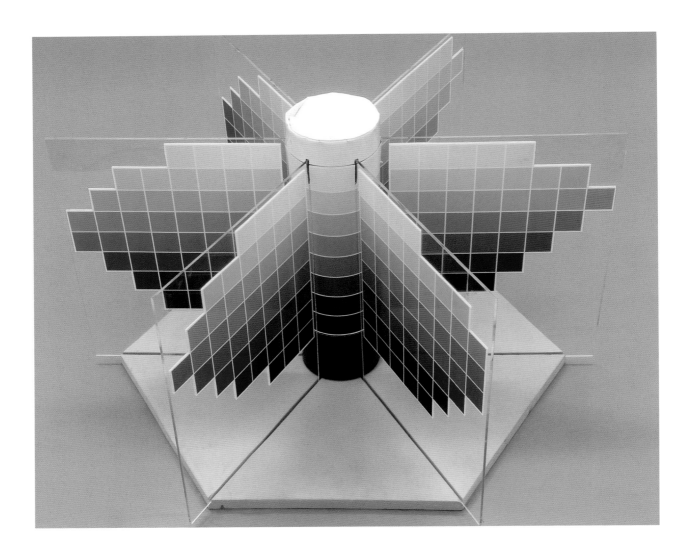

The color chart model shown here emulates the hue, value, and chroma arrangements of the Munsell system. In each "arm" of the model, colors range from neutral and grayer near the center column to lighter above to darker below and to more chromatic farther away. The central column is a corresponding gray scale to which all the colors are matched.

The Twentieth Century and the Abstraction of Color

In the first decade of the twentieth century, Albert Munsell, a painter and teacher at the Massachusetts College of Art, outlined his concepts of *hue, value,* and *chroma,* which became known as the Munsell Color System. His rational view of organizing the experience of color has become one of the primary modern systems of color notation both in the fine arts and the color industry. He suggested that any given color can be described by its hue (color family: red, yellow, or blue), value (lightness or darkness on a scale from pure white to black, with middle values in between), and chroma or chromatic intensity (brightness or dullness—i.e., vibrancy or color purity). This comprehensive approach to understanding colors added to an array of concepts that painters utilized in organizing the experience of color via their eye and materials.

Again, such concepts as neutrals, brights, and families of colors were known throughout history, but Munsell's comprehensive system allowed for a deeper and more objective understanding of color mixing and interaction. Most manufacturers of artists' oil colors and acrylics that were developed in the 1950s used and still use the Munsell system and even note the hue, value, and chroma of a color on the paint tube. In art education, Munsell's system has become a standard.

In the 1920s in Germany, a young artist and teacher at the Bauhaus school was to become one of the most important influences on modern art of the twentieth century. Over the next fifty years, Josef Albers developed concepts of color organization that would be outlined in his work *Interaction of Color*, which lays out important concepts of pure color reactions through hue and value changes. One of the most important contributors to the understanding and practice of color in the twentieth century, Albers's own work is subtle and surprising. His endless arrangements of flat, interactive colors have a poetic quality in their purity. His extensive series of paintings and prints, called "Homage to the Square," presented innumerable subtle interactions between colors of varying hues, values, and chromatic intensities. His concepts lent themselves both to intellectual understandings of color interaction and to poetic aesthetic explorations of color in painting. Innumerable painters—such as post-World War II abstract expressionists, pop artists, and minimalists—employed the pure concepts of color interaction inspired by the work of Josef Albers. In art education, along with the Munsell system, the Albers system of color interaction became standard in classrooms across Europe and America.

Andrew Graham, *Untitled [red] 2008*, 2008, oil on wood panel, 9¾ x 30 inches (24.7 x 76.2 cm). Private collection, Philadelphia. Courtesy of the artist and Larry Becker Contemporary Art, Philadelphia

Optical illusions of color interaction have taken many forms in the twentieth century. Josef Albers, Victor Vasarely, and Bridget Riley have all made tremendous contributions to modern color usage. Andrew Graham integrates many of these influences into a strong and personal whole: Color contrast, rhythm, and play of light against dark colors are all elements of this work.

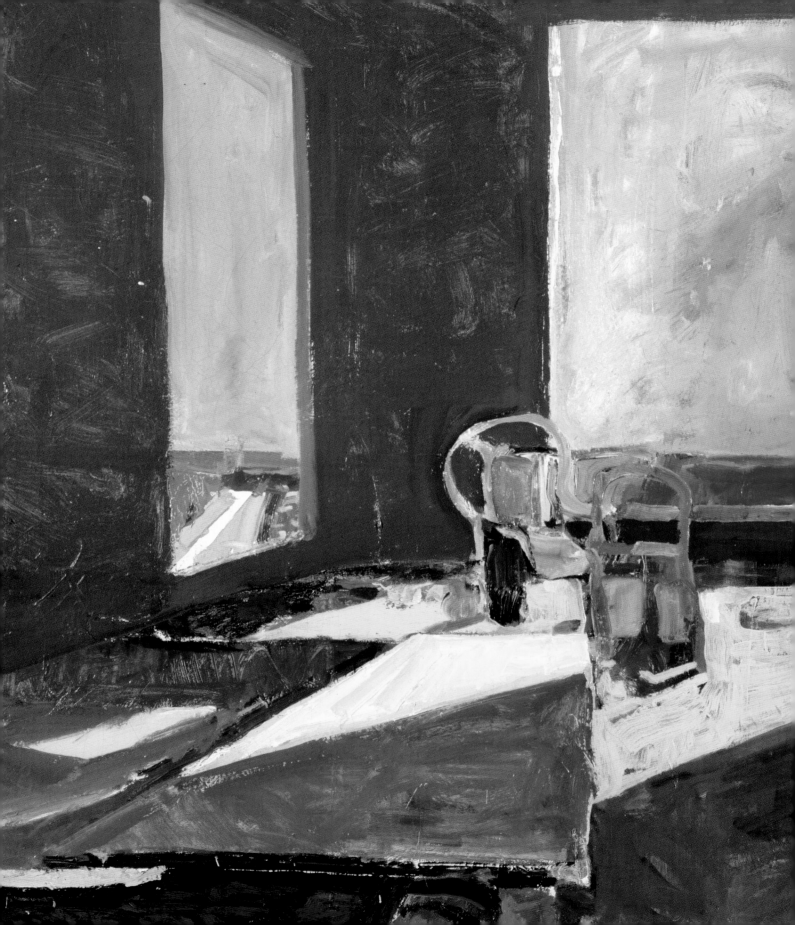

Where We Are Today: Revivals, Personal Journey, and the Digital Age

Today we live in an art world where a multiplicity of color traditions, influences, and aesthetics coexist—not the least of which are digital and additive color processes. To make sense of this confusing and complex landscape, a simple yet comprehensive overview of the history of color and its methods is needed. What follows in subsequent chapters is a systematic attempt to provide this overview, from the development of artists' palettes (including the palettes for a range of iconic painters and styles) to practical exercises and examples that will promote the student's and viewer's appreciation of color interaction.

Richard Diebenkorn, *Interior with View of the Ocean*, 1957, oil on canvas, 49½ x 57⅞ inches (125.7 x 147 cm). The Phillips Collection, Washington, DC. Copyright © The Estate of Richard Diebenkorn

As an abstract painter, observation of the surrounding natural world as a point of departure is a strong force in Diebenkorn's work. The color of light, rather than being broken up into small touches, as in impressionism, is organized into large masses that are at the same time abstract and natural. As the eye moves over a Diebenkorn, the picture plane (the flat surface of the canvas) and abstracted, or simplified, color arrangements create a tension between perceptions of depth and atmospheric light and the texture of paint and pure color interaction.

Colors, Palettes & Materials

A general understanding of the history of pigments and artists' palettes is essential for painters to ultimately make choices about their own colors and the aesthetics of colors. The huge array of colors presented in art-store displays can be confusing and frustrating. Having a general knowledge of core colors (classic palettes) as they have appeared and evolved is a good starting point in building one's own palette. Adding to that an awareness of the modern developments in colors can finally create some sense of clarity and purpose in choosing colors. The color exercises described in chapter 5 will also help clarity the "identity" of colors and their uses.

Joan Becker, *Pencil Sharpener*, 2009, gouache and charcoal on watercolor paper, 29 x 41½ inches (73.6 x 105.4 cm). Courtesy of Gross McCleaf Gallery

An observational painter, Becker integrates modernist color sensibilities with subtle turns of form and humor. Scatterings of touches of bright color are held in place by a strong geometric composition and skillful line drawing.

THE STORY OF PIGMENT

The earliest known color palettes, which appear in Paleolithic cave paintings and decorations, derive from naturally occurring clays, chalks, and carbon products. Colored clays dug up from the exposed strata of stream beds display many shades of ochres, browns, reds, and even greens. Manipulation of these clays, through heating or charring, produces other ranges of colors, such as burnt reds. The modern burnt sienna is a beautiful example of clay that is heated to produce a more reddish color. Soils rich in rusting iron also produce reddish colors of great beauty and permanence.

Black colors—produced from burnt wood, bone, or other organic materials—added the strength needed for the drawing and outlining of pictures and symbols. White was derived from deposits of chalk, pale clays, or ground bone or shells. This simple, early palette of colors was relatively easy to manufacture by hand, came from source materials that were very common in the environment, and was very durable. Today, the "earth palette" is still largely made from these solid, simple materials and provides the basis of much of modern painting.

Ancient palettes also included bright colors made from vegetable dyes and flower extracts. Beautiful blue, green, and rose colors mixed with clay or chalk were used for decoration and embellishment or for the finishing of an image. These often fragile and non-lightfast colors faded easily and were gradually replaced by the brilliant colors of ground precious and semiprecious gemstones, such as lapis lazuli and amethyst, while other colors continued to be produced from plants, such as colored berries and even insects (for example, the pigment cochineal).

White lead would supplement the making of whites from chalk. In writings from as early as 500 and 400 BC, carbonate of lead was described as made by combining metallic lead and vinegar. Lead whites have been highly prized for their mixing capabilities and balance between opacity and translucency. White lead paints today go by names such as lead white, flake white, Cremnitz white, and so on. Lead white became the most commonly used white throughout the history of European oil painting.

When raw red clay from a field is mixed with linseed oil, the result is a natural burnt sienna.

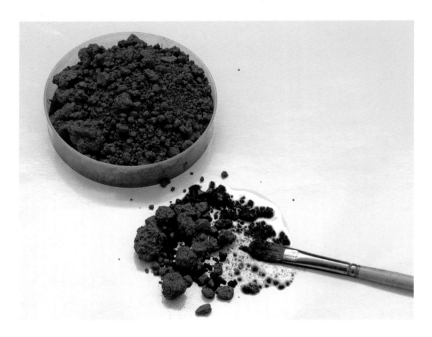

Lead white's high toxicity, and the possibility of darkening when exposed to other compounds such as sulfur, has caused it to often be replaced by modern white pigments and substitutes. Combinations of zinc and titanium whites are often marketed as reliable lead white substitutes. Though lead whites are still highly valued today by many painters, titanium white has become a more commonly used white oil paint.

Difficult, time-consuming, and expensive to make, artists' colors of all sorts came to be produced by craftsmen who specialized in the making of colors as well as other valuable powders and medicines. With the development of stable cultures throughout the Mediterranean and ancient Near East, manufacturing of colors would become the province of trade guilds such as the apothecaries of medieval Europe and the artists' colormen of nineteenth-century color factories. Raw pigments were purchased from these guilds and apothecaries and mixed with various supporting mediums (wax, egg, or oil) in the studio by painters or their assistants.

New scientific and technological developments in the eighteenth century would, over the next hundred years, produce a wealth of color by-products from the new chemical and petroleum industries. The industrial revolution affected artists as much as anyone else. Less expensive replacements for the old bright colors, as well as refinements in the mechanical production process itself, introduced cadmiums, ceruleans, purples, and greens of great brilliance and permanence. While permanent and beautiful earth colors would remain the basis of artists' palettes, painters would expand their "bright" list by dozens of new colors.

Until the eighteenth century, the production of colors remained as it had been for centuries and even thousands of years, involving traditional color grinding with a grinding stone.

Color manufacturers—such as Winsor & Newton in England (founded in 1832) and Sennelier in France (founded in 1887)—gradually removed the making of artists' colors from the hands of the artists and the apothecaries. Even as early as 1720, the Lefranc & Bourgeois company began making colors commercially for artists. A wide array of artists' materials now provided by these companies and sold in art supply stores became the norm by the mid-nineteenth century.

The by-products of this explosion in the artists' materials industry were such things as the expansion of outdoor painting through the use of new, easy-to-use, collapsible paint tubes and the growth of the myth of the "lost secrets of the old masters." Transfer of the manufacture of materials from the artist's studio (where the craft of production was taught from one generation of painters to the next) to manufacturers and technicians created a disconnect between working artists and the craft of their materials. Painting education, largely confined to the academies by the nineteenth century, increasingly followed the methods of individual artist-teachers and sanctioned academic approaches. Some technical approaches were encouraged and others fell into eclipse. The general result was a spotty or incomplete knowledge on the part of the average art student and even the teachers.

Connoisseurs, teachers, historians, and students speculated on the "methods" of the older masters. This led to a mixture of myth, fact, and misinformation about old-master techniques. With the advent of modern conservation methods, and also scientific analytical methods, and the availability of early documents, we now have a much greater clarity about early painting methods.

A corresponding evolution in the *education* of painters away from the studios and into art schools and academies added to the growth of art supply stores and the need for ready-made, easy-to-use products. Art schools now taught aesthetics and ideas, not the craft of grinding colors. The traditional crafts of artists' techniques became increasingly remote and mysterious.

Continued growth and exploration in the chemical and petroleum industries from the nineteenth century to the present has resulted in artists' colors of great variety and permanence. Today, the diverse manufacturers of artists' paints, while adhering to industry guidelines for the quality of their colors, often use their own recipes and "secrets" for the making of beautiful signature colors. Also, there is a current vogue for handmade (rather than machine-ground) colors produced by small companies.

The past fifty years have also seen the addition of artists' acrylics and colors that are premixed with resins and other dryers, like alkyds. Yet still, except for the addition of new colors and technologies in the past 150 years, artists' colors and palettes remain today remarkably like their ancient predecessors.

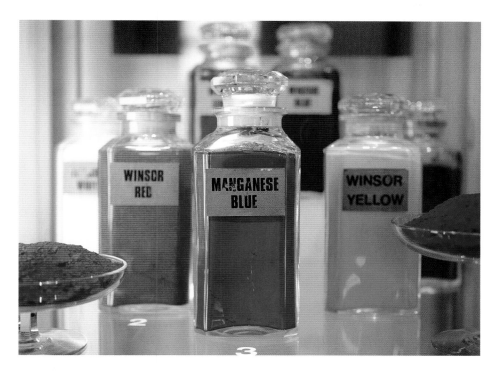

Grinding pigments to make paint is an interesting but labor-intensive process. Prior to the development of premade collapsible paint tubes and shops that focused on selling ready-to-use artists' paints, dry pigments had to be purchased in containers, mixed, and then carefully ground to create paint of the right density and texture. Densities of paint would vary according to each painter's taste and aesthetics. Freedom from this sort of labor, in the form of premade paints, changed the nature of the artist's studio and made the discipline of painting more readily available to amateurs and hobbyists. The studio could move out of doors and painters could focus more on the aesthetics of painting and its immediacy of creation.

As the nineteenth century saw more and more painters wanting to paint out of doors—and even paint as they traveled—suppliers of artists' materials created a wide range of equipment to suit the task. The collapsible landscape easel, the pochade box (a small kit for outdoor sketching), stools, umbrellas, foldable palettes, and the like became very much in vogue and commonly used by painters. Winsor & Newton catalogues of the period feature an enticing array of reasonably priced portable painting materials and equipment.

SELECT PALETTES

The remarkable thing about many artists' palettes through history is how simple and practical they were. Mostly limited to eight to twelve paints, palette colors were chosen for their maximum flexibility and ability to mix many hues, tints, and shades. These palettes were then easily extended with additional colors as needed. The "core" palettes included both time-honored colors, which carried the same name no matter the time and place (like ivory black), as well as colors that looked the same but whose names changed depending on the locale (such as burnt sienna and burnt red earth or Verona earth).

What follows is a selection of artists' palettes. Regardless of particular colors, however, a palette should be practical, flexible, stable in tinting strength (when mixed with white), and well organized on the mixing surface, like the tools of a carpenter or any other craftsperson. (We'll consider palette arrangement more on page 42.)

Titian (Tiziano Vecellio), *Bacchus and Ariadne*, 1520–1523, oil on canvas, 69½ x 75 inches (176.5 x 191 cm). National Gallery, London. Bought, 1826 (NG35). © National Gallery, London / Art Resource, NY

The brilliance of color in Titian's paintings is often obscured under old, dirty varnish. When modern cleaning practices uncovered intense colors, viewers used to the "golden glow of the antique" were outraged, much as they were after the cleaning of Michelangelo's Sistine Chapel ceiling.

Using a combination of direct painting, velatura, and glaze layers, Titian's color methods have a tremendous force and variety. Largely opaque and dense, being built with lead white mixtures, his figures have a luminosity that is intensified by the surrounding darks and the single-skin glazes over clothing, skies, and other objects. His late work becomes more direct and brushy, while his early work was influenced by the smoother layered methods of Giovanni Bellini.

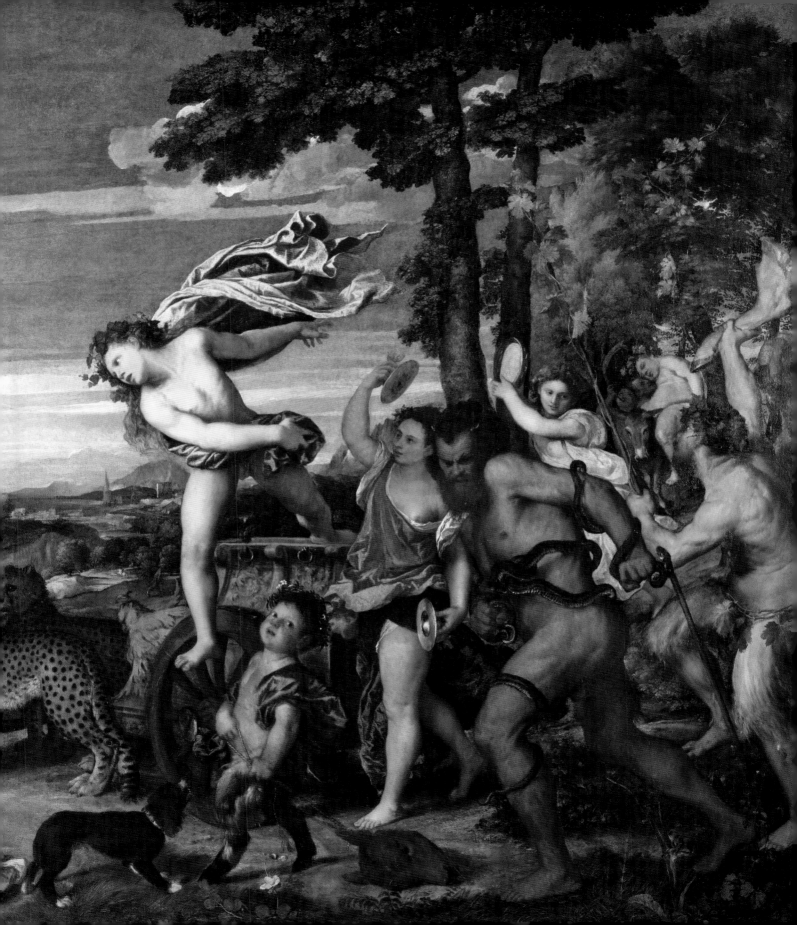

TITIAN (TIZIANO VECELLIO)
Italian, c. 1488–1576
lead white
ultramarine blue
red madder
burnt sienna
malachite green
red ochre
yellow ochre
orpiment (a yellow)
ivory black

EL GRECO (DOMÉNIKOS THEOTOKÓPOULOS)
Spanish (Cretan-born), 1541–1614
lead white
carbon black
burnt umber
yellow ochre
orpiment
lead-tin yellow
cochineal lake (a rose)
indigo
copper resinate (a green)
lapis lazuli

PETER PAUL RUBENS
Flemish, 1577–1640
lead white
orpiment
yellow ochre
yellow lake
red madder
vermilion
red ochre
ultramarine blue
cobalt blue
green earth
vert azur (a blue-green)
malachite green
burnt sienna
ivory black

FRANCISCO JOSÉ DE GOYA
Spanish, 1746–1828
lead white
Naples yellow
yellow ochre
brown ochre
light red
vermilion
burnt sienna
crimson lake
cobalt blue
raw umber
burnt umber
ivory black

JOHN CONSTABLE
English, 1776–1837
lead white
yellow ochre
umber
red earth
emerald green
ultramarine blue
Prussian blue
black

THOMAS SULLY
American, 1783–1872
lead white
yellow ochre
burnt sienna
ultramarine blue
vermilion
Indian red
raw umber

CAMILLE COROT
French, 1796–1875
lead white
yellow lake
light cadmium yellow
Naples yellow
raw sienna
burnt sienna
vermilion
Verona green
rose madder
Robert's lake (a brown)
cobalt blue
Prussian blue
emerald green

umber
Cassel earth

EUGÈNE DELACROIX
French, 1798–1863
lead white
vermilion
Naples yellow
yellow ochre
Verona brown
ru ochre (a light brown)
raw sienna
red brown
burnt sienna
crimson lake
Prussian blue
peach black
ivory black
Cassel earth
bitumen

CAMILLE PISSARRO
French, 1830–1903
lead white
chrome yellow
vermilion
rose madder
ultramarine blue
cobalt blue
cobalt violet

JAMES MCNEILL WHISTLER
American, 1834–1903
lead white
yellow ochre
raw sienna
vermilion
Venetian red
Indian red
burnt sienna
umber
cobalt blue
mineral blue
black

PAUL CÉZANNE
French, 1839–1906
white
brilliant yellow
Naples yellow
chrome yellow
yellow ochre
raw sienna
vermilion
burnt sienna
red madder
crimson lake
burnt lake
Veronese green
emerald green
Verona earth
cobalt blue
ultramarine blue
Prussian blue
peach black

PIERRE-AUGUSTE RENOIR
French, 1841–1919
silver white
red madder
red ochre
cobalt blue
emerald green
Verona earth
Naples yellow
yellow ochre
raw sienna
ivory black

THOMAS EAKINS
American, 1844–1916
white
cadmium yellow
cadmium orange
vermilion
light red
rose
burnt sienna
permanent blue
Van Dyke brown
black

Palette Surfaces for Color

The word *palette* can refer to the surface on which artists mix their paints as well as to the array of colors that an artist uses on the palette. Traditional mixing surfaces require a stable, nonabsorbent, smooth surface.

Hand- and arm-held wooden palettes of various sizes have been most common. The large, beautifully curved Beaux-Arts palette is seen in the hands of many nineteenth-century painters in their self-portraits. The wood surface of the palette must be sealed or "cured" so that the paints will not sink in and is often a natural wood color and tone. Throughout history, the color of the palette has most often been a neutral color or a natural, sealed-wood color.

Sealing the palette with shellac, or multiple coats of linseed oil rubbed in, works well. Many painters gradually seal a new palette when they clean it of used paint residue. They rub the remaining paint into the wood and buff it down. The resulting patina of thin paint seals the wood permanently and imparts a neutral color to the palette surface.

Other color-mixing supports include glass, enamel butchers' trays, and plastic surfaces and disposable paper palettes. Unlike the Beaux-Arts palette held on the arm, many palettes are more usable if kept on a painting table near the easel. White palettes are very common today, and have been since impressionism, as are palettes whose color is similar to the color of the gessoed canvas (gray, brown, tan, and so on). Should a white palette or colored palette be used? It's a good question, but what's more important is that the painter become familiar with the palette surface and its arrangement of colors so that there is consistency in color mixing and decision-making approaches. Some painters use palettes that are the color of their canvases. Others use a different color.

The palette should be large enough to accommodate all of the colors laid out around the periphery of its surface. Enough mixing room is essential. To arrive at a mixing surface that is suitable for each individual painter, one should experiment with the various types and colors and see what works best.

PIERRE BONNARD
French, 1867–1947
cadmium yellow
strontaine (strontium) yellow
cadmium orange
carmine lake
ultramarine blue
cobalt blue
cobalt green
emerald green
cobalt violet
white

HENRI MATISSE
French, 1869–1954
cadmium yellow
strontaine (strontium) yellow
cadmium red light
cadmium red purple
light sienna
burnt sienna
yellow ochre
Venetian red
cobalt violet deep
cobalt blue
ultramarine blue
special green
emerald green
silver white
ivory black

ARTHUR DECOSTA
American, 1921–2004
titanium white
yellow ochre
ivory black
burnt sienna
transparent red oxide
Venetian red
lemon yellow
vermilion
permanent rose
ultramarine blue
chromium oxide green

AL GURY
American, born 1951
titanium-zinc white
yellow ochre light
raw umber
Mars orange
burnt sienna
burnt umber
Venetian red
Mars violet
Indian red
greenish umber
ivory black
cadmium yellow light
cadmium orange
cadmium red medium
permanent rose
ultramarine blue
chromium oxide green

RIGHT: **Al Gury**, *Portrait of Emma*, 2001, oil on panel, 16 x 12 inches (40.6 x 30.4 cm). Collection of the artist

This portrait is an example of tonal color and color identification of a middle-tone to dark complexion. Yellow ochre and burnt sienna heightened with cadmium orange create the lightest colors. Highlights are yellow ochre and white. Shadows grade to umbers and dark, cool red-browns.

OPPOSITE: **Arthur DeCosta**, limited-palette still life, c. 1970, oil on linen mounted on board, 7 x 5 inches (17.7 x 12.7 cm). Collection of the Pennsylvania Academy of the Fine Arts

This lovely small flower study uses a very economical and limited palette to create form and temperature changes in a neutral range: titanium white, burnt sienna, ivory black, and yellow ochre. Temperature changes (warmer to cooler) in neutral (low-chromatic) colors are typical aesthetic and structural concerns in DeCosta paintings.

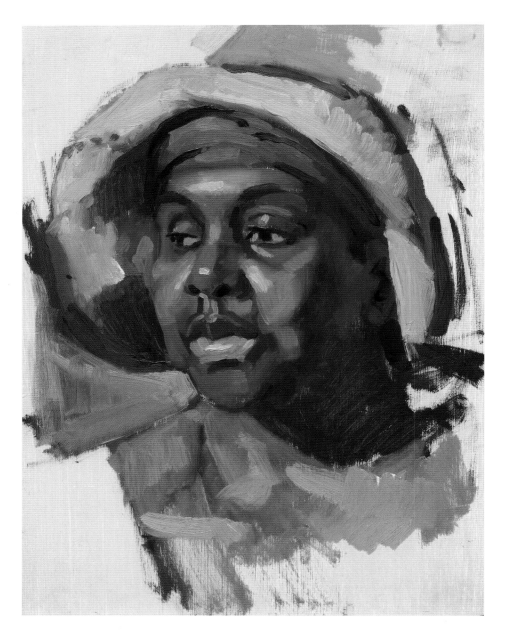

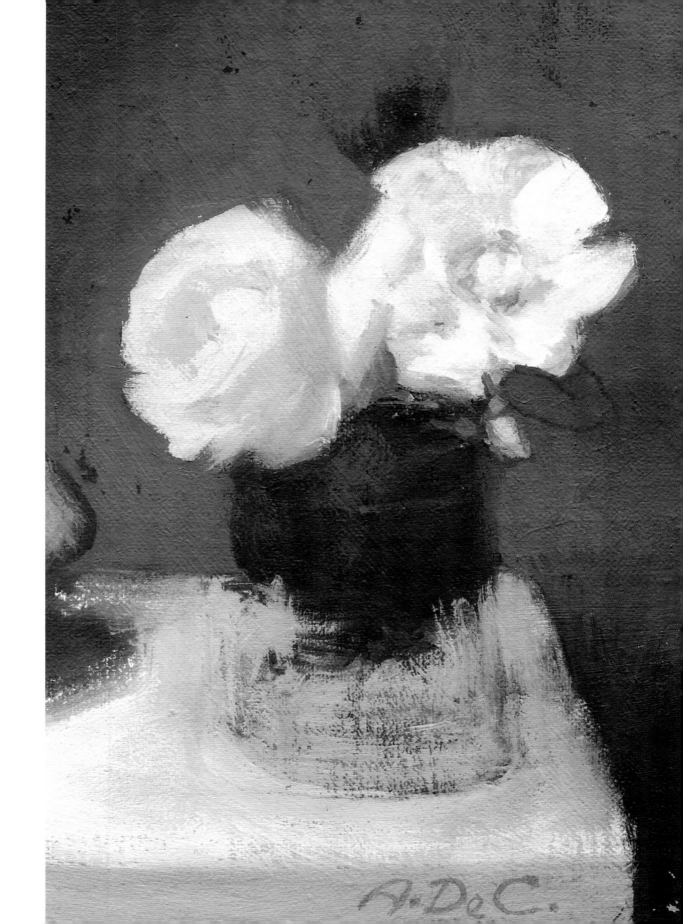

BASIC PALETTE COLORS AND ARRANGEMENT

What follows is the recommended basic or classic palette. This palette represents colors that have been the most common on historic palettes and the most stable and intermixable with one another. Of course, many additional colors can extend this classic palette, and a few stable and very usable colors are suggested for that, as well. There are many beautiful prismatic and earth colors that can be added or substituted. These vary according to manufacturer, grade, and price. Colors should be added or substituted as you experiment with color types.

Historically, painters have laid out their colors in very simple, practical manners. Some arranged them from lightest to darkest around the rim of the palette. Others arranged them in hue groups, such as reds, yellows, blues, browns, and so forth. Some arranged them from brightest to dullest. Others separated the earth colors from the bright colors, forming two distinct groups. Still others arranged them in mixed gradations of each color.

Whatever the chosen arrangement, the placement of the colors on the palette should suit the working methods and aesthetics of the painter. Until one discovers those elements, staying with a simple, classic palette will provide a proving ground while the painter works out any technical and aesthetic issues. Most painters have arrived at a workable arrangement and stay with that for reasons of practicality. Knowing where the pigment is on the palette becomes something to rely on when dipping into colors for mixing.

Recommended Classic Palette	Additional Colors	
titanium white	cadmium orange	green earth
cadmium yellow light	thalo yellow green	greenish umber
cadmium red medium	lemon yellow	red oxide
permanent rose	Naples yellow	transparent red oxide
ultramarine blue	cobalt violet	Mars yellow
yellow ochre	cobalt blue	Mars violet
raw umber	cerulean blue	raw sienna
burnt umber	cadmium red deep	flake white
burnt sienna	dioxazine purple	zinc white
Venetian red	cadmium green	
Indian red	chromium oxide green	
ivory black	viridian green	
	Prussian blue	

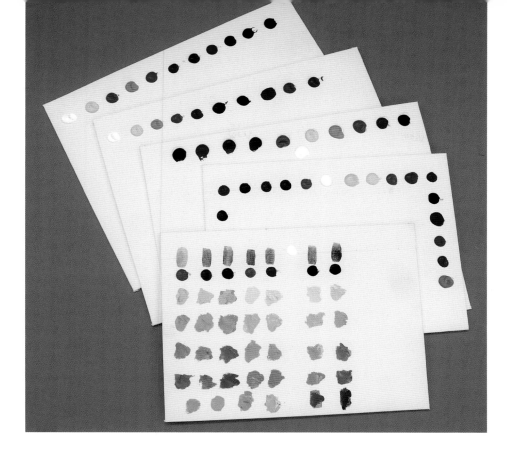

In this selection of various palette arrangements, the first palette follows the manner of Thomas Sully, with colors pre-mixed in tonal gradations. The next two under that show the earth colors laid out to the left and the prismatic colors to the right, with white in the middle. The fourth shows the pigments arranged from lightest to darkest and the fifth from warmest to coolest.

Arranged on a traditional wooden palette from lightest, brightest, and warmest (yellow) to darkest and coolest (black), with white at the end, this is a variant of a classic palette arrangement. In this strategy of palette layout, the colors follow a very simple concept of light to dark, bright to dull. Other classic palette layouts include ones of all earth colors, ones of graded mixtures of each color, ones of all prismatic colors, and limited palettes.

As one of the several typical classic palette layouts (with light/bright to dark/cool [dull], prismatic on one side/earth opposite, and gradation mixtures), the palette shown here offers simplicity, consistency, flexibility, and practicality. These are qualities most often characteristic of historic palettes.

Variations in Colors & Manufacturers

One of the mysteries of choosing colors is the variation in colors of the same name from one manufacturer to another. Some colors of the same name can be remarkably similar, while others will vary greatly. What one company calls cadmium red light will look like cadmium red medium by another company. A green earth made by one will be opaque and dull in appearance, while another green earth will be more transparent and brighter. Burnt sienna from one manufacturer will be redder, while another's will be browner.

The degree of difference may vary from the subtle to the obvious—or colors may seem to be exactly the same. One should, over time, become familiar with the varieties by testing and comparing them and choosing the preferred types. Eventually, painters arrive at color and brand choices that suit them and their work. Some use only one manufacturer's paints for all their work. They may like the quality and mixing properties of that product over all others. Others may use paints from a variety of companies based on their preferences for the hues, densities, and temperatures that each provides. There is no problem in mixing colors from different companies. Again, testing over time leads to decisions that suit one's working methods and aesthetics.

Al Gury, painting of a plaster cast, oil on panel, c. 1990. Collection of the artist

For this demonstration, a limited palette of only titanium white, raw umber, burnt umber, yellow ochre, and ivory black was used.

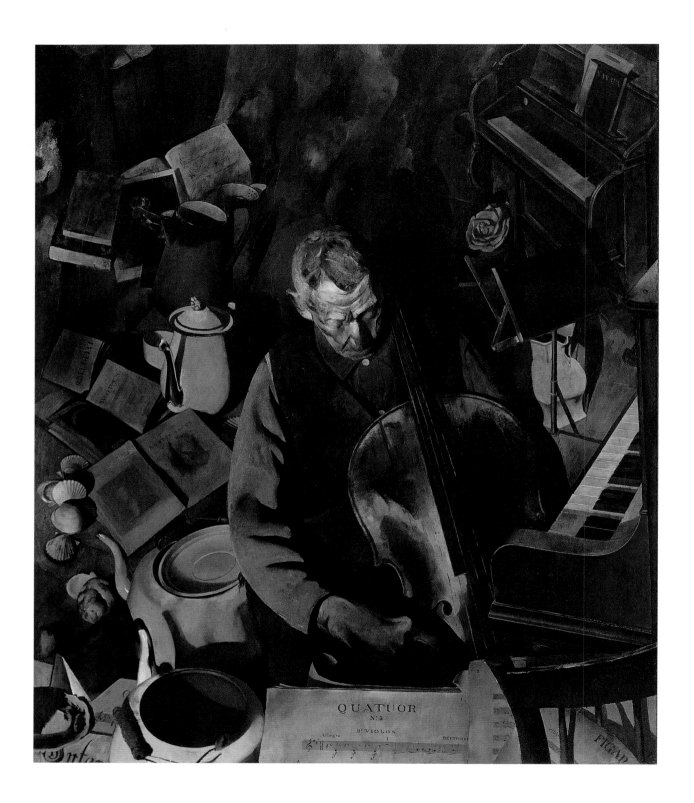

Recommended Limited Palettes

Limited Palette 1
black
white

Limited Palette 2
black
burnt umber
white

Limited Palette 3
black
burnt umber
yellow ochre
white

Limited Palette 4
ultramarine blue
burnt sienna
white

Limited Palette 5
yellow ochre
raw umber
burnt sienna
Venetian red
ivory black
green earth
white

Limited Palette 6
cadmium red medium
cobalt blue
cadmium yellow light

Limited Palettes

Limited palettes have a historic role in the craft of painting and are invaluable in learning to understand colors and palettes. Limited palettes of umbers, black, and white have been used for centuries in grisailles, tonal paintings in gray scale, and in trompe l'oeil paintings.

Grisailles are made usually of just black and white, for a gray-scale effect. Paintings in tonal gray scales can be made of black, white, and additions of umbers for warmth. Burnt sienna and ultramarine blue, with white, can be used to understand warm/cool relationships. Any set of a warm and a cool color can also be used to explore simple warm/cool relationships and color interaction. Using only red, yellow, and blue, plus white, is a time-honored exercise in understanding color mixing. Palettes can also be limited to just earth colors or just prismatic colors.

Painting a subject in each one of the recommended limited palettes provides an excellent view of the possibilities of color ranges and interactions. For example, try painting the same still life, landscape, portrait, or abstraction using each one of the palettes recommended in the box above, and then compare the results and various properties of color, temperature, and color interaction.

Edwin Walter Dickinson, *The Cello Player*, 1924–1926, oil on canvas, 60 x 48¼ inches (152.4 x 122.5 cm). Fine Arts Museums of San Francisco, Museum purchase, Roscoe and Margaret Oakes Income Fund, 1988.5

Thought of as a "painter's painter" because of the freedom and independence of his vision and avoidance of commercial concerns in his work, Dickinson is a great influence on contemporary representational painters. His color interpretations are very personal, with homage to both impressionism and tonal painting. Often limited in color range, Dickinson's deep colors suggest tremendous variety in feel and temperature change.

THE EFFECT OF MEDIUMS AND VARNISH ON COLOR

Unknown artist, nineteenth-century self-portrait of an artist, oil on academy board, 10 x 8 inches (25.4 x 20.3 cm). Collection of the author

Executed on academy board (a prepared nineteenth-century artists' cardboard for oil studies), this self-portrait exhibits an unmistakable difference when cleaned of its dirty varnish. Typical of damar-based varnishes, the varnish coating on this painting darkened and became warmer and browner with age. In addition, dirt and grime imbedded in the varnish, adding to the dark-brown tone.

Careful cleaning revealed a relatively limited palette of colors in a strong tonal range. To ensure that no color of the original was removed, cleaning was approached very slowly, first with distilled water and later with mild solvents. The effect of the painting, typical of mid-nineteenth century tonal painting, was not diminished or damaged by cleaning. The overall final result is brighter but still aesthetically focused on light and dark in a limited classic palette.

Vehicles and additives to colors can have a tremendous effect on the nature of the paint. Oil paints are ground with light, or non-heavy, and relatively fast-drying oils, such as linseed and safflower oil. Modern oil paints, when dry, will retain their original hue, value, and intensity with little change under normal circumstances if they haven't been altered by the addition of mediums, especially excessive amounts of mediums.

Adding any medium or liquid to oil colors potentially alters their density and thus their temperature, vibrancy, and stability. The addition of materials such as varnishes, dryers, resins, and the like can cause colors to darken or yellow or to dry unevenly. Linseed and other mixing oils are known to darken with age and will darken colors when used in excess. The pigment asphaltum, a petroleum by-product popular in the nineteenth century, was known to darken colors with age, even though the initial effect was attractive. Excessive amounts of any additive to oil paints runs the risk of changing the color over the long term.

As a general rule, you should learn what any additive does to the paint, what its aging properties are, and why it should or shouldn't be used. Use mediums sparingly. "Less is more" is a sound idea, both in immediate painting practice and long-term conservation issues.

In addition, surface varnishes placed over dry paintings have a number of considerations. Over the centuries, paintings covered with heavy varnishes have often yellowed and darkened. When this happens, usually the color under the varnish remains intact and unaffected. In rare cases, however, these seemingly protective coatings have damaged the surface color and glazes of a painting. At the very least, the original vibrancy of the original colors becomes obscured. Uneven drying, cracking, and brittleness of paint mixed with too much medium or due to the inappropriate use of varnishes are common problems, as well.

There are famous myths and stories of paintings being transformed over time by their varnishes and their removal. The famous painting of a windmill by Rembrandt (now in the collection of the National Gallery in Washington, DC) had always presented a "golden glow"—until it was cleaned. The painting under the varnish revealed a cool, gray day. As mentioned earlier, a similar golden glow covered many paintings by the Venetian master Titian. The removal of the varnish exposed brilliant colors undetected through the dirty varnish. And yet another revelation occurred during the famous cleaning of Michelangelo's Sistine Chapel ceiling. Viewers had become used to the golden-toned qualities of these works and were often distressed when the real painting was revealed.

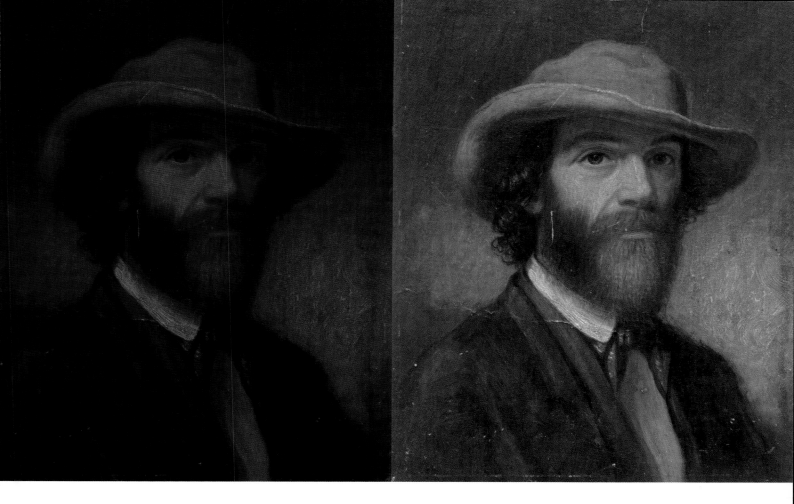

By the same token, overzealous, inexpert removal of varnish can seriously damage a painting's surface and original colors. Many Titians were "skinned"—that is, their surface glazes were inadvertently removed during cleaning away of old varnish.

Many modern mediums and picture varnishes are advertised as non-yellowing and are very stable. Modern synthetic, non-yellowing varnishes are often easily removable by such solvents as acetone. Before using any additive or surface coating, you must consider the long-term effects of the product for the good of the painting and its color. Do a little research first.

COLOR PERMANENCE

The fadeometer is a device used to test the permanence of colors by manufacturers. In the factory laboratory, colors are exposed to a high degree of ultraviolet light similar to sunlight to test permanence.

You can test your own paints by placing sample swatches in strong sunlight for long periods of time and noting the changes. An interesting experiment, this is somewhat impractical for most artists. And the testing of pigments by manufacturers and the labeling of color tubes has removed much of the guesswork involved in determining the permanence of artists' paints. Permanency ratings are now standard on paint packaging, along with the chemical makeup of the pigment. A scale of 1 (most lightfast or least fugitive) to 5 (least lightfast) is used. Manufacturers also freely provide permanency information when not listed directly on the packaging.

Colors have variations in permanence relative to the material used in the pigment, responses to daylight, and reaction to air quality, humidity, and surfaces to which the paint is applied. Ancient bright colors made from plant extracts and dyes often were very impermanent, or fugitive, over time and faded when exposed to sunlight. Some yellows were very fugitive when exposed to strong daylight but not when kept away from strong light. Rose colors, for example, were especially fragile until replaced by more permanent alizarins, madder lakes, and the modern quinacridone colors.

Colors with a high lead content could react to sulfurous air by darkening or turning black. Colors could darken and change appearance according to how much oil or varnish had been added.

The color industry of the nineteenth century introduced a multitude of new permanent colors and replacements for older fragile colors. Today, most artists' oil colors are permanent, or mostly so. The manufacturers often label the tube colors with permanence ratings. This information can also be acquired in handout form from the manufacturers. Even so, unwise use of mediums and exposure to extreme light and air conditions can be very harmful to color permanence in oil paintings.

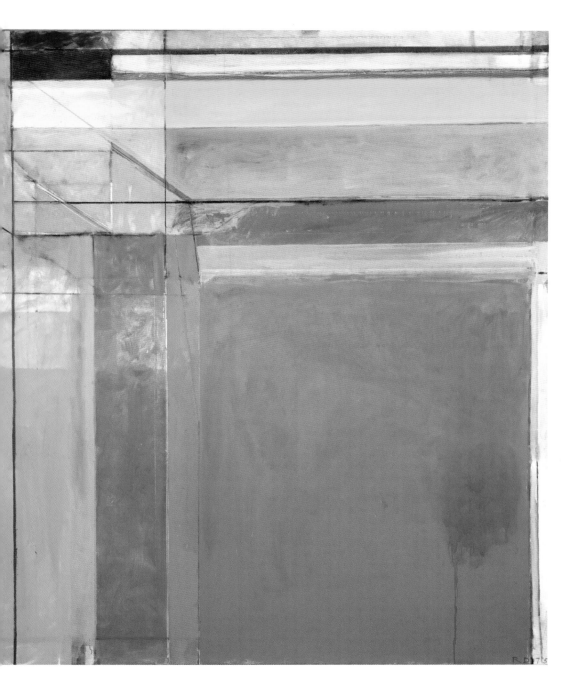

Richard Diebenkorn, *Ocean Park No. 79*, 1975, oil on canvas, 93 x 81 inches (236.2 x 205.7 cm). Philadelphia Museum of Art: Purchased with a grant from the National Endowment for the Arts and with funds contributed by private donors, 1977. Copyright © The Estate of Richard Diebenkorn. Photo: The Philadelphia Museum of Art / Art Resource, NY

Diebenkorn moves gracefully back and forth between semi-representational images and fully abstract ones. A unifying factor is his observation of color in nature and the harmonizing of those observations in his paintings. Warm and cool blue interactions dominate this painting, with hints of complementary colors organizing the color contrasts of the blues.

Problems with color permanence are not limited to older works. Modern painters, too, have had their color troubles. Experimentation and aesthetic concerns often override technical issues, and unsound layering of paint, use of unusual mediums and paints, and experimental surfaces have all created nightmares for conservators of modern paintings.

While Diebenkorn most often painted on gessoed canvas with standard oil colors, some of his contemporaries—such as Morris Lewis and Helen Frankenthaler—often used raw canvas. Painters using raw canvas saw their colors change over time as the fabric darkened and became more brittle. Modern conservation methods have been able to stem the damage in some works but not all.

COLOR AND BRUSHES

Jeff Reed, *Dark Sky*, 2008, oil on paper mounted on panel, 10 x 9½ inches (25.4 x 24.5 cm). Courtesy of Gross McCleaf Gallery, Philadelphia

In Reed's painting, texture, depth, and atmosphere are created by a variety of brush-strokes appropriate to each area. Loading of the brush with heavier or thinner paint is important to the area to be described. Here, the brightness and lightness, combined with the clarity and strength of the brushwork, brings the foreground into close focus.

The amount of blending is also a factor in the integrity of the atmospheric and special effect. Broader, denser, clearer strokes describe the foreground. The distance and its hazy soft-ness is achieved through softening of brush edges. Thus, space and atmosphere are achieved through the relation-ships created by the brushwork.

Artists' brushes have very distinctive uses in the application of color, depending on the scale of the painting and the painting process being used. Each brush type has inherent properties for mixing and applying paint. Soft animal-hair brushes, such as sable and badger, work best for smaller paintings or for refined detail work, glazing, and blending. Bristle brushes are more efficient for loading thick paint and scumbling.

Longer brush hair, whether sable or bristle, is capable of broader or more grace-ful strokes. Shorter hair loads shorter, rougher strokes. Square or chisel-point brushes can make one kind of stroke, rounds another, filberts yet another, and so on. The shape of each brush and the length of its hair must be considered for the type of painting in progress. Synthetic-hair brushes, often cheaper than natural-hair brushes, are very usable and similar in effect to their organic counterparts. The main problem with them is that the hair may not hold the paint in the same way as natural-hair brushes. Also, some of the synthetic brushes react badly to solvents and hairs dete-riorate, or the ends of the hairs curl up. They're worth a try but have hidden problems.

It's not uncommon for painters to use bristle brushes for rougher lower layers of color and softer brushes on top for details. The common misconception is that

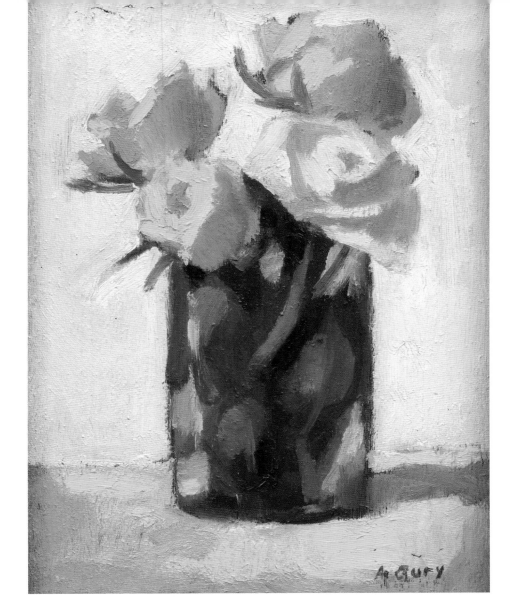

Al Gury, *Still Life with Roses*, 2002, oil on panel, 7 x 5 inches (17.7 x 12.7 cm). Collection of the artist

Immediacy and strength are created in this small still life through the use of densely loaded, bold brushstrokes. The limited range of sizes and types of strokes creates a strongly alla prima and slightly abstract quality. It is another example of the brushwork having a direct effect of the aesthetic outcome.

A simple color scheme of four color masses was used: cool background, neutral yellow flowers, earth green leaves and stems, and brighter yellow in the foreground.

seemingly refined, old-master paintings depended on small, fine brushes. The reality is that the layering of color in many old paintings is really very broad and often rough. The refinement arrives in the final effects through detail and blending. Many impressionist, modernist, and expressionist painters have preferred bristle brushes for their ability to layer on thick paint.

Experimenting with the various types of brushes is essential to working out your preferred manner of loading paint and layering color. Many painters arrive at types of brushes they prefer and use that type their whole life. Museum vaults are filled with "process materials," such as the brushes and palettes of the painters in their collections. These materials are often less refined than the popular imagination would envision them.

TRANSPARENCY, TRANSLUCENCY, AND OPACITY

Controversy over Vermeer's possible uses of optical devices to organize his compositions and tonalities does not deny the richness of color in this painting. Optical devices, such as the Claude glass and the camera obscura, had been commonly in use for a very long time.

Like his contemporaries, Vermeer used opaque under-layers to provide settings for thin surface scumbles and blended modulations as well as single-skin finishing glazes in bright areas of clothing and backgrounds. The brilliant vermilion of the hat is brushed on as a finishing layer over a solid, underpainted, tonal form. An ultramarine blue glaze finishes the coat.

Artists' oil paints have inherent properties of densities. These densities, when seen brushed out on a canvas, can have very specific color qualities and effects. Understanding them is important to the color-mixing and layering process. Depending on the raw materials used to make the paint color, the final tube color may be opaque, translucent, or transparent.

Transparent colors come from pigments that are typically colored liquids bound to chalk or other substances to give body to the paint. Typical examples of transparent colors are quinacridone red (sometimes known as rose red, thalo red rose, permanent rose, and the like), ultramarine blue, and sap green. Transparent colors are clear and glasslike in quality when brushed out on a white surface or thinned with medium. They can be easily mixed with other colors or used as transparent washes or glazes.

Translucent colors appear cloudy when brushed out over a white surface or thinned out with medium and are neither truly transparent nor densely opaque. Not appropriate for glazes, translucent colors work well scumbled over other color layers or mixed with other colors. Scumbled translucent colors or mixtures allow the lower layers to show slightly through, creating a mixed effect. Translucent colors could be candidates for use as velaturas in layered painting or scumbled areas in more direct paintings. Raw sienna, zinc white, and green earth are examples of oil colors in this category.

Opaque colors are typically dense and are often heavy in weight. Their pigments can contain clays, heavy metals, or iron—or all of the above. They have strong covering power and will mask out surfaces and colors over which they are painted. Good examples of opaque colors are cadmiums, yellow ochre, and titanium white. Opaque colors are heavily used in direct painting methods and as top-layer touches in a great variety of painting methods.

The densities of colors can be determined though the tint test described on page 142, and again, artists' tube colors have inherent properties of densities based on the raw materials used to make them.

Drying Times

Drying times vary according to the amount of oil in the tube color, the temperature of the painting's environment, and the nature of the pigment material itself. For example, earth colors, such as umbers and ochres, tend to dry quickly. When these earth colors are mixed with more slow-drying colors, such as cadmiums, the result is a new drying time for each. The cadmium with the umbers mixed in will dry faster than the cadmium would on its own.

Transparent colors tend to dry slower than opaque colors. Bright cadmiums and chemical-dye colors will dry slower than their earth counterparts. The more oil in a color, the slower it tends to dry. And of course, any color applied more thickly to a surface will tend to dry slower than it would if thinned or scumbled out.

Mediums of all kinds have been designed to change the drying rates of oil colors. These mediums should be used sparingly and application should follow the *lean-to-fat* model. Also referred to as *fat over lean*, this indicates that "lean" (less oily) paint should be applied before "fat" paint (thicker paint with a higher oil content). The reason for this is that thin paint applied over oily paint may not adhere well and may ultimately crack as the underlayers expand and contract in environmental temperature changes.

Note, too, that colors tend to dry more quickly in general in a room or outdoor space that's warm. Cooler spaces slow down drying time. A landscape sketch done outdoors in the summer may already start to dry by the end of the session because of the summer heat. A painting done in a cool room in winter may dry slower by comparison. The drying times of colors should be considered as part of the overall layering process of a painting, particularly the lean-to-fat model.

Thomas Eakins, *Maud Cook (Mrs. Robert C. Reid)*, 1895, oil on canvas, 24½ x 20 1/16 inches (62.2 x 50.9 cm). Yale University Art Gallery, Bequest of Stephen Carlton Clark, B.A. 1903

Eakins received much criticism in his life for the bluntness of his portraits. Unlike fashionable portrait painters, he painted people as he saw them. His understanding of women presents them as intelligent, strong figures. Largely developed in opaque earth colors, this fine portrait has rose added into the opaque mixtures of the cheeks and used again as a thin glaze over the dress.

Pigment Density

The density of an oil paint refers not only to its thickness but to its covering power when applied over other colors. This relates also to the discussion of opacity, translucency, and transparency.

Very dense colors—such as cadmiums, titanium white, and clay- and iron-rich colors like the Mars pigments—will cover or mask out other colors quite effectively. These dense pigments will cover an underlayer in one coat. Translucent colors—such as umbers, Naples yellow, and cobalts—will only partially mask out or cover other colors. More than one layer may be needed. Transparent colors, having such low density of covering power, are mainly used in mixture with other colors or as a glaze or other transparent coat.

Density is also affected by the amount of other additives, such as oil and mediums, mixed with the colors. Choosing the right densities of colors for a painting is very important. Experimentation and comparison provide a good understanding of the densities of available paints.

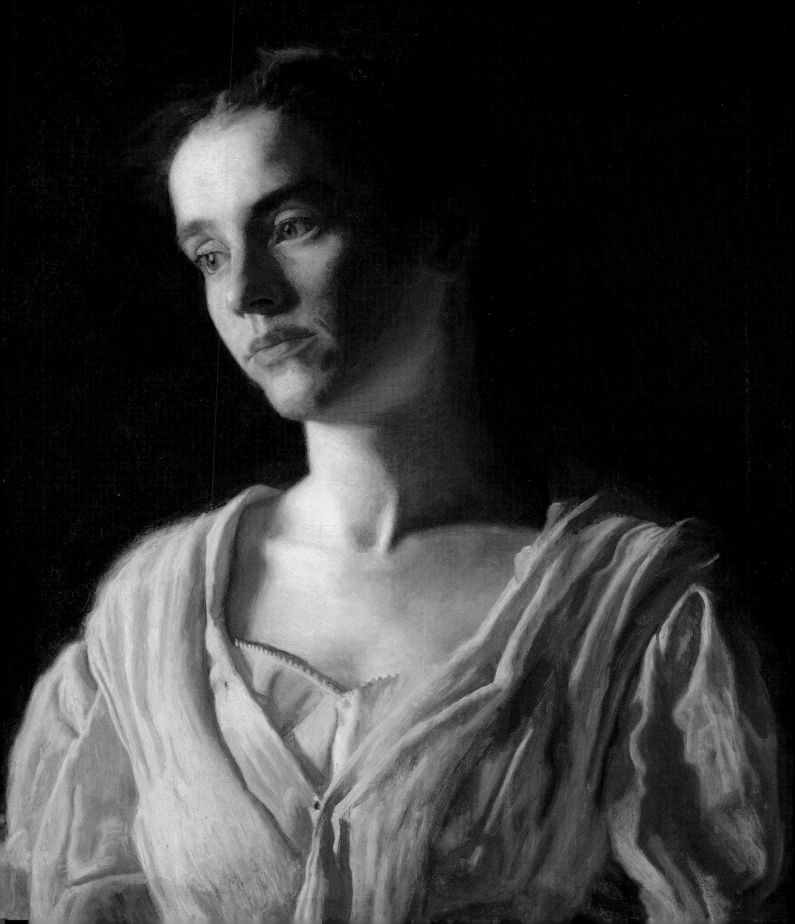

TINTING STRENGTH

Tinting strength refers to a paint color's ability to tint white or another color. Colors with *high tinting strength* require the artist to use only a very small amount of the paint to tint white or to affect a mixture with another color. For example, the beautiful earth color Indian red is rich in iron and has a very high tinting strength. When a touch of it is mixed with white, a vibrant, cool pink results almost immediately. Use too much of the Indian red and the white is overwhelmed and becomes too strong or dark.

Colors with *low tinting strength*, on the other hand, seem almost to disappear when mixed with other colors. For example, Naples yellow is a beautiful color by itself, but a lot is needed to tint or change the appearance of another color. When it is mixed with a color of high tinting strength, its effect is almost imperceptible.

Classic color palettes tend to be well balanced in terms of tinting strength. Many modern colors, such as cadmiums or phthalo pigments, can overwhelm colors when not used thoughtfully. The color identity test on page 142 is an ideal way to become familiar with tinting strengths and the wide range of differences between pigments.

Euan Uglow, *S Picture 2000* (also called *Girl Profile*), 2000, oil on canvas, 32½ x 21¾ inches (82.5x 55.2 cm). Private collection. Courtesy of Marlborough Fine Art, London. Photo: Copyright © Estate of the artist

Uglow's use of brilliant tints shaped by value contrasts and closed-form drawing presents color saturations of purity and intensity. His high-key tints are balanced by clean neutrals, and both serve to model structural form.

WHITE

White pigments, the most-used world-wide of all pigments, have an extensive range of densities, mixing properties, tinting strengths, and uses. Titanium white is the "whitest" white and also the densest. It is thick and has great covering strength, tinting strength, and permanence. Titanium white works very well when a dense paint mixture, or impasto, is required. It also has a very high tinting strength; it makes light tints very quickly when mixed with almost any other color.

The lead whites have historically been known for the beauty of their handling. Cremnitz white, flake white, lead white, and so on have the dual properties of being thick and of taking on a translucency when brushed out over other colors.

The lead whites tend to be slightly warmer in temperature than titanium white. They were the basis of paint mixtures for centuries and were prized for their flexibility. Velaturas and scumbles as well as dense impasto layers all benefited from the lead whites. Today, manufacturers provide lead white substitutes, which are usually a mixture of titanium white and zinc white.

Zinc white is the thinnest, or most translucent, of all the whites. It has a low tinting strength. Whereas titanium will produce a light tint immediately with almost any color (due to its high tinting strength), a great deal of zinc is needed to create a light tint. Due to zinc white's low tinting strength, some painting instructors suggest it as an antidote for the common student problem of using too much white. As a rule of thumb, it's better to learn how to use and control white directly as an essential part of color-mixing training and practice.

Other whites exist on the market that are referred to as underpainting whites, mixing whites, Permalba white, and so on. These whites are variations of the previously mentioned pigments and can be used in conjunction with them. An important goal is to understand the mixing properties of each of the white pigments and learn to use them properly with the rest of the palette.

Jeff Reed, *Evening Sky/ Ballyglass*, 2008, oil on paper mounted on panel. Courtesy of Gross McCleaf Gallery, Philadelphia

Brushwork, texture, and color intensities harmonize to create great depth here. The flawless attention to color temperature, value, and paint density issues clarifies each area perfectly, relative to the viewer's vantage point and the quality of the light and atmosphere.

The white used to create the effect of sun on clouds is mixed with a yellow to create the appropriate warmth and glow. Naples yellow is ideal for this. It is bright and warm but subtle in its chromatic intensity.

VEHICLES FOR PIGMENT

Al Gury, *Portrait of Mike*, 2008, oil on panel, 14 x 11 inches (35.5 x 27.9 cm). Collection of the artist

Oil paints and acrylics each have their virtues and advantages. The fast drying times of acrylics allow the artist to build and complete a work quickly. The difficulty is that the quick drying time of acrylics can inhibit subtle adjustments and changes to the paint, especially to edges of brushstrokes.

The slow drying time of oils allows considerable adjusting and correcting of a painting in many ways but does require a slower or longer working time where layers are needed. The slow drying time of oils both creates and aids a longer working time.

Note: The model's deep complexion is grayed here by the use of raw umber and white mixed with burnt sienna.

Vehicles are the liquids in which pigments are ground and suspended. Typically, linseed or safflower oils are used. Alkyd colors have synthetic drying resins added to the vehicle. Acrylic paints are mixed in acrylic polymer emulsions or what amounts to a liquid plastic. Oil paint, when ground thoroughly and cured well in the tube, has the right amount of vehicle to promote correct density and drying time and the best inherent qualities of the pigment. Technically, nothing need be added to the paint for it to respond and age well as a painting.

Sometimes when a paint tube is opened, a lot of oil, or vehicle, will drain out. This can either mean that the color was ground with excessive amounts of oil or that the absorption of oil during the curing process subsequent to grinding was complete and the excess is running off. Let the tube stand upright, open end down, on a paper towel to let the excess oil drain out. Occasionally the tube color is poorly mixed, and color and oil run out together. The tube may have to be discarded or squeezed out and drained on an absorbent surface and then repackaged in a container for further use.

Acrylics

The principles of color use described in this book also apply to acrylics. Developed in the 1940s and in common use by the 1950s, acrylic colors come in a wide array of pigments that look very similar to oil colors. The dry pigments used in their manufacture are the same as those used in oils. The difference is the vehicle. An acrylic polymer emulsion, rather than oil, is used. This vehicle has the desirable attribute of drying fast and being water based. Superficially, oil colors and acrylics have similar attributes in hue, value, and chroma as well as in the mixing of neutrals. The main differences are in mixing properties, drying times, and densities.

While oil paints come in a wide variety of densities based on the inherent properties of the pigment used and the amount of oil in the tube, acrylics often seem to have a similar density to one another. Some have fewer paste or thickness qualities than similar, thick oil paints. Still others are never truly transparent.

Painters often argue about the various merits of oils versus acrylics. They each have distinct properties, which take time and experience to master. In the hands of a skillful painter, an acrylic painting can look either very like one done in oils or have very distinct and unique qualities. Acrylic mediums of all types have been developed to enhance the acrylic painting and layering process and aesthetic effects.

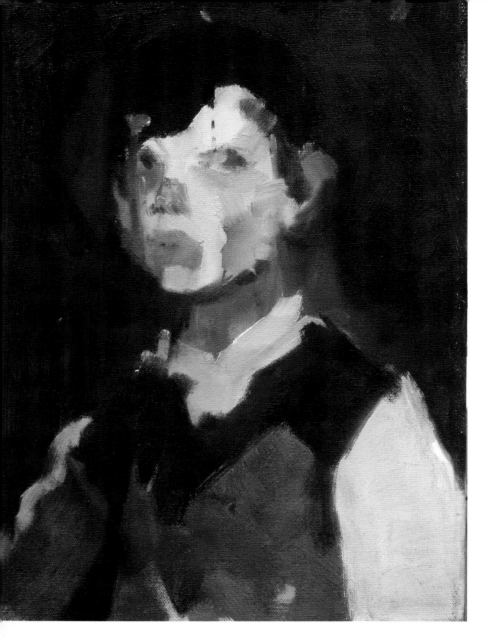

Student vs. Professional-Grade Paints

Professional-grade oil paints are a manufacturer's top grade of product. These paints are ground to the company's highest standards and, when possible, are just pigment and vehicle. In some cases, other additives, such as chalk, are needed to provide body for a very transparent pigment. Alkyds, as mentioned previously, have the addition of synthetic resins.

Student-grade oil paints are made by most of the big manufacturers. They usually have their own brand name and are marketed at prices much lower than those of professional-grade paints. These paints often have pigment substitutes and fillers, which keep the price lower. Superficially, student-grade paints operate like their more expensive, professional-grade counterparts and are generally as permanent. The main difference is the amount of pigment in the tube and the level of intensity and tinting strength that the colors produce when used in painting.

For example, professional-grade cadmium red will have great density, high tinting strength, and strong brilliance with very little effort. Student-grade cadmium red may have comparatively less density and lower tinting strength in mixtures with other colors. Literally, more of it has to be used to get the same effect as the professional grade. The trade-off is an economic one for the student.

When a student-grade color is referred to as a *hue* on the label, it generally means that the color is a less-expensive substitute. For example, *cadmium red hue* may contain a substitute pigment.

PAINT LIFE EXPECTANCY

Oil colors kept sealed in tubes will last for many years. Thirty-year-old paint tubes will contain paint that is as good as when it was made—as long as it is still wet and easily spreadable. If the tube isn't sealed properly, the paint will start to dry and oxidize and can no longer be reconstituted to a wet state. Paint near the top of the tube may be denser and even dried to a plug. Breaking through to the fresh color is okay, as long as the dried color is removed. If a tube of paint is clearly dense, solid, or rubbery in feel, the paint has begun to dry and is beyond use. The same is true of acrylics.

Aluminum paint tubes also age. Sometimes the paint inside is usable, but the aluminum tube is fragile and rips when opening a stiff cap. The good paint inside can be transferred to a new tube or a sealed jar for use.

On the palette, colors with slow drying times will remain wet and usable on a palette for several days. Others will dry out overnight. Trying to reconstitute partially dried paint on the palette is futile. Sometimes a squeeze of paint will develop a dried skin, with otherwise-wet paint inside. Breaking the skin and scooping out the fresh color inside is okay. The same is true for partially dried tubes.

Some painters will try to slow down the drying time of the paints on their palette before the next day's work by putting it in the refrigerator or covering it with plastic wrap. This may help, but unless the palette is virtually hermetically sealed, the paints will continue to dry. One of the hazards of painting is the wasting of paint. Sometimes it can't be avoided and is just part of the cost of being a painter.

Student copy after Robert Henri, 2006, oil on canvas, 12 x 9 inches (30.4 x 22.8 cm)

A tonal painter, Robert Henri used vibrant prismatic colors in both skin areas and clothes, with earth colors as a base. In most cases, student-grade paints, which were used for the execution of this copy, show no practical difference in the outcome of a painting, as long as the drawing, color, and brushwork are all done well. The actual differences are more subtle and involve the feel of the paint, tinting strength, and color availability.

Paint Toxicity & Safety

Artists' oil paints contain a great variety of chemical salts, leads, petroleum products, and other potentially toxic materials. A good rule of thumb is to avoid getting them on your skin and especially avoid inhaling the dry pigment forms of colors. While some colors (such as ochres and umbers) may primarily be clay, oil, and little else, most paints on the market have one or more possibly toxic ingredients in their composition.

In addition, never wash oil paint from your hands with paint thinners or turpentine. Soap and water is the best. Some of these materials may cause allergic reactions in some individuals. Many individuals who become allergic to oil paint materials shift to acrylics successfully.

Good room ventilation, avoidance of skin contact, washing with soap and water, and proper disposal of pigment, paint rags, and thinners are necessary for both the health of the painter and the environment. Detailed content information can be easily acquired from paint manufacturers.

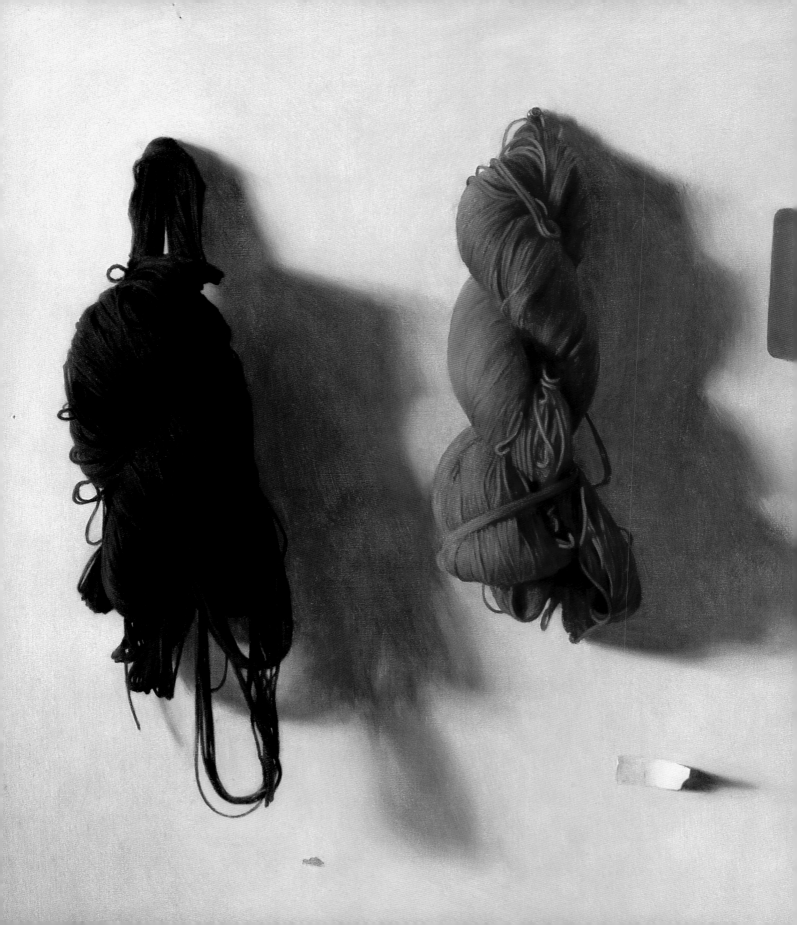

Basic Concepts: Organizing *the* Experience *of* Color

Choosing color can be a process that's fraught with confusion, fear, and misunderstanding. A breakdown of the basic painting processes and considerations as they relate to color use can be helpful as a means to organizing the experience of color.

While the "magic" of color that occurs through an experienced artist's use of a palette is very personal and intuitive, the mechanics of color is largely learned through information, practice, and repetition. As with any other skill, the mechanics, their history, and their practice allow practitioners to hopefully get to a level where their own vision can intuitively emerge.

Carlo Russo, *Yarns (study in complements)*, 2009, oil on linen, 23 x 28 inches (58.4 x 71.1 cm). Courtesy of the artist

Painters have always "played" with the ideas of color. Here, Russo sets up a reference to color harmonies through obvious and not so obvious elements. The orange and red tones, while not strict complements to purple, are complementary to it here. The swatches to the right are a formal reference to the colors used in his painting as well as a comment on Josef Albers's writings on the simultaneous contrast of colors. The wall has subtle green and gray tints, which further push the sense of complements in the composition (green is the complement of red, for example).

OPEN VS. CLOSED FORM

The terms *open form* and *closed form* refer to the manner in which volume, or form, is developed in a painting, drawing, or sculpture. The concept crosses all mediums, aesthetics, and uses of color.

Closed form is created primarily by line. The outside contour line of the figure or other subject creates a sense of form through the line edge's ebb and flow from light to dark or thick to thin and through its continuity or brokenness. Closed-form painting incorporates color that's totally dependant on the enwrapping line to give the color and tone of the subject its solidity.

In many closed-form paintings, the color is added through layered approaches to a highly developed, line-oriented underpainting. The detailed underpainting is a guide throughout the process. If the line and contour quality of the painting were to be deleted, the color would have little sense of form—or at least a diminished quality of solidity. Examples of closed-form painting and use of color can be found in the work of Italian Renaissance painter Sandro Botticelli, Northern Renaissance painter Hans Memling, and French nineteenth-century painter Jean-Auguste-Dominique Ingres.

Open form describes work in which the sense of volume is created by the assembling of lights and dark tones, loose paint touches, and color that's assembled through the massing process to create a sense of atmosphere. Open-form paintings depend on their tonality and color for their reality. If the tones or color variety were deleted, the open-form work would begin to break up and lose its sense of solidity in the atmosphere.

Open-form underpaintings are often loose and cursory, with the form developing from the general to the particular and the details being established at the end of the process. Good examples of artists whose work follows this technique are Rembrandt, John Singer Sargent, and most impressionist painters.

Abstract painters also use open- and closed-form concepts. Piet Mondrian's work is more closed form and Hans Hofmann's more open form. Frequently, painters merge the two concepts in various combinations and degrees. Diego Velázquez and Peter Paul Rubens used line to solidify otherwise open-form tonal and colorist paintings.

Since the times of the ancient Greeks, there have been arguments among artists, art theorists, and art collectors concerning the virtue of line over color in art:

the Dionysians (more emotional) versus the Apollonians (more rational), the Rubenists (more sensual) versus the Poussinists (more classical), the Romantics (more poetic) versus the Classicists (more restrained), the Venetians (more open form) versus the Florentines (more closed form), male (line) versus female (color), and so on. These discussions have all centered on the issue of the relationship of color to drawing.

One process of organizing form is not superior to the other. They each allow artists to find their own voice and make choices about how they want to address their subjects. Contemporary painters continue this dialogue.

Arthur DeCosta, *The Birth of Venus (after Botticelli)*, c. 1970, oil on board, 12 x 10 inches (30.4 x 25.4 cm). Courtesy of the Pennsylvania Academy of the Fine Arts, Philadelphia

Both Sandro Boticelli's famous sixteenth-century work *The Birth of Venus* and this more modern underpainting copy of it offer examples of closed-form painting.

LEFT: **Michael Gallagher**, *Sligo*, 2009, acrylic on panel, 16 x 11 inches (40.6 x 27.9 cm). Courtesy of Schmidt-Dean Gallery, Philadelphia

Gallagher's painting *Sligo* represents open-form work in an abstract approach. The broad, quick paint strokes capture the "painterly" openness of the open-form aesthetic.

OPPOSITE: **Louis B. Sloan**, *Autumn Landscape*, oil on board, c. 1980, 16 x 12 inches (40.6 x 30.4 cm). Collection of the author

Open-form paintings are sometimes referred to as "painterly," and this landscape is a good example, featuring open-form brushwork.

COLOR AND GROUNDS

The color of the surface to which paints are applied is crucial to completing the artist's desired aesthetic effect. Since the beginning of oil painting, a layer of color, or a *ground*, has been applied to canvas and panels. The purpose is to facilitate the development of the painting and its layers. There are many technical reasons to use grounds, including to provide a gripping surface for the paint and prevent discoloration by raw surfaces, but this discussion focuses solely on the color issues.

Grounds generally fall into two categories: (1) white or off-white and (2) toned or colored. Many open-form paintings from the sixteenth through nineteenth centuries have employed toned or darkened grounds. These simulate the related drawing process of making a charcoal drawing on toned paper and adding white highlights, with form developed quickly through the use of dark, middle, and light values. The toned ground provides a middle value on which to develop a dark drawing and light highlights. The results are the basics of three-dimensional form and will then develop a richer and more complex sense of form and depth.

Toned or colored grounds can range from dark browns to grays to light tans to off-whites. Atmospheric and alla prima painting often employ toned grounds. A painter desirous of doing tonal painting is often advised to use toned grounds. The tones should be neutral colors, so as to not overwhelm the colors when applied to the canvas.

Grounds that are too bright in color inhibit the development of color and tone relationships in traditional painting, though they do show up in modernist painting practice, and a red "bole" ground was common in medieval painting. Many students make the mistake of using ground colors that are too bright, such as burnt sienna for a brown ground. The brown grounds should be neutral, made from umbers or other neutral mixtures. Bright grounds can be very useful, however, in paintings that have flat color interactions as their main goal. The brightly colored ground becomes part of the overall structure of interactive colors. Modern and abstract painters have often used toned grounds as a way of organizing their color and compositions.

White grounds can be used in a variety of ways. Many closed-form painters of the fifteenth and sixteenth centuries would use a white gesso panel as a base for a refined closed-form underpainting that would cover the surface of the white canvas or panel. In effect, the completed underpainting on a white ground would provide a toned surface or drawing for the application of color. In any case, the white of the support needs to be covered to develop effects of form quickly; since white's brightness is so strong, it needs to be covered with an underpainting or colors to get to the development of tonal and atmospheric effects.

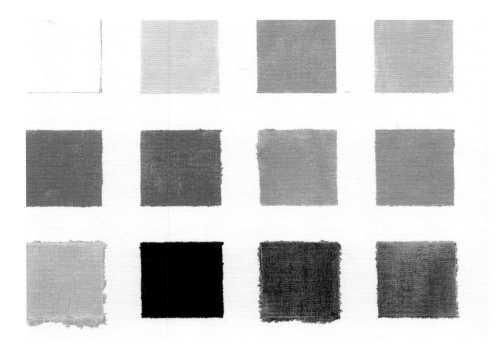

This chart of ground colors shows examples in white, light beige, middle-tone warm, and middle-tone cool in the top row; grays in the middle row; and blue, dark brown, cool imprimatura, and warm imprimatura in the bottom row. Seeing the common grounds all together provides the chance to choose temperatures and values for one's painting.

A white canvas can derail and confuse a student who wants to develop a tonal (light-to-dark) painting, while the same canvas could be a help to a painter who wants transparent or highly colored effects. White canvases also have been used when applying an imprimatura to be painted into "wet into wet." The painter could draw into this wet surface with a brush and then wipe away the light areas to form a tonal underpainting. The white of the canvas would provide the light areas in the underpainting. The imprimatura could also be allowed to dry to create a dry, cloudy, atmospheric surface on white to be painted on later.

Many impressionist painters favored white grounds. The white would be allowed to show through between the brushstrokes for the purpose of providing a reflection of light coming through thin colors as well as white spaces between the strokes that would help create optical mixing and a sense of atmosphere. The white canvas would often provide a unifying field for the touches or spots of color in these often open-form works.

Many abstract painters also use white surfaces. One reason is to facilitate the creation of an even, flat picture plane relative to the viewer. Another is that white canvas can be a passive surface on which to create the drama of colors and paint strokes. For these painters, colored grounds can also create an immediate, strong color effect, especially when the ground color is complementary to the colors of the applied paint. Today, painters use a great variety of grounds to help them create the aesthetic effects they wish.

UNDERPAINTING FOR COLOR

Arthur DeCosta, grisaille under-painting, c. 1990, oil on linen mounted on panel. Courtesy of the Pennsylvania Academy of the Fine Arts, Philadelphia

A grisaille underpainting is meant to provide the form and tone of a structure that will later be tinted with a finishing glaze of color. It is the base for a layered form of painting, whether open- or closed-form, in which one layer determines the effect of the next. Typical grisailles use black and white paint and should not be confused with under-paintings done in gray tones, which are very different in that they match all the tone variants in nature directly. In grisaille, the light areas (or light masses) are painted much lighter than they are in nature because the correct tone will be arrived at when the final glaze is applied. Painters as diverse as El Greco and Ingres used grisaille under-paintings, which they finished with a thin glaze of color. A painter might use this type of underpainting when more inter-ested in tonality and form than in the varieties of mixed colors.

Color usage in painting often depends on a particular type of underpainting for its efficient development. Closed-form linear underpaintings, loose open-form under-paintings, wipe-outs, and color washes all facilitate color development, among other aesthetic elements, in one way or another.

Closed-form underpaintings create structure for the application of color layers that react to one another and complete the sense of drawing; the results are called, appropriately, *layered paintings*. Closed-form underpaintings are detailed drawings that the subsequent paint (the "over paint") only adds to. Details are refined again at the end to complete the process and to clarify the original drawing.

Open-form underpaintings range from loose marks that serve as a guide for the massing of color and tone to oil drawings that are fairly complete but just short of providing exact details. Details are added at the end and only gradually, through a building process. Brushstrokes are very important to this type of painting, and details created at the end are often only quick accents and touches of the brush.

In some painting types, particularly in the modernist era, the underpainting is a layer of color scumbled in directly to create color shapes and masses without any lines or clear edges. In some cases, especially in open-form abstract painting, the underpainting is really only a layer of color on which other color layers are built.

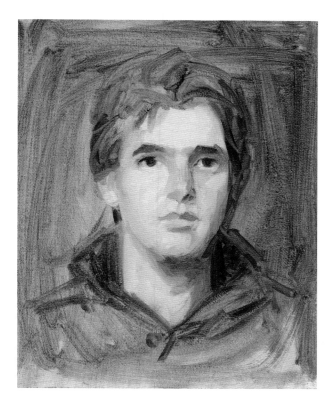

Arthur DeCosta, imprimatura underpainting, oil on linen mounted on board, c. 1970, 10 x 8 inches (25.4 x 20.3 cm). Courtesy of the Pennsylvania Academy of the Fine Arts, Philadelphia

An imprimatura (meaning *at the first*) underpainting is typically a transparent wash brushed over a gessoed or sealed painting surface. Imprimaturas are always transparent, and the color can be warmer (browner) or cooler (more blue or gray). They can either be allowed to dry so that the painter can paint on a dry surface or be painted into "wet into wet." Most commonly used by open-form painters, they are also used by closed-form painters. Artists might choose an imprimatura

ground when a quick, wet-into-wet, alla prima effect is desired. They might also choose to apply this type of underpainting over a flat, opaque, colored ground to quickly create a sense of atmosphere in the painting. Some painters will leave the imprimatura as part of the finished painting; others will paint over all evidence of it with opaque paint.

This imprimatura underpainting also shows the start of a limited-palette portrait. A reddish-brown imprimatura (made with burnt sienna and ivory black) has been brushed over a light gray gessoed panel. The form of the head is loosely drawn into it with a brush, with the darkest darks added at the end. The light areas have been wiped away with a rag.

Édouard Manet, *Madame Édouard Manet (Suzanne Leenhoff, 1830–1906)*, c. 1866–1869, oil on canvas, 39½ x 30⅞ inches (100.3 x 78.4 cm). Bequest of Miss Adelaide Milton de Groot (1876–1967), 1967. The Metropolitan Museum of Art, New York, NY. Image copyright © The Metropolitan Museum of Art / Art Resource, NY

A fine example of the impressionist painting process, this unfinished painting is really complete in most ways. Scumbled thin paint over a light-colored ground has denser opaques and touches of darks in the finished areas.

SUBTRACTIVE VS. ADDITIVE COLOR

Al Gury, *Still Life with Flowers*, 2000, oil on panel, 12 x 9 inches (30.4 x 22.8 cm). Courtesy of F.A.N. Gallery, Philadelphia

Here, the colors of the flowers were chosen carefully to create a graded, "complementary effect." That is, the flower colors of magenta, orange, yellow, and green play off against each other to create a brighter effect. Also, the shadows of each are a cooler version of the flower color, which also enhances the complementary effect. The vase and background, being neutral colors, also help to set off the flower colors.

Subtractive and additive processes refer to two very different technical and even technological approaches to color. Traditional color-mixing, which is what a painter does, is referred to as *subtractive color*. (Among other meanings, this indicates that mixing two colors together "subtracts" from the original colors to make a new one.)

In 1666, Sir Isaac Newton found that all colors of light come from the starting point of, and are contained in, pure white light. He also found that subtracting colors from white light formed the many colors we see. His experiments with a prism demonstrated this discovery and provided the basis for a modern understanding of the nature of color and light. Surfaces of objects in the natural world were also found to absorb light frequencies and reflect others. The ones reflected are the colors we see. The eye and brain organize the perceived experiences of light into the colors of the world we see around us. Mixing all the colors together arrived at black, or the complete absence of light.

To further prove his observations, Newton distilled the colors back to white light through another crystal. Newton proved that color existed in the light and that the colors we see are the result of surfaces in nature interacting with, and absorbing or reflecting, the light. His three *primary colors*—cyan (blue), magenta (red) and yellow— were better described for the painter as red, yellow, and blue and related better to the materials artists use.

Newton then organized the colors, gradations, and color mixtures created by his prism into what we know as the color wheel. For the painter in oils, acrylics, watercolors, and so on, subtractive color translates as the system of using the color wheel as a model for visualizing basic colors and using the primary colors to mix the *secondary colors*—violet, orange, and green—and *the tertiary colors*—red-violet, blue-violet, yellow-green, blue-green, yellow-orange, and red-orange—in addition to *analogous colors* (those that are contiguous on the color wheel and have in common one primary).

Mixing the three primaries together, in theory, produces black. When the three are mixed together in varying amounts, not only will a seemingly pure black be created but very dark, "blacklike" colors can result. This was an important concept in impressionism, whose proponents believed there to be color in all things and that the complete absence of color (black) should be avoided.

Painters must rely on oil- or water-based colors mixed in varying intensities, temperatures, and values. For the painter, the theories of light and its color reactions are important knowledge to have. In a practical sense, though, understanding how artists' colors interact with one another when mixed together and the nature of their intensities, temperatures, and values is the day-to-day information needed to paint. How these paints and paint mixtures interact visually, optically mix, and create

afterimages are all very important for the construction of color in a painting and its final aesthetic effect. Optical mixing of color and afterimages are discussed in the writings by both Michel Eugène Chevreul and Josef Albers.

Additive color, usually associated with light projected from a source, such as stage lights, derives from working backward from black by adding colored light. Newton tested this theory when he returned the colors created by his prism back through another crystal and the result was white light. The additive primaries are red, green, and blue. Overlapping the three additive primaries produces the additive secondaries of cyan, magenta, and yellow. Manipulating the luminosity of each area produces gradations of colors, temperatures, and intensities of colors. Adding colored light to a black, lightless scene gradually illuminates the darkness until, when at peak amounts of light, white light is arrived at. Television and computers use optical mixing of bands and pixels of color.

Painters should become familiar with the concepts of both subtractive and additive color and of optical mixing and afterimages (which result from the way fatigued cells in the eye respond to light). Having a good general working knowledge of both subtractive and additive color helps painters organize the experience of what they see in nature as well as of what they want to create in their paintings.

Al Gury, landscape study, 2004, oil on panel, 5 x 6 inches (12.7 x 15.2 cm). Courtesy of F.A.N. Gallery, Philadelphia

This landscape study is done in two basic tones: light and dark. Both tones are made by earth colors. The soft, neutral dark purples, grays, and reds are made from the earth colors Indian red, black, raw umber, and white. The sky is made from Naples yellow and white. Earth colors are by nature neutral in intensity when compared to prismatic or bright colors. Although the colors in this painting are relatively dark and neutral, their color identities or hues are still apparent because they aren't muddy.

Earth colors have their place on the palette as a counterpoint to the bright or prismatic colors. They provide neutral and less chromatic versions of the bright colors and also act as rich colors in their own right. For example, burnt sienna is a deeper, more neutral version of cadmium red light. Artists sometimes choose earth colors for their neutrals or use them to "tone down" or neutralize bright colors.

Following subtractive color concepts, earth colors can be mixed from bright colors by combining complements together. For example, mixing green into orange (its complement) produces a color that's browner and more neutral than either of the original colors. The amount of green determines how "broken" (or neutralized) the orange will become, and a color that looks very much like burnt sienna, or a burnt orange, is the result.

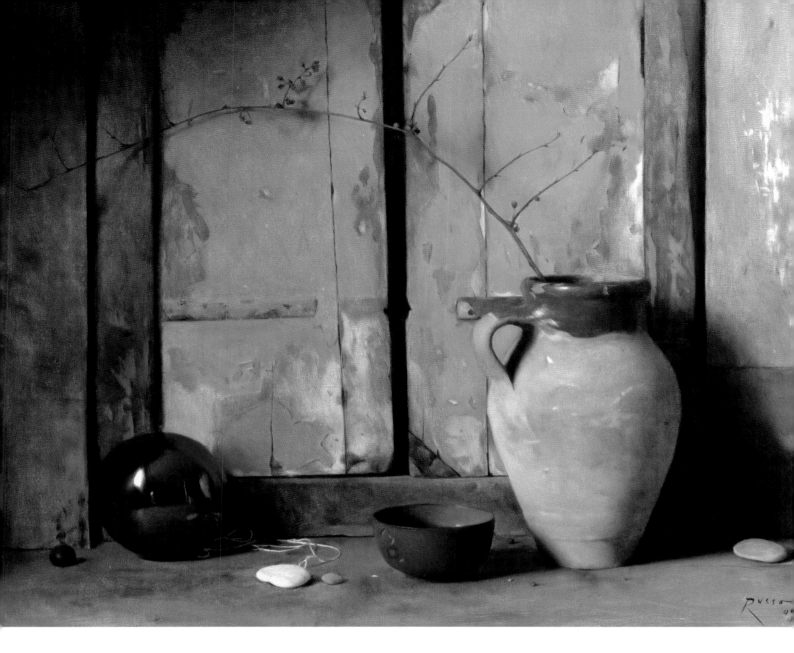

Carlo Russo, *Still Life in Green*, 2009, oil on linen, 22 x 27 inches (55.8 x 68.5 cm). Courtesy of the artist

At first glance, this still life seems made of green and brown. On closer analysis, there are a great variety of greens present, representing shifts on the color wheel, tonal scale, and a neutral-to-bright range. Light bright green, blue-greens, brown-greens, and yellow-greens all create variety and subtlety in this composition. The browns also exhibit such diversity; they grade from a lighter, brighter reddish-brown on the jar to a neutral, darker, and grayer brown in the woodwork. All display a beautiful and subtle range across hue, value, and chroma.

A good exercise is to set up a still life with closely related colors and look for the variety in them. A classic example is an all-white still life. This will help clarify the concept of subtractive color and the subtle shifts in hue, value, and chroma that can occur.

FAT OVER LEAN AND THE DEVELOPMENT OF LAYERS

The first meaning of *layering* is the sound technical principal of fat over lean. This means that layers of paint that are "lean," or thinner (less oily), should be placed first, and layers and touches of paint that are "fat" or thicker (more oily), should be layered gradually on top. Not following the lean-to-fat process may result in paint and colors that dry unevenly, crack, or discolor.

Oil paint expands and contracts slightly not only as it dries but also as temperature and humidity change in the environment of the painting. In most museums in the United States, temperature and humidity are controlled carefully in galleries and storage rooms. Temperature and humidity can also cause dramatic changes not only in the paint layers but also in the support (canvas, panel, and so on) of the painting.

Furthermore, pigments have differing drying times based on the material composition of the paint. For example, cadmiums take longer to dry thoroughly to the touch than umbers. Colors thinned with turpentine or mineral spirits, or extended by drying mediums, may dry faster than colors that have no additives. Paintings that have confused layering may well have long-term problems in drying well and may eventually crack.

Examples of paint layering may range from thin paint washes made with thinners to upper layers of just thick paint or thick paint in the lower layers to oil-rich mixtures on the top. In any event, the lean-to-fat model should be followed for the long-term health of the painting.

John Constable, *Hilly Landscape*, c. 1808, oil on panel, 6⅜ x 9⁷⁄₁₆ inches (16.2 x 23.9 cm). Philadelphia Museum of Art: John G. Johnson Collection, 1917. Photo: Lynn Rosenthal

Considered to be the father of plein air painting and a great influence on the impressionists, Constable follows traditional tonal and monochrome color concepts. Light-to-dark and brighter-to-grayer gradations are used to notate and organize outdoor observation. In this sense, he is following common studio concepts of color organization rather than the responsiveness seen later in the impressionists. The overall color tones of this study are cool, or grayer, while the study on page 97 is generally warmer and brighter.

Building on a loose scumbled blocking of large shapes and tones, Constable touches in opaque specific textures and color changes to complete the scene. This is a classic example of alla prima painting.

Henri Matisse, *Yellow Odalisque*, 1937, oil on canvas, 21¾ x 18⅛ inches (55.2 x 46 cm). Philadelphia Museum of Art: The Samuel S. White 3rd and Vera White Collection, 1967. © 2010 Succession H. Matisse / Artists Rights Society (ARS), New York. Photo: Graydon Wood

Color organized by large simple shapes and strong calligraphic drawing both captures the simplicity sought by the fauves and early moderns and creates a decorative, lyrical quality typical of Matisse. The picture plane is tilted forward, toward us, and flattened. Here, too, layering is an important factor. Being classically trained, Matisse was well aware of the layering process. Thin washes in a first layer are settings for thicker layering and strokes, as the shapes, lines, and colors of the subject are realized and finished.

It's wise to follow the lean-to-fat approach in both density of paint (less oily to more oily) and in layering of pigments so that paint with the slowest drying pigment is placed on the top layers *over* more quick-drying pigments underneath.

The second aspect of layering is the placement of one color over another to create a desired aesthetic effect in the final painting. This understanding of layering can refer both to techniques of oil painting that require layers that create optical effects through the interaction of opaque, translucent, and glaze layers (indirect methods) and to the variety of touches in an alla prima painting (direct methods).

Sixteenth-century northern European painter Hans Memling, for example, used color layers that interacted with one another to create color and tone effects that were planned and measured through his painting process. The final glaze colors provide not only the desired final color of a background, hat, or flower but also the final and correct tonality. Such layered processes are highly organized, and the final result is preplanned not only in terms of lean-to-fat but also as an aesthetic effect of form and depth.

In the directly painted landscape studies of John Constable, direct color touches are stroked and scumbled on, anticipating color interaction with other touches on top. Constable quickly stroked on earth color as the base of the color effect, anticipating that he would add brighter and thicker touches on top to finish the sketch. Both layers interact to create a fresh impression of atmosphere and a range of color and tonality.

In a third approach to layering, modern colorists, such as Henri Matisse, carefully consider the interaction between primary and secondary colors in their compositions. Each stroke reacts with the colors around it or under it to create vibrancy and intensity in the whole painting. One color prepares a "setting" for the next. Matisse's paintings are layered from lean to fat and have held up very well over time.

In many ways, these three methods are all the same in that the artists considered their color effects through various kinds of planned layering. The difference is the technical or aesthetic approach that each used to arrive at a satisfying and harmonious finish. Whether layering is seen through the lens of perspective and atmospheric effects, such as it was in seventeenth-century painting, or through the abstract color interactions of the twentieth century, layering of color must be considered carefully.

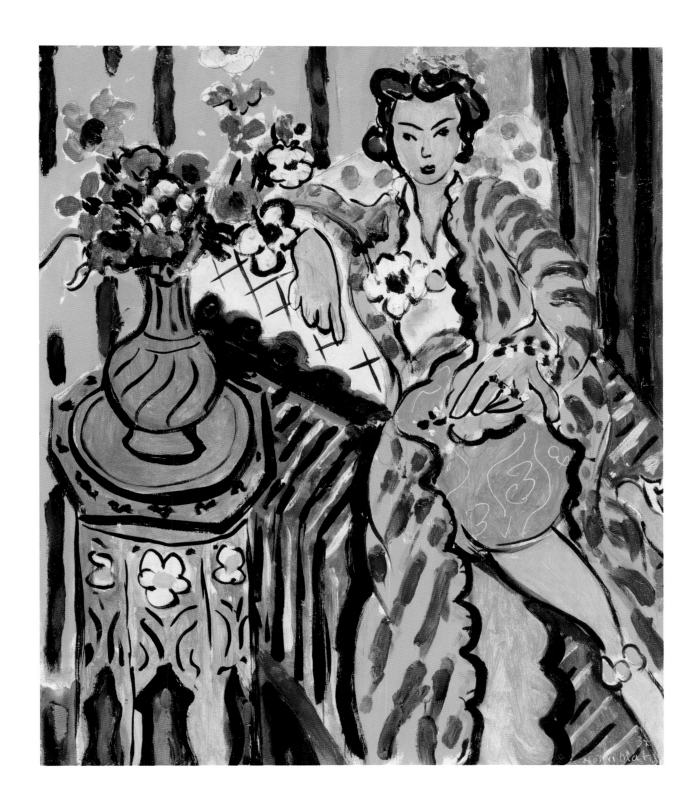

Settings

The concept of a "setting" is crucial to the understanding of the layering of color, and the term applies to a broad range of structures in a painting, including tonality and drawing. A *setting* refers to a layer or area of a painting that is set up to receive another touch on top. This combination then creates a complete structure, color combination, or form. This is comparable to a ring providing a setting for a jewel; the ring sets off the jewel and holds it in place.

For example, French painter Camille Corot would often finish a landscape of silver-greens and grays with the figure of a shepherd wearing a hat of brilliant scarlet.

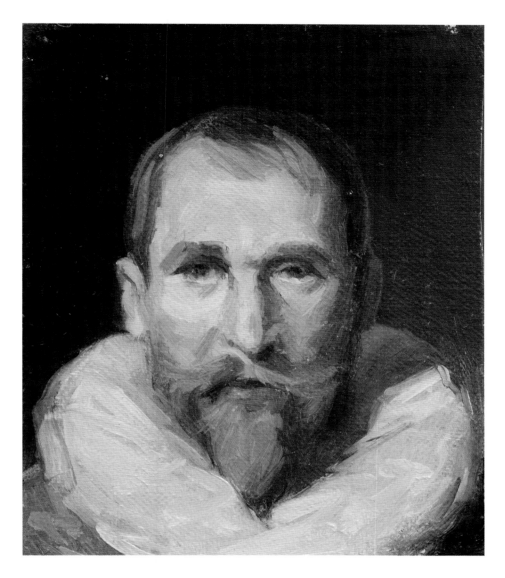

Arthur DeCosta, portrait copies after Frans Hals, c. 1970, 6 x 4 inches (15.2 x 10.1 cm). Courtesy of the Pennsylvania Academy of the Fine Arts, Philadelphia

Even though these are copies after different Hals originals, these two images illustrate what a setting (opposite) can look like for a finished portrait of this type (left). In the setting, the structures of the face are set in generalized halftones. The eye sockets, for example, are described with short brush-strokes. When the dark touches of the eyes and their details are set in (as in the finished version), the original setting provides the illusion of depth in the eyes.

Providing settings implies a planning of the process and practicing the setting and layering development. The concepts of settings and layering cross the aesthetic boundaries of representational and abstract work.

The greens and grays are the settings for the final touch of scarlet. The scarlet touch focuses the viewer's eve and directs it to the center of the painting. Another example is common to portrait painting, in which the soft neutrals and generalized planes of paint strokes that make up most of the face are settings for sharper details and highlights placed at the end.

In an abstract painting, broad scumbles of soft colors can be a setting for another layer of more specific bright strokes of color. This use of settings creates vibrancy in the final abstract color effect.

Body Color

The ideas of transparency, translucency, and opacity (page 54) are related to, but different from, body color, glazes, velaturas, and scumbles. The terms *transparent*, *translucent*, and *opaque* refer to physical density in tube paints, whereas terms such as *body color*, *glazes*, *velaturas*, *scumbles,* and others that we'll explore in this section refer to technical approaches to the application and layering of color—in other words, types of paint layers.

Body color refers to masses of opaque color used to form a basis for other paint layers. Some paintings are constructed entirely of opaque body color, while others use an opaque layer of body color as a "bed" on which to build a variety of paint and color touches of different densities. The massing in of the large color blocks of a subject is often accomplished with the application of these body, or basic, colors. These color masses create the underlying color and tone of the subject for the layers to come. Direct painting techniques rely heavily on this concept.

Glazes

A *glaze* refers to an entirely transparent layer of color used to modify the tone or color of the layers underneath it. Glazes are rarely built up in layers, though they can be part of a complex set of layers in a painting. The most common type of glaze is one thin layer of transparent color mixed with medium and brushed out over a more opaque underlayer. This glaze layer completes the overall color and tonal effect of the painting. Glazes were most often used to finish a painting by providing a brilliance of color over a well-structured and dense underlayer in a specific area.

Glazing is a process shrouded in myth, mystery, and false information. One myth suggests that layers upon layers of glazes are used to produce subtlety and depth in old-master paintings. Another suggests that glazing is an elaborate technique in its own right that is separate and distinct from other painting techniques. Yet another suggests that all old-master painting used extensive amounts of glazing. These misguided ideas have confused generations of painters in the last hundred years.

The truth is quite different. For example, Dutch seventeenth-century painter Frans Hals might paint a portrait of a cavalier and finish it with local glazes. He might glaze the cavalier's sash (underpainted with ochre, umber, and white) with a finishing glaze of transparent yellow-gold. The background behind the cavalier's head (underpainted in black and white) might be glazed one layer of ultramarine blue, and so forth. Painters such as the early-sixteenth-century Northern Renaissance masters of Flanders, Holland, and Germany (known for their more layered approach) would also use glazes as a finishing layer over sky, complexion, or clothes.

El Greco (Domenico Theot-okópoulos), *The Assumption of the Virgin*, 1577–1579, oil on canvas, 158¾ x 83¾ inches (403.2 x 212.7 cm). Gift of Nancy Atwood Sprague in memory of Albert Arnold Sprague, 1906.99. The Art Institute of Chicago. Photo © The Art Institute of Chicago

This great altarpiece exhibits all the best of El Greco's aesthetics and working methods. Many of the figures are portraits of actual models, whereas in some of his works he presents idealized and fanciful invented "types." His use of the grisaille technique is particularly bold and direct; a dark brown ground is the base for a bold black-and-white alla prima grisaille. The "lights" in the faces and clothing are glazed with one skin each of a pure, transparent color. Darkest dark touches—for example, in the eyes—are added on top at the end with dark, transparent, medium-rich touches, as well as some opaque light touches.

This underpainting has been developed first as a grisaille, with the shadows left as the transparent brown of the imprimatura. Over the top of the whole structure, a thin velatura has been pulled to unify the light area and to create a cool neutral halftone in the shadows. In some cases, DeCosta would paint in opaque touches of reflective colors in the shadows and color touches in the light mass to add variety and greater form. This is one of the varieties of traditional procedures in which velaturas are used. A thin glaze would complete the model's color with dark touches added to accent the eyes and creases.

The use of a glaze is planned as part of the layering process, whether the painter used indirect or direct methods. Glazes will darken the layer painted underneath. What is painted underneath must be lighter than the finishing glaze so that it shows through and lights up the glaze. For this reason, the idea of many glazes is impractical and unsound; the glazes not only would become darker but their oiliness would create very unstable layers in the painting. Also, a glaze is usually oil- or medium-rich so as to follow the lean-to-fat model of paint layering. Due to these factors, glazes are rarely built up one over another in many layers. More than two glaze layers will create a risk to the proper drying of the painting and its overall color effect.

Some nineteenth-century painters, in an effort to follow what they *thought* were the "secrets of the old masters," or through simple lack of knowledge, overused glazes or didn't follow sound layering practices. Some even used glazes of asphaltum to create an antique effect in the painting. Many of these paintings have darkened or suffered excessive cracking.

Velaturas

A *velatura* is a milky or translucent layer that reacts much like a glaze, except that it is not transparent. Whereas a glaze is made from a purely transparent color, a velatura (from the Renaissance Italian, meaning *little coat of velvet*) can be made by thinning out an opaque color or using a translucent color. Velaturas let a hint of the underlayers of tone or color show through.

Velaturas, as a technical device, are most often seen in carefully layered paintings. Most often used in closed-form works, they also show up in open-form works like those of sixteenth century Italian Venetian master Titian. Velaturas are often moderate in their use of medium or oil and serve to unify an area of a painting or to allow optical illusions to come through from underlayers. They were often used by Renaissance portrait painters or by later, classical, closed-form painters to create optical grays in skin tones or for atmospheric effects in skies. An area of a painting covered by a velatura can then receive opaque touches or even a glaze to finish the final effect of the painting.

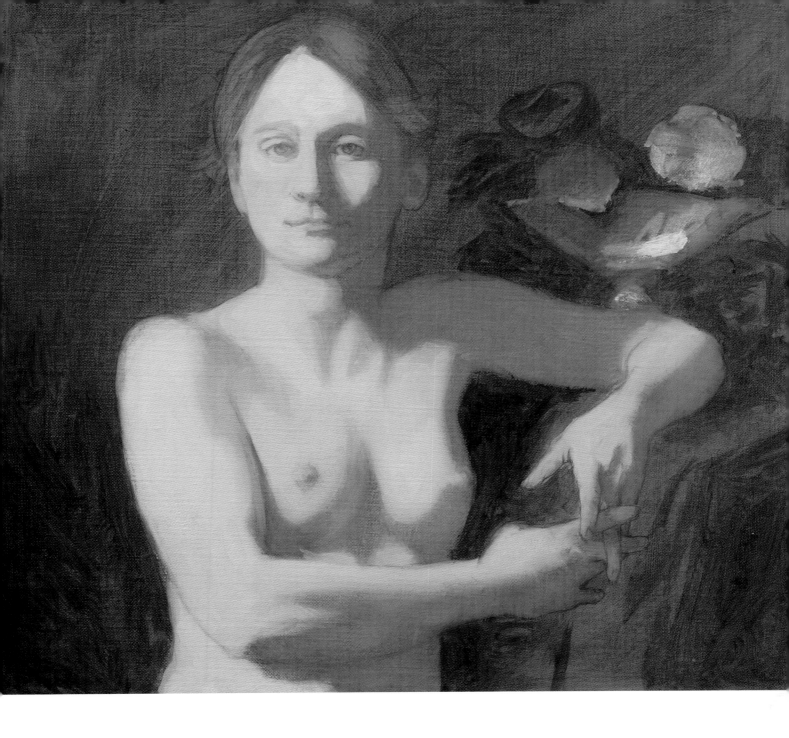

Scumbles

Al Gury, velatura color test, 2009, oil on board. Courtesy of the artist

Translucent white is scumbled over pure colors here. The result is an illusion of optical mixing and of the cooling of colors in layers. This is one variant of the velatura process and its uses.

The difference between a scumble and a velatura is one of intent and approach. *Scumbles* are rough and are usually seen in more vigorous or even direct paintings, whereas a velatura is a more controlled and specific application. A scumble is often synonymous with the term *drybrush*. The paint is dragged roughly over previously painted layers, letting some of the color or tone of those layers come through to create a unique effect.

Scumbles usually have little or no medium in them. They're typically translucent and depend on rough brush action for their spreading of paint rather than the smooth gliding of a velatura. A scumbled layer can also provide the first layer of color massing or body color for a painting. In addition, scumbles are used to unify seemingly disconnected areas of color or tone in a painting or provide transitions between areas. Remember, the use of these color techniques depends on their appropriate layering in the development of the painting.

Michael Gallagher, *High Noon*, 2009, acrylic on panel, 16 x 11 inches (40.6 x 27.9 cm). Courtesy of Schmidt-Dean Gallery, Philadelphia

Homage to Philadelphia colorist Arthur Carles as well as the American abstract expressionists gives order and harmony to the color in Michael Gallagher's abstract paintings. Like Carles, Gallagher uses colors that are very balanced in their shapes and interactions. The force of expressionist brushwork lends strength to the play of colors and to the layers of scumbles and opaques.

R.P.Foulks 1995

Washes and Imprimaturas

A *wash* is a thin transparent or translucent layer that's most often used in the earliest paint layers close to the painting's ground. Following the lean-to-fat model of layering, a wash is very lean and is often pigment thinned out with mineral spirits or turpentine and a very small amount of oil or other medium. Washes can be used to spread out a layer of thin color on a canvas to provide a color or tone base for upper layers of color. They can also be used to tint or stain white canvases. Similar to an imprimatura in appearance, a wash is very thin, while an imprimatura uses more medium to keep it wet and fluid and is used in the wipe-out method of underpainting (see page 73).

Thin washes of color appear as a first layer in many impressionist paintings on white canvases as well as in many modernist works. A wash used as a first layer can be any color that suits the color effect and layering of the painting. For example, French impressionist Renoir often used blue washes as a starting layer or placement drawing. More neutral colors can also provide settings or a loose underpainting.

As mentioned earlier on page 73, an *imprimatura* is typically a transparent, neutral color layer (for example, an umber or a sienna) that is applied over a dry, gessoed surface. It's usually rich with medium but follows the lean-to-fat model for subsequent layer application. An imprimatura is most often used as an underpainting layer into which the painter draws with a brush or wipes out the light areas of the subject and leaves the dark imprimatura as the shadows. Imprimaturas are typically a middle tone.

Imprimaturas are usually associated with open-form or alla prima painting but can also be used as a base for paintings that are "closed up" in the top layers by blending and refinement of drawing. Imprimaturas in oil painting history are usually a neutral transparent brown but can be in any color that suits the goals of the painting. They can be painted into "wet in wet" or can be allowed to dry and then painted on later. For example, American painter Thomas Eakins often coated small panels for oil studies with a brown imprimatura. He also would pull an imprimatura over dry, older paintings when he wanted to reuse the canvas or panel or rework a piece.

Renée P. Foulks, *Horus*, 1995, oil on board, 14½ x 17½ inches (36.8 x 44.4 cm). Image courtesy of Hirschl & Adler Modern, New York, NY

In *Horus*, a fine closed-form underpainting and drawing are developed. Layering of color evolves through translucent and opaque scumbled layers, with final opaque touches on top. Finishing touches of darks restate the drawing, and single-skin glazes unify specific areas of tone and color.

IDENTIFYING OBSERVED COLOR

When painting from life, identifying the observed colors to mix is the most daunting task. The organizing of the masses, values, and temperatures of the observed colors of the scene must ultimately be translated through the identification of the color and the mixtures or combinations to be chosen on the palette.

For still life, portrait, landscape, interior, and figure painting, a simple, almost abstract method can be used. Stand back from the subject and visually simplify each area of it into large blocks or masses of color and tone. Then mentally name the colors of those areas. For example, in a portrait, if the model has a generally pink complexion, you would simply say the mass of the face is pink. If the model's complexion is brown, you would say it is brown, and so forth. Is it a bright pink or a dull, neutral pink? Is it a warm golden brown or a neutral brown? If the background is greenish-gray, you would identify it as such. Is it a warm set of yellowish-greens, or is it cool, bluish colors? Obviously, there are a variety of tones, reflections, and subtleties in each area, but you're simplifying them so that you can "see" them in an organized way.

Now, identify the color changes in the big areas according to tone. For example, for the model's basically pink complexion, ask, How is the color of the light mass (light areas) and the shadow mass (shadow areas) different? The light mass could be described as a warm pink and the shadow mass as a cool gray-pink, and so forth. The eye tends to get very involved in details very quickly. The challenge here is to learn to organize the experience of what you see into simple, large blocks of tone and temperature change. The problem for most painters is that they see too much at once. This whole experience can be maddening and can ultimately create very muddy colors if you put too much in each mixture. The effects of what you see can be created more easily by creating organized masses and blocks of color to which you can add.

The practical application of this is to then identify which pink or red on the palette would be the closest match for the basic complexion of the model. For example, you might say that, based on the tint test experience (see page 142), a mixture of Venetian red and yellow ochre with white would get you closest to the model's base complexion color. You could analyze that a touch of permanent rose would be appropriate for the heightened pink in the fleshy areas of the face, such as the nose and cheeks. To "dull down" the more neutral areas of the lower face, you might determine that adding raw umber or a touch of black to the mixture would be the right choice.

The shadow mass, being cooler (in this example), could be made (again, hypothetically) from a mixture of the original Venetian red, yellow ochre, and a touch of black with a bit of white. The value of the light mass might be a 3 or 4 on a 1-to-10 value scale (where 1 is lightest and 10 is darkest), while the shadow mass might be a 6 or 7. This base shadow mixture could be the setting, as is the light area, for a variety of

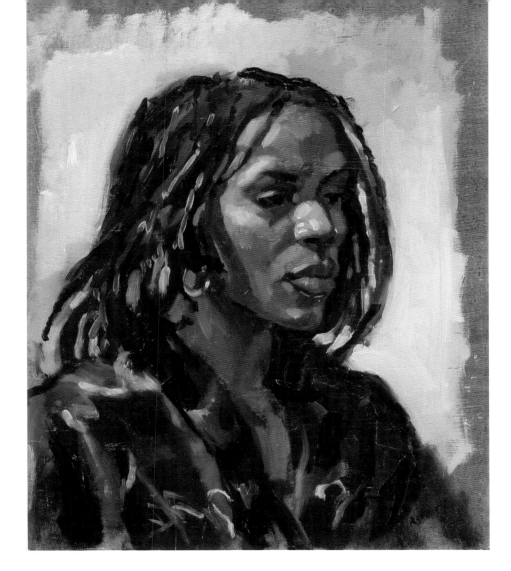

reflections or other color touches, highlights, and dark accents. The color analysis of the reflections and other subtleties is the final stage of the color-identification process.

This is all very, very dependant on having done the color tint tests, gradation mixtures, and other exercises described in chapter 5 to get a sense of the whole concept of color masses, tones, and tints. This whole process—whether for a portrait, landscape, or other subject—has the effect of slowing you down so that you can begin to think through the color-mixing and -matching process.

Visually simplifying the masses of color and naming the different levels of the masses or areas (i.e., identifying the layers and their order of application) clarifies and makes more rational what could otherwise be a very confusing experience. No matter what the lighting situation—or whether you are working in a representational, semiabstract, or fully abstract manner—this simple, clear color-identification process works very well.

"Seeing" Color

There is much debate among artists and color theorists as to whether we all see the same colors in a real, physical sense or whether we see color through a variety of personal and emotional and physiological lenses. Accurate color identification by color-industry workers has been tested for decades. Also, accurate matching of colors to tones is standard teaching in art-school design and color classes.

The human eye can provide consensus concerning the identification of the hue, value, and chroma of a color. Difficulties arise when painters have no structure through which to filter the experience of what they see or when (through temperament, inclination, or previous lessons) they cast observed colors in a different light than their peers, or when they actually have physical difficulties in seeing colors at all (see page 154 for more on this topic).

Observing color in nature is related to practices that allow painters to understand what they are seeing and organize this in a structure that makes sense. This is very important to understand and practice as an academic (studied) basis for the knowledge and practice of color. "Seeing" color is both a physical and an intellectual process. "Looking closely" is only half the battle. Having a system and a craft to make sense of the experience of looking is what has allowed painters for centuries to produce works of beauty, harmony, and expression. Various ways to organize the complex experience of color are presented throughout this book.

OPPOSITE, TOP: **Jon Redmond**, *Bays*, 2009, oil on Mylar, 12 x 16 inches (30.4 x 40.6 cm). Courtesy of the artist

OPPOSITE, BOTTOM: **Jon Redmond**, *330*, 2007, oil on board, 10 x 10 inches (25.4 x 25.4 cm). Courtesy of the artist

Geometry and the play of pure chromatic colors against neutrals are themes in Redmond's work. Highly chromatic colors are those at their purest or most intense; in practical terms they are the brightest reds, yellows, blues, greens, and so on. Cadmium colors are an excellent example of this. Often, the high-key colors in Redmond's paintings almost seem to exist as abstract elements in their own right on the surface of the canvas. His understanding of the modernist concept of the picture plane (the flat surface of the canvas) is incorporated in his work. He sets up tension between illusions of depth created by neutrals and the aggressive geometric shapes of bright colors. The whole effect is one of complexity, intensity, and variety.

COLOR AND ATMOSPHERIC PERSPECTIVE

Pigment mixtures and layering of pigments can aid in the development of perspective or depth in a painting—or hinder it. As a general rule of thumb, stronger, clearer, darker, and brighter colors will seem to advance spatially, while softer, grayer, fuzzier, and more neutral colors will seem to recede by contrast. In addition, areas of color that have clearer edges will seem to advance, relative to areas that have softer edges. And as seen in the color tint tests (page 142), transparent colors appear to move forward spatially, relative to opaques, which recede by contrast. Translucent pigments can be seen to settle in the middle, relative to the others. Like most visual rules, these concepts can be mixed and matched or broken according to the aesthetic desires of the artist.

For example, a landscape can be made entirely of cadmium red. Thinned-out, nearly transparent red can establish the foreground with clear, definite strokes. Denser translucent red can establish the middle ground with slightly softer, less clear strokes. The distance can be described with softly stroked light tints of red with white. While this painting might not have all the subtleties that are possible through a greater variety of mixtures, the fact is that manipulation of densities and tints with one color can create the effects of depth.

In Renaissance portraits, a rich red background often recedes behind the sitter because the red is diffuse and the figure is clearer and stronger in its edges and tonalities. Conversely, a painting made only of colors with the same chromatic intensity or temperature can create a completely flat or less spatial effect. In a painting in which the cools or neutrals are missing, relative to the warms, the overall effect may be one of less depth. And in a painting in which all the colors are of the same chromatic intensity and the edges all of the same clarity, the resulting effect will be one of flatness and lack of optical depth. Understanding these optical qualities of pigments can be crucial to a painting and to the painter's desired aesthetic effect.

John Constable, *View toward the Rectory, East Bergholt*, 1810, oil on canvas on panel, 6⅛ x 9¾ inches (15.5 x 24.7 cm). Philadelphia Museum of Art: John G. Johnson Collection, 1917. Photo: Eric Mitchell

The brilliant sky in this oil sketch remains in the distance due to the modulations of clear darks in the foreground and hazy edges in the distance.

Jeff Reed, *Ballyglass Hill*, 2008, oil on canvas, 13 x 14 inches (33 x 35.5 cm). Courtesy of Gross McCleaf Gallery, Philadelphia

Reed uses limited palettes and palettes extended with only a few prismatic colors with great subtlety in his landscapes. Optical illusions of depth and atmosphere are created through the color, tone, and texture relationships of "near to far" as well as in the modulation of edges to create an enwrapping sense of atmosphere.

Al Gury, monochromatic landscape studies, 2009, oil on board. Courtesy of the artist

Both of these studies clearly communicate the depth in the scene using only one color plus white. Even though cool colors tend to recede, a cool color can be used to establish the foreground as long as it is transparent or bright with clear, definite strokes, while a warm color used in the sky can recede into the distance as long as it is applied in soft, diffuse, and opaque tints. Both these landscapes—the first in ultramarine blue and white and the second in cadmium red medium and white—have an illusion of depth created following basic optical principles that it's good to remember: sharper, darker, and clearer advances; softer, grayer, and fuzzier recedes by contrast. More important, this concept can be played with for different effects.

COLOR TEMPERATURE AND SPATIAL RELATIONSHIPS

A dark blue drawing on a gray ground gives form to the intense and simple color masses and brushwork of this painting. Purity of color, simplicity of design, and boldness of brushwork are typical of Derain and other fauvist painters. Even though this painting does not use a variety of neutrals to create form (as the fauves often rejected neutrals in favor of pure colors), a sense of recession and depth is created through color changes and through brushwork and drawing variety. The blue shadow of the face seems to recede. The background, being softer in its brushwork and slightly darker, also creates an illusion of depth.

Color is sometimes described in terms of temperature as being either *warm* or *cool*. All artists' tube colors have inherent properties of relative temperature—that is, warmth to coolness—when compared to one another. Mixtures of colors also have these differences and relationships. A simplistic understanding of color temperature suggests that warm pigments (like yellows or oranges) are those associated with sunlight, while cool colors (like blues and violets) are associated with shadows. The truth, however, is more complex. There are several forms of temperature difference in oil colors and their mixtures. In addition, another consideration of color temperature involves the relationship between high-chroma, or bright, colors to more neutral colors or mixtures.

It's important to realize that all artists' pigments come in a variety of "temperatures" within any hue or family. *Hue* refers to a color being part of a color family—for example, a *red* family, a *blue* family, or a *yellow* family. So, cadmium yellow light is warm, whereas lemon yellow is cool by comparison, yet they are both in the yellow hue family. The cadmium yellow light contains properties of gold/orange, while lemon yellow contains hints of green and blue. Similarly, cadmium red deep is really a purple and is cool relative to cadmium red light, which often appears to be a deep, warm orange-red.

These relationships can also be explored by creating color wheels of primary, secondary, and tertiary colors. (See page 144 for color wheel exercises.) But the key starting point for the painter is to understand both the concept of warm and cool and the actual temperature properties of tube colors on the shelves in art supply stores.

Another set of temperature relationships derives from the comparison of the brilliant, or prismatic, palette colors with the duller, or earth, palette colors. Earth colors, by nature, are neutral when compared to prismatic colors. Burnt sienna is neutral or less chromatically bright than cadmium red light, for example. Yellow ochre is duller or more neutral than any prismatic yellow. Traditionally, many painters have used the earth palette as the neutral or cooler counterpart of their bright colors when constructing the structure of a painting.

Mixing an earth color with a prismatic color will automatically dull, cool, or neutralize the prismatic color. Umbers and black have always been used to dull, cool, or neutralize all other colors. Also, gray can be used to cool or neutralize any color. *Cool* can simply mean a grayer or more neutral version of a color. White added to colors will lighten them, but too much white will "cool" or neutralize a color. Too much white added to already neutral colors will create chalky colors.

Mixing a color with its complement (the color that falls opposite it on the color wheel) can create a new neutral or cool color. When red, yellow, and blue are mixed

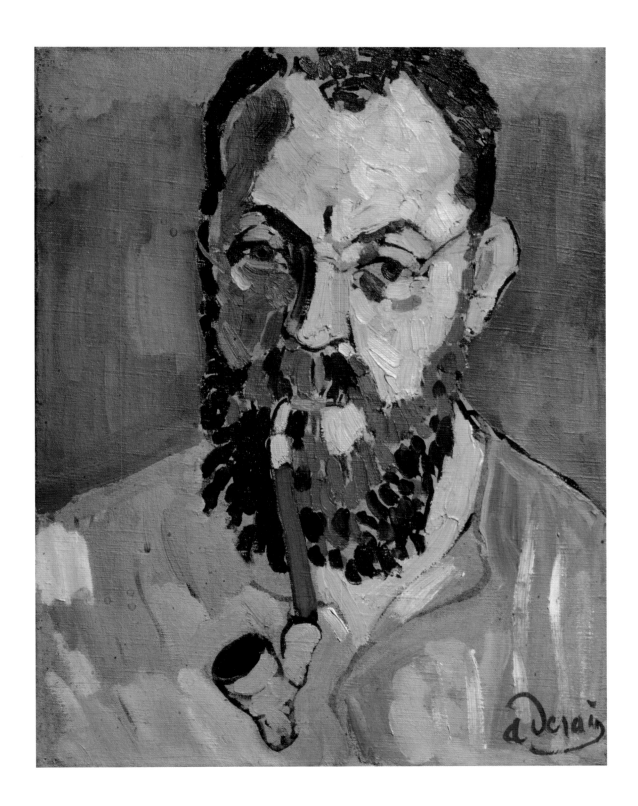

Bill Scott, *A Handful of Cherries*, 2007, oil on canvas, 48 x 36 inches (121.9 x 91.4 cm). Private collection. Courtesy of Hollis Taggart Galleries, New York

Using nature—and in particular, plants, gardens, and flowers as a point of departure—Bill Scott creates compositions of the abstract essence of the forms he loves. A range of earth and prismatic color are juxtaposed and layered to create a visual flow of color throughout the composition. Atmosphere is evoked through the subtlety of the colors and their temperature and textural changes.

A vibration between slightly forward-moving and backward-moving colors and shapes is a strong part of this rich painting. Colors seem to float, moving in and out through temperature changes. Some struggle with one another for dominance of intensity. The picture plane is respected, while at the same time, a clear but shallow sense of depth is created through temperature and edge changes. Many abstract painters, especially those who use observed nature as a source, create complex spatial relationships using the tools of temperature changes and spatial rules.

with their complements (green, purple, and orange, respectively), the resulting colors are neutrals—or cooler colors—relative to the original bright color. However, adding complements—or any color, such as black or umber—can eventually create muddy colors when the color identity of the basic color hue is lost. At some point, the color is so neutral that it just looks muddy and has no identity as a member of a red, yellow, or blue family.

In a painting, the relationships set up between warm or cool or prismatic or neutral colors are key to creating depth and form. In abstract paintings particularly, the relationships between these versions of colors are crucial to maintaining the flat picture plane of the canvas and the interactions of colors in the composition. Temperature depends on the relationship set up between pigments and mixtures of pigments. Simple tests and mixing exercises to determine temperature can be found in chapter 5.

The Effect of Light on Color

Do colors exist objectively devoid of the light that touches them? Or, are they always a product of the environmental conditions in which they are seen? This discussion has directed many of the great color movements in European and American painting since the Renaissance.

We may say the color of a vase is blue, for example, but how has the blue been affected by the light on or around it? Does the light make the vase slightly pinker, slightly greener, slightly grayer, or slightly lavender? What kind of blue was it to begin with? Cobalt? Ultramarine? Turquoise? Cerulean? The objectivity of the color provides a basis for consideration and organization of the richer and possibly truer understanding of what the color has become in its light. The color of the light on the subject guides all the decisions and aesthetics of the final painting when dealing with observational color in nature.

Al Gury, temperature studies

The figure to the left shows a model painted under a warm spotlight, while the one to the right shows the same form under cool daylight. The spotlight demands the use of prismatic colors to match the chromatic intensity of the model. The cool daylight is matched by earth colors. The model's color may objectively be described as a pinkish-beige, but it is radically altered and reinterpreted by the color of the light source.

CONCEPTUAL VS. OBSERVATIONAL COLOR

Gilbert Stuart, *Sarah Wentworth Apthorp Morton (Mrs. Perez Morton)*, 1802–1820, oil on canvas, 29 x 24 inches (73.6 x 60.9 cm). Worcester Art Museum. Gift of the grandchildren of Joseph Tuckerman

Considered the greatest of the early American portrait painters, Stuart painted almost all of the important American statesmen of the period. His technique combines a sense of looseness and generality in the beginning of a painting with a finishing refinement and detail of drawing at the end.

Essentially a direct painter, like many of his English contemporaries, Stuart employs simple tonal gradations of colors and a fairly limited palette for his effects. Many of his subjects' faces are painted with color that is more about society's expectations of appearance than what they really looked like. This approach allows for a more systematic use of color than a responsive one. *Mrs. Perez Morton* is a fine example of the best of all of Stuart's qualities as a painter.

Two important approaches or traditions of color in painting are conceptual color and observational color. The first, *conceptual color*, is the oldest in the history of oil painting and refers to the choosing of colors that illustrate the point or content of the image rather than describing just what one sees or observes. The observation of color in nature provided cues and guidelines for the making of the image, but the real goal was to create a painting that went beyond the imperfection of nature. Except for during rare periods in Western history (and indeed most other cultures of the world), nature was seen as needing to be subdued and shown in its perfected state through art. Prevailing cultural philosophies and theologies were the major motivators of style and content in art, especially in the West.

The Greeks used idealized colors to create highly elegant images of perfect human and divine bodies in their mosaics, encaustic paintings, and painted statues. Medieval craftsmen in Ireland, France, and Italy used color in icons, illuminated manuscripts, altarpieces, and stained glass to tell the stories of holy figures and identify these stories through symbolic color for a mostly illiterate public.

In a fifteenth-century painting of a saint, the colors identify the attributes of that saint and illustrate other theological concepts pertinent to the image. The public knew these ideas not from writings so much as from having learned visual symbols and cues. While many parts of the painting appear naturalistic, the main focus is communicating the content of the image. Medieval and early Renaissance artists' notebooks contain many sketches of people, plants, and animals as they are in nature. These are then "adjusted" to serve the higher purposes of Art with a capital A.

Renaissance painters used observation of color in nature as a reference for images of "nature perfected" in oil portraits, history paintings, and holy images. For eighteenth-century classicists, color took a supporting role to drawing and beauty, which were highly conceptualized ideas. Nineteenth-century academic painters thought color to be in the service of beauty and the harmony of composition and drawing, while others claimed that color in nature and everyday life, when organized and perfected, is superior to the academic concerns of drawing. Twentieth-century painters often saw color as a product of the mind and imagination and a key to creativity and personal expression. Still other artists and writers throughout history have seen color as subordinate to drawing and graphic images, or vice versa. In this tradition, nature and the observation of color are seen as being in the service of higher purposes.

Throughout the course of painting history, painters who have focused on symbolism, narrative, and even modern conceptual abstraction have chosen colors that make their desired point rather than those that are simply available in the environment. Many of these mandates are societal or are based on class, tradition, and expectations

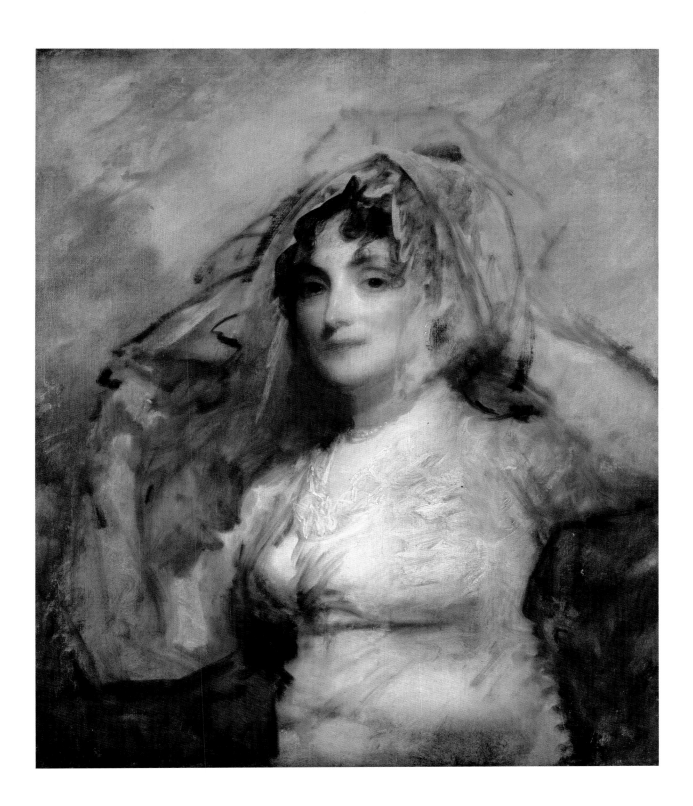

of beauty in art. This is not to say that they aren't using naturalistic colors or imagery in telling their story, but they are freely adapting those elements for the good of the image.

Painting manuals from the fourteenth through sixteenth centuries suggest appropriate colors for specific subjects—for example, the colors for a maiden as opposed to those for a man, or the colors for one saint or another. Landscape backgrounds for a figure were often invented according to a concept of the land as opposed to a direct description of a specific location. Through most of painting's history, portraits have had to conform to the societal expectations of the appearance and class of the sitter. Colors in portraits were freely adjusted or invented to suit these purposes. Historical paintings, in the effort to present an iconic figure or event, had to use color, among other elements, in a way that the public would understand. Probably the most "nature related" of the subjects has been still life. Even so, still life has always been a vehicle to teach values, morals, and ideas. Accordingly, still lifes incorporated concepts of color as much as any other genre.

Related to conceptual color is the interpretation of color used in many modern and abstract or semiabstract works. Here, the artist is freely changing what might occur in nature to what is needed to tell the visual story or portray an idea. These great traditions of the *conceptual* constructions of color in painting continue up to today.

The second tradition, *observational color*, is one in which color in art is a response to nature and is based on understanding, studying, organizing, and describing color

and its effects as they occur in nature. Nature is the main point of reference rather than an idea, philosophy, or theology.

While the awareness of nature and color in the natural world has always been of interest to artists and theorists, painting nature as a primary subject is a relatively new idea. As mentioned above, painters often kept elaborate notes and sketches as reference for their work but mainly as a starting point for a process of perfecting nature into ideals of beauty. These very beautiful observational "notes" would often be discarded or were never shown as serious art.

As Europe's theological focus on heaven and the means of getting there moved toward a fascination with science and nature and the presence of God in the world through His works in the Renaissance, so also did art begin to incorporate more of the visions of that natural world. Baroque theology required a sense of "being there" in images of holy stories and persons. This growing interest in naturalism or realism emerged parallel to the continuing traditions of conceptual color and the "perfecting impulse" in many schools of art. By the eighteenth century, artists such as Chardin and Constable painted images that were primarily about relationships and visual effects found in nature, or at least dominated by nature.

Observational painting and the use of observed color emerges in the nineteenth century as a major movement in the art academies as well as in the studios of mature artists. Impressionism, plein air painting, the direct oil study, and alla prima painting all reflect the powerful attraction of describing color in nature as it is rather than as it should be. Painting the figure, the on-site landscape, the observed interior, and so forth all became subjects for the exploration of color through the filter of the human eye.

In the twentieth and now the twenty-first centuries, practitioners of observational color produced and are continuing to produce paintings of great eloquence and beauty through describing harmonies and relationships of colors in their work.

The irony is that to adequately organize the experience of observed color, one must employ principles or concepts of structure to make sense of the experience. Whether a quick alla prima study of a landscape or a major composition of figures in an interior, underlying concepts must be used to bring order to perceptual chaos. The objective matching of the colors and tones in a scene requires that the principles of color mixing, the creation of temperatures, the hues and chromatic intensities, and compositional concerns all be well understood as concepts. This understanding will aid the artist in the creation of paintings that reflect either of the great traditions of conceptual or observational color or a mixing of the two.

Arthur DeCosta, *Flower Still Life*, c. 1970, oil on board, 8 x 7 inches (20.3 x 17.7 cm). Courtesy of the Pennsylvania Academy of the Fine Arts, Philadelphia

This painting was started with a burnt umber underpainting on an imprimatura ground. Utilizing entirely observational color, DeCosta interweaves neutrals and brights and softness and clarity to create an illusion of the flowers observed in a soft light.

COLOR AND COMPOSITION

Color (among other formal elements, such as line, tone, and shape) has always been used to design the composition, or the arrangement of elements, in the rectangle of the painting space. Titian would move the viewer's eye through the composition from one bright area of color to another. Corot often placed a bright spot of color, such as the red cap of a shepherd, as a focal point for the viewer's eye to begin its movement through the composition and as a place to come back to rest.

Colors might vary tremendously throughout the composition or exhibit simplicity and have a limited range. The movement, focus, and balance of color are elements of composition in painting as much as line, tonality, and texture. Color also sets the mood of the composition in its key, or overall, range of intensities and color interactions.

An arrangement of highly interactive secondary or complementary colors—that is, colors that have strong hue differences (orange against purple against green, for example)—will create a bright, intense, and active composition. A close range of related colors might suggest a somber or quiet mood (for example, a composition all in browns, tans, and grays). The tones of the colors also have an impact.

A key point is to consider the relationship of color to the overall composition to obtain the desired effect of one's aesthetic idea. More traditional painters might have a very clear plan through a number of preparatory studies, such as a sketch of their tonal colors (colors organized around tonal gradations, as seen in the work of Rembrandt, for example). More "reactive" modern artists (such as German expressionist painter Hans Hofmann) might follow their instincts as they paint, achieving a sense of harmony through experimentation and feel.

George Inness, *Peace and Plenty*, 1865, oil on canvas, 77⅝ x 112⅜ inches (197.1 x 285.4 cm). The Metropolitan Museum of Art, NY, USA. Gift of George A. Hearn, 1894. Image copyright © The Metropolitan Museum of Art / Art Resource, NY

Peace and Plenty is one of the quintessential American landscape paintings. It combines traditional tonal color gradations with both observation and a sense of conceptual grandeur. Here, the composition is organized around the dark masses of the trees set against the glow of the sky. Small elements in the painting, such as the haystacks in the foreground, balance and support the composition, which is designed around curving lines of the river and the shapes of the trees. Color interaction occurs through warm/cool temperature differences and differences between the sky and the earth.

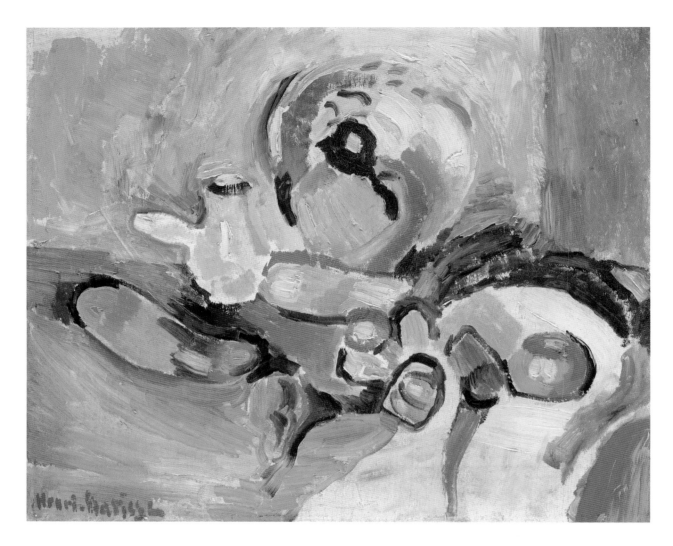

Henri Matisse, *Still Life with Vegetables*, 1905, oil on canvas, 15⅛ x 18⅛ inches (38.4 x 46 cm). The Metropolitan Museum of Art, NY, USA. Jacques and Natasha Gelman Collection, 1998. © 2010 Succession H. Matisse, Paris / Artists Rights Society (ARS), New York. Photo: Malcolm Varon. Image copyright © The Metropolitan Museum of Art / Art Resource, NY

The fauvist works of Matisse prefigure his bold, flat color designs. This still life is painted with broad, scumbled color areas in the first layer followed by dense, opaque modifications of color mass and variety. Bold, dark drawing touches in rich, prismatic colors finish and solidify the painting. The composition is integrated by oblique curving lines and color passages.

Hans Hofmann, *Rising Moon*, 1965, oil on canvas, 84 x 78 inches (213.3 x 198.1 cm). Private Collection. © 2010 Renate, Hans & Maria Hofmann Trust / Artists Rights Society (ARS), New York. Photo: Art Resource, NY

One of the most chromatically powerful of Hofmann's paintings, *Rising Moon* is made simply of primary and secondary colors. The play of sharp and soft edges gives variety and excitement to this intense painting. The viewer's eye is moved from shape to shape and color to color by a variety of textures, color intensities, and paint densities.

COLOR HARMONY

Romantic, tonal, atmospheric, poetic, and *interpretive* are all words that describe the landscapes of George Inness. His color ideas were derived from nature but interpreted through his memories and sketches in his studio. Inness's color is generally neutral with "brilliances" of color in an individual tree or bit of sky. Respected by the American impressionists, he was also an influence on tonalist painters and romantic realists.

Well-organized paintings often have an overall "effect"—that is, a quality of impact, mood, poetry, color quality, and so on that we call harmony. Harmony can be created by balances of color intensities and effects, whether in Renaissance or modernist paintings. It can be created by an overall feeling of softness and neutrality, as seen in many limited-palette paintings or through bright, highly interactive mixtures of colors in a composition. Colors repeated throughout a painting can create a sense of integration and harmony as seen in many impressionist paintings, while one spot of a bright color can be balanced by darks and large masses of neutral colors.

These harmonies and other formal elements can be planned in advance. The preparatory color study, usually on a small scale, is an important method for planning the overall effect of the painting. As preparatory studies, Ashcan School painter Robert Henri did small, almost abstract arrangements of the colors he would use in larger works. The great portrait painter John Singer Sargent frequently executed numbers of small studies of color and tone compositions for his larger works to plan the harmonies and compositions.

Nineteenth-century studies were often done on pre-prepared "academy boards," which were a form of cardboard, as well as on small wood panels of the pochade size (approximately 8 x 10 inches). Modernist painters sometimes work through a series of preparatory color "notes" before going to a larger canvas.

In most cases, the integration, balance, and harmony of color in paintings is created by thinking through and responding to the balance of all elements of the painting beforehand. This is very true for observational painting but is especially true for images done from the imagination or following a specific aesthetic or content. Titian's allegorical figure paintings are a marvel of balances of bright colors and neutral darks, for example, while paintings from Picasso's Blue Period embody an overall psychological mood as well as close balances of blues and grays to create a poetic integration.

Harmony can also be created simply as the artist develops a painting by instinct. Even the best-planned paintings still rely on the instincts and intuitions of the painter to create an interesting artwork. Some, especially twentieth-century painters, have followed the belief that painting is a journey of exploration. Many artists prefer to just start a painting and see what happens. Creating harmony is an exciting and intuitive part of the whole aesthetic process.

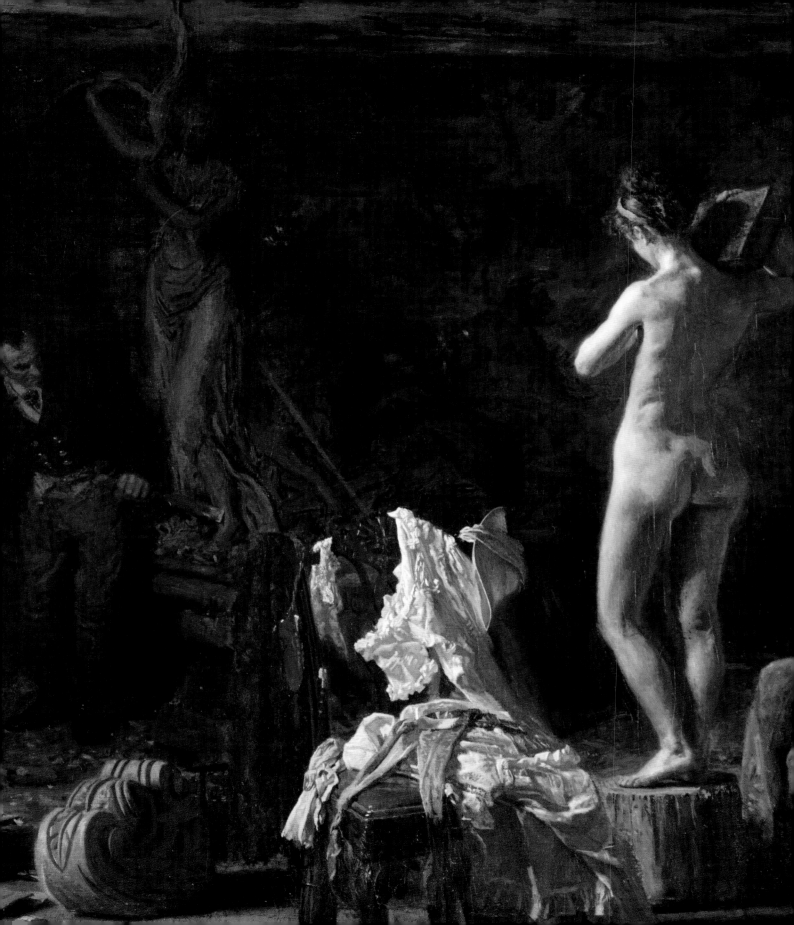

Aesthetic Approaches *to* Color

There are various aesthetic or stylistic ways of organizing color in painting. They incorporate technical approaches but primarily provide the overall color "style" of a painting. Understanding them not only helps painters learn how to organize color in their paintings but also guides painters in developing their own personal color aesthetics in their work. These concepts also help the nonpainter understand the basic variations of color in painting styles. We could describe a painting and its color as impressionist or tonal in style, for example. These simple descriptions are really just for the purpose of organizing ways of thinking about color concepts in painting and to get a sense of the overall aesthetic, or "stylistic," approach to color.

Thomas Eakins, *William Rush Carving His Allegorical Figure of the Schuylkill River*, 1876–1877, oil on canvas mounted on Masonite, 20⅛ x 26⅛ inches (51.1 x 66.3 cm). Philadelphia Museum of Art: Gift of Mrs. Thomas Eakins and Miss Mary Adeline Williams, 1929. Photo: Graydon Wood

Eakins has been referred to as the first modern American painter because of his objectivity concerning his subjects. His use of the camera as an *aide-mémoire* was less influential on his color than were the Spanish Baroque painters he admired.

Largely neutral and earth-color mixtures dominate his paintings with bright areas of color added in small local touches. His shadow colors, generally gray-ish-brown or greenish-gray, are more neutral than those of most academic painters of his period.

TONAL COLOR

Tonal color refers to the primary organizing qualities of a painting being seen through value gradations of light to dark in the colors and forms. Painters such as Caravaggio, Rembrandt, Velázquez, Goya, Sargent, and Eakins are prized for their focus on tonality, which produces atmosphere and character in a painting. Tonal paintings and color are characterized by an overall sense of light set off by shadow. Tonal paintings can have high contrast or be essentially very dark in quality.

Peter Paul Rubens, *Portrait of a Gentleman (possibly Burgomaster Nicholaes Rockox)*, c. 1615, oil on panel, 15½ x 12⁵⁄₁₆ inches (39.3 x 31.2 cm). Philadelphia Museum of Art: Gift of Mrs. Gordon A. Hardwick and Mrs. W. Newbold Ely, 1944. Photo: Graydon Wood

Probably a preparatory study for a more formal portrait, this small painting captures the full range of Rubens's use of color. Warm earth colors in the light areas are neutralized and "grayed" with black in the shadows over a transparent brown underdrawing. Touches of rose in the cheeks and transparent burnt sienna in the reflected light areas add brilliance to this tonal construction.

Colors in tonal paintings vary from light hues in the topmost layers and light masses through middle tones in connecting and recessive areas to a variety of dark tones in the shadow masses. Even though there may be a variety of colors, reflected lights, and even glazes, the primary organizing factor of the painting is its tonal construction. Tonal painters usually begin the painting on middle-toned grounds. They place an oil drawing or underpainting on the canvas, which describes the main masses and structures, and then move to blocking in middle tone and light areas. Lightest lights, darkest darks, and details are added at the end.

In many tonal paintings, the middle tones are neutral versions of the light color. The shadows are neutral, grayer, or browner darker versions of the general color of the subject. The painting has a full range of value changes and depends on the understanding of neutrals and the relationship of tone or value to color gradients.

Caravaggio (Michelangelo Merisi da Caravaggio), *The Deposition*, 1600–1604, oil on canvas, 118 x 80 inches (299.7 x 203.2 cm). Pinacoteca, Vatican Museums, Vatican State. Photo: Scala / Art Resource, NY

A defining force in tonal painting, Caravaggio used color that gradates simply from lighter and brighter to darker and more neutral. Each figure has an overall color tone that follows this strong format. The value of the color is extremely important to both the individual forms and the overall composition. The bright colors of clothing were often directly painted by Caravaggio, although he also used local glazes to adjust colors and tones.

MONOCHROME COLOR

Eduard Charlemont, *The Moorish Chief*, 1878, oil on panel, 59⅛ x 38½ inches (150.1 x 97.7 cm). Philadelphia Museum of Art: John G. Johnson Collection, 1917. Photo: Graydon Wood

The Moorish Chief is one of the masterpieces of nineteenth-century salon painting and tonal color. The color is organized around simple gradations from warmer/brighter to grayer/duller, with manipulations of line and texture completing the form. In this light, it is a superb example of the broader definition of monochrome color. *The Moorish Chief* stands out as a good nineteenth-century example for comparison and contrast with French impressionism.

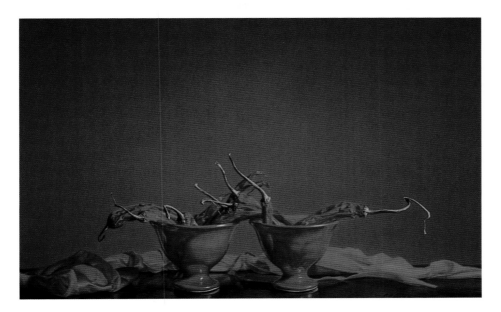

In the strictest sense, monochrome refers to the use of one color. Paintings that use a very limited color range, such as paintings in gradations of grays (from black to white) or from light brown to dark brown, would be strict examples.

However, monochrome color also refers to a limited—though not one-color—gradation of colors in a painting. The color in such a painting would range from lighter, brighter colors through neutral, middle-tone versions of those colors to grayer or browner, darker versions of the same colors. Temperature differences are very important. Colors simply become grayer or duller as they descend though value gradations.

Monochrome color usually appears in paintings that are also tonal in nature, but tonal paintings are not always limited to monochrome color. Rembrandt's work is tonal in nature, but he uses a variety of colors. Caravaggio's work is also tonal in quality, but his color and tone blocks are usually simply graded from lighter/brighter to darker/duller. He more clearly fits the model of a monochrome painter. Even modernist works, such as those by French cubist painter Georges Braque, can reflect powerful monochrome color.

Though monochrome tonal color effects are often associated with neutral, soft colors, as seen in Rembrandt or Caravaggio, bright colors can also be used. For example, a painting of all cadmium reds can be graded from lighter to darker, from more intense to duller.

POLYCHROME COLOR

Carlo Russo, *Gourds with Brown Paper Bags*, 2007, oil on linen 32 x 36 inches (81.2 x 91.4 cm). Courtesy of the artist

Rather than limiting this painting to simple warm gradations of monochrome colors, Russo adds a cool light source to create bluish highlights and shadows, which have gray-greens reflected into them. The whole effect is subtle but contains a rich variety of color changes.

Tonal, atmospheric color organizes the fall of light on earth-colored volumes. Neutrals are illuminated with a slight glow of color in the shadows of the pumpkins and the cast shadow on the wall to the right. Saturation levels are carefully modulated to create the gentle poetry of this painting. Throughout the painting, touches of cool colors and reflected colors create a subtle, polychrome effect.

Polychrome color refers to the use of a variety of colors in any form of painting. This is seen in the work of a range of artists from all periods—from baroque painters such as Peter Paul Rubens (also a tonal painter), to impressionists such as Monet, to modern painters such as Hans Hofmann.

Polychrome paintings are characterized by a great variety of colors, not just simple gradations. Colors can often be very interactive and create a bright effect, especially when warm and cool hues are played off against one another. Many paintings by American painter John Singer Sargent fall into this category, as do those of the impressionists such as Alfred Sisley. The understanding is that the structure of the painting is developed through a variety of color and temperature changes rather than the more limited monochrome approaches. Interaction of colors, along with tone changes, are important. In a polychrome abstract painting, color range and interaction are paramount.

Al Gury, *Portrait of Colin*, 2008, oil on panel, 14 x 11 inches (35.5 x 27.9 cm). Collection of the artist

Whereas previous examples have exhibited more subtle versions of polychrome color, this variation pushes the concept to the other end of its spectrum. Not only are there a great variety of colors present, but they also push complementary contrasts to an extreme. The essentially orange and lavender face is set off against a complementary green background. Reflected colors are highly chromatic and add to the color contrasts throughout the painting.

Vincent Desiderio, *Nude I*, 2008, oil on linen, 49½ x 67 inches (125.7 x 170.1 cm). © Vincent Desiderio. Courtesy of Marlborough Gallery, New York

Primarily tonal in nature, reflected colors in the shadows are important to this painting and speak to its use of polychrome color. Subtle greens reflected into the model's legs in the foreground and complementary colors in the quilt add complexity to the overall color scheme and keep it from being simply monochrome.

IMPRESSIONISM

The painters who became known as impressionists, both in Europe and America, began their training in the traditional, academic painting practices of the nineteenth century. Many attended academies where they were instructed in classical drawing and tonal interpretations of form and both observational and classical painting techniques.

The new theories of color by Michel Eugène Chevreul and others published in 1854 in France suggested an approach to color that allowed painters to focus on the illusions of the available light and its effects on the subject. Also, these concepts suggested that impressions of colors in nature could be created on the canvas through various kinds of optical mixing and afterimages. Combined with the novel idea of art for art's sake, the new color theories and the sketchlike approach to modern subject matter created this new movement in the arts. In 1874 an unkind critic, upon viewing Claude Monet's *Impression, Sunrise* (see page 170) in the first independent exhibition of work by Monet and his contemporaries, dubbed the show "impressionism." He meant it as a slur, but the name stuck.

As they evolved, impressionist color practices acquired great variety in their interpretation by painters. Some are virtually tonal and even monochromatic. Others are highly chromatic or polychrome in effect. Still others employ more drawing, while others seem to be devoid of lines, contrasts, or edges. French painter Pierre-Auguste Renoir and Americans George Inness and Daniel Garber are all considered impressionist in their sensibilities, but their work is very different. Renoir heavily interpreted and conceptualized his colors and images. Inness (also considered a romantic) focused on the poetry of tonality through his colors. Garber, considered very naturalistic and documentary in his description of a location, incorporated the methods of French painters Alfred Sisley and Camille Pissarro. The Macchiaioli in Italy painted intense works of light and shade.

Impressionist palettes were most often a traditional range of earth and prismatic colors; looked very much like palettes from earlier periods; and included black, umbers, and other earth colors. A very few used only prismatic colors or removed black from their palettes. Even fewer only used red, yellow, and blue. American impressionists take many points of view in their interpretation of the concept of impressionist color.

Impressionism continued to diversify greatly as it evolved. The defining commonalities of impressionist color would be a concern for the observed color and effect of available light on the subject; a loose, sketchlike approach to the application of paint; and color effects created by optical mixing of colors. Even so, the interpretations are very diverse.

Many impressionist painters gravitated to white canvases, with the white of the canvas providing a reflective field that both organized the colors and provided areas

Adolph Borie, untitled, c. 1900, oil on canvas, 20 x 16 inches (50.8 x 40.6 cm). Courtesy of the Pennsylvania Academy of the Fine Arts, Philadelphia

Borie, a prominent Philadelphia painter who studied with William Merritt Chase and Thomas Anshutz, was influenced first by impressionism and later by modernist concepts while studying in Europe. This intimate painting employs natural daylight, a casual pose, and a loose approach to brushwork. All are hallmarks of impressionist methods. The cool daylight color effects of this painting were very popular with impressionist painters.

for optical mixing of colors and for afterimages of color in the eye. Other painters, now classed as impressionists, retained their use of toned grounds. For example, early Seurat paintings were done on brown panels. Some Manet works were painted on a light blue-gray surface. Henri de Toulouse-Lautrec sometimes used a brown imprimatura. The artists' suppliers continued to present a variety of colored surfaces on canvases, panels, and academy boards.

When one looks in retrospect at the impressionist movement, there are some clear examples of the aesthetic (such as Monet or Renoir), but there are many, many painters in Europe and America who employed the characteristics of impressionism in a great variety of ways or only in part. A very good exercise is to look at the work of American and European landscape painters from 1870 to 1940 to try to identify where and how impressionist concepts are present.

Daniel Garber, *Tohickon*, 1920, oil on canvas, 52¼ x 56¼ inches (132.7 x 142.8 cm). Smithsonian American Art Museum, Washington, DC, USA.
Photo: Smithsonian American Art Museum, Washington, DC / Art Resource, NY

The Pennsylvania impressionists, largely trained at the Pennsylvania Academy of the Fine Arts, worked in the counties and towns surrounding Philadelphia. This strong landscape tradition continues today. Garber, a master teacher, was also a fine draftsman whose drawings and prints are highly prized. Influ-ences—such as French impres-sionists Pissarro and Sisley and the pointillists—show strongly in Garber's work, alongside more traditional plein air and tonal impulses. His color is laid down in large, scumbled masses and then developed with small touches of local and atmospheric colors.

Pierre-Auguste Renoir, *Portrait of Madame Renoir*, c. 1885, oil on canvas, 25¾ x 21¼ inches (65.4 x 53.9 cm). Philadelphia Museum of Art: Purchased with the W. P. Wilstach Fund, 1957. Photo: Graydon Wood

Portrait of Madame Renoir captures the interaction of warm and cool strokes of colors that fascinated the master. Renoir's early training as a china painter adds a delicacy and poetic quality to his color. Also a master draftsman, he included touches of intense darks that add strength to the image.

Jon Redmond, *Self-Portrait*, 2009, oil on board, 10 x 10 inches (25.4 x 25.4 cm). Courtesy of the artist

Impressionism's broken color and light touches of small spots and strokes of paint create a very different atmospheric feel from Redmond's cityscapes constructed of solid color masses. Halftones created by the pale ambient light are held together by small touches of darks in the head. Redmond's emphasis on the boldness of the paint touches creates an almost abstract approach to the paint and color that becomes more and more present in post-impressionism.

POSTIMPRESSIONISM

Painters heavily influenced by the impressionists and a great variety of other cultural influences in Europe developed a broad range of color approaches and vehicles for their color explorations. Painters in France such as Vincent van Gogh, Paul Gauguin, and Paul Cézanne introduced uses and understandings of color that drew inspiration from earlier forms of painting as well as from those used by the first generation of impressionists.

Some painters, such as Georges Seurat, formalized color theories and approaches into an abstract language of optically mixed spots of primary colors. Others, such as Gauguin, interpreted color in the service of poetic semiabstract images of Tahiti. Still others, such as the fauves, moved toward what would later be called color expressionism.

Some postimpressionists appear very similar to the first generation of impressionist painters. Others are very different in content and approach and introduce a whole new language of color. However, the subjects of postimpressionist painters, like those of their predecessors, were still the familiar surroundings of urban life, country scenes, and the figures of friends and models.

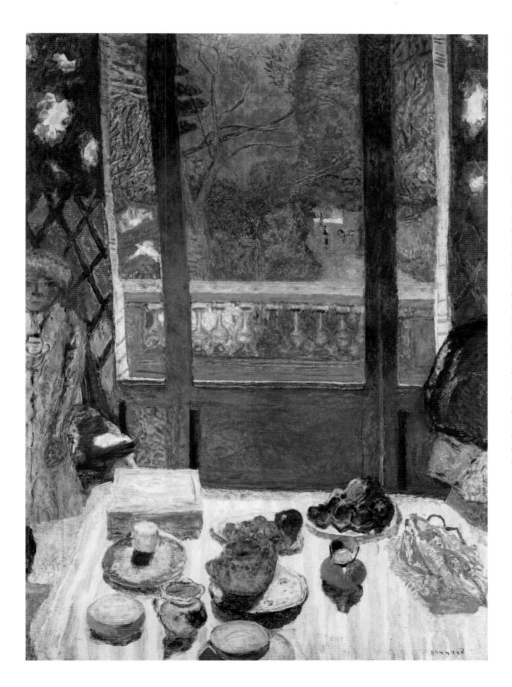

Pierre Bonnard, *Dining Room Overlooking the Garden (The Breakfast Room)*, 1930–1931, oil on canvas, 62⅞ x 44⅞ inches (159.7 x 113.9 cm). The Museum of Modern Art, New York. Digital image © The Museum of Modern Art/ Licensed by SCALA / Art Resource, NY. © 2010 Artists Rights Society (ARS), New York / ADAGP, Paris

Operating on many levels of beauty and invention, Bonnard's color is both observational and abstract in that he creates illusions of atmosphere and depth through a variety of colors and tones, while at the same time emphasizing flat shapes and the texture of the paint for its own sake. He responded to color in nature through the filter of his free imaginative and poetic responses. Using small touches and scumbles of opaque colors, he integrated the technical approaches of Renoir, Pissarro, and Seurat. Actually made of many neutral mixtures as well as pure touches of color, the overall effect is one of high-key or bright, intense color.

POINTILLISM: COLOR AS AN ABSTRACT PROCESS

This student piece is an example of pointillist color spots. Pointillism created images and color harmonies through the optical mixing of spots or small strokes of paint. Sometimes they are gradations of reds, yellows, and blues with white, which optically mix when viewed from a distance, as seen in Georges Seurat's work. In other cases, they are mixed colors simply applied in a very broken buildup of small spots or touches of paint. The spots describe both the basic color of the subject as well as the color of the light source.

Here, fairly large, rough spots of paint in mixed colors create an almost abstract effect. Many postimpressionist painters, such as Camille Pissarro, paved the way for abstraction by synthesizing both observed illusions of color and space with a flat, shape-oriented and highly simplified composition.

Pointillism often marks the turning point in color away from observation of nature into abstract color interpretations of subjects. Pointillism produces a form of painting that utilizes the strictest concepts of optical mixing, little or no line, and tonalities that are highly polychromatic in nature. Pointillism styles range from very colorful and almost garish in their interpretations to very mute and subtle in their observations of nature. Some are more atmospheric and others seem very flat. Created by dots of color—usually in combinations of the primary colors of red, yellow, and blue with white (though mixed colors are also used)—pointillist paintings can create a strong sense of atmosphere and complexity of color.

Even so, pointillist painters differed from one another in their approach and sensibilities. French painters Georges Seurat, Paul Signac, and Camille Pissarro, for example, exhibit many personal differences in their use of pointillism. Seurat's color effect tends to be bright overall, while Pissarro's color is softer and exhibits more depth. Signac creates arrangements that are flat and almost abstract.

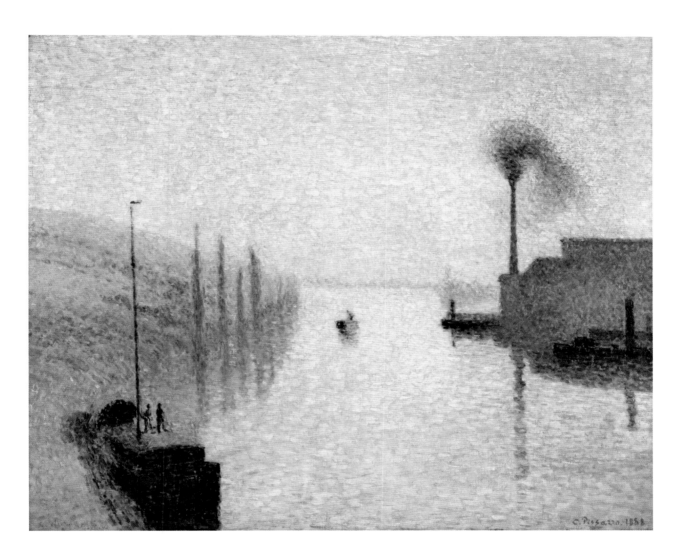

Camille Pissarro, *L'Ile Lacroix, Rouen (The Effect of Fog)*, 1888, oil on canvas, 18⅜ x 22 inches (46.6 x 55.8 cm). Philadelphia Museum of Art: John G. Johnson Collection, 1917. Photo: Graydon Wood

Pissarro was an important influence in the development and legacy of impressionism. *The Effect of Fog* reflects the analytical concerns of late impressionism and pointillism. When viewed from a distance, small spots of color coalesce and optically mix to form the illusion of solid forms seen through heavy atmosphere.

EXPRESSIONISM

As painting was increasingly identified with personal interpretation and freedom of expression by the end of the nineteenth century, color became a subject in its own right in painting. Expressionist color can range from very high chroma and almost flat constructions to very tonal and neutral color designs. Expressionist palettes most often are traditional in nature, featuring earth colors alongside prismatic ones.

An example of expressionist colorists and part of the group called the fauves (the "wild beasts"), painters Henri Matisse, André Derain, and Maurice de Vlaminck usually retained a subject such as a still life or a portrait as the vehicle for their exploration of color. This was a common practice of French painters.

German expressionist painters differed from their French counterparts through a focus on emotional expression and content rather than just on color expression. The Germans incorporated social commentary and satire through emotionally expressive, bold brushwork and dramatic shapes and tones. Expressionism, like the other movements of the time, mixed and matched elements. For example, an expressionist painting might incorporate fauvist bright color into a portrait observed from life. Other expressionists might work entirely from imagination and memory. Expressionist color could be bright or dull, and the corresponding brushwork and design could be poetic or harsh. The unifying elements are a sense of personal expression in color, content, design, and brushwork.

OPPOSITE: **Pablo Picasso**, *Man with a Guitar*, 1912, oil on canvas, 51 13/16 x 35 1/16 inches (131.5 x 89 cm). Philadelphia Museum of Art: The Louise and Walter Arensberg Collection, 1950. © 2010 Estate of Pablo Picasso / Artists Rights Society (ARS), New York

Cubism developed both as an exploration of interactive color as well as an investigation of geometric shapes, forms, and planes. The limited palette used here gives emphasis to the cubes, triangles, and linear qualities close to the picture plane of the painting.

Abstraction of color takes many forms: hard edged, semiabstract, and open form, for example. If Édouard Manet is considered the father of modern art, Paul Cézanne is considered the father of abstraction.

Many painters at the end of the nineteenth century were turning to color, or the other formal principles of painting, as the main subject of their work and leaving behind traditional observational subjects and their concern with illusions of depth.

Abstract color interactions, not surprisingly, followed the ancient impulses in Western painting: closed- versus open-form issues as well as bright color versus limited, neutral color. Closed-form colorists, such as Piet Mondrian, maintained hard, clean edges in their work, not unlike the impulses that drove earlier closed-form draftsmen. Painterly, open-form abstractionists, such as Franz Marc, softened and blurred edges and layers according to the feel and atmospheric poetry of the work as it progressed.

Others, such as Wassily Kandinsky, mixed the two concepts in an effort to relate sound and color. Still others limited their palettes or expanded them in monochrome or polychrome fashion. Some were layered, while others were only one skin of color. The "personal journey" of the modern artist took color into ever more abstract and complex forms. A unifying factor is the desire to simplify and get to something essential about the elements that interested the individual artist.

Jan Baltzell, *08-19*, oil on mylar, 26 x 40 inches (66 x 101.6 cm). Courtesy of the artist and Schmidt-Dean Gallery

An important member of the school of "Philadelphia color," which descends from Arthur Carles, Baltzel's color is both completely responsive and carefully planned. Intensely chromatic hues are held in check by rich earth colors and touches of brush drawing.

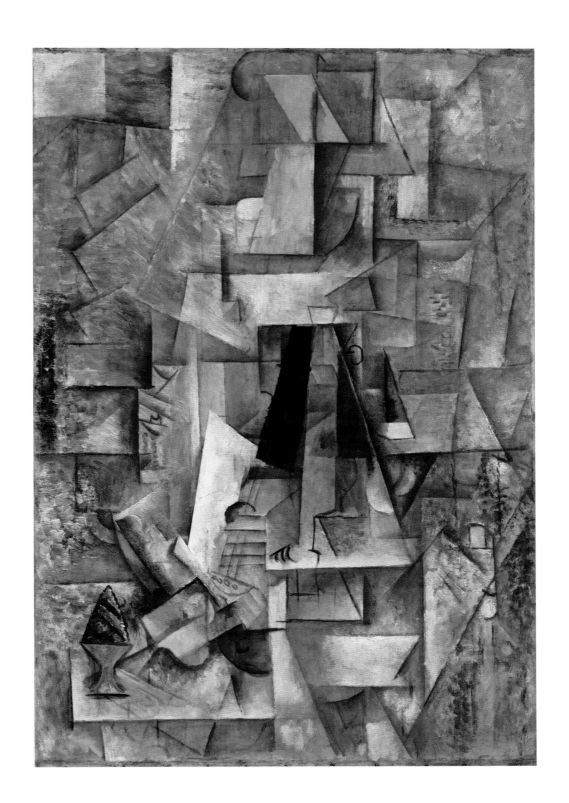

RIGHT: **Emily Mason**, *Tidings*, 2008, oil on canvas, 62 x 52 inches (157.4 x 132 cm). Courtesy of David Findlay Jr Fine Art, New York

Mason is an important American colorist in the tradition of the color expressionists of the 1950s and such painters as Hans Hofmann. More lyrical and subtle in her paint marks and compositions than Hofmann, Mason's compositions are organic and subtly balanced. Her color recalls the pure beauty of cathedral stained-glass windows and lacks the harshness of many of her expressionist abstract contemporaries.

OPPOSITE: **Mark Rothko**, *Orange, Red and Yellow*, 1961, oil on canvas, 93 x 81 inches (236.2 x 205.7 cm). Philadelphia Museum of Art: Private collection. © 2010 Kate Rothko Prizel & Christopher Rothko / Artists Rights Society (ARS), New York

Color-field painting and abstract expressionism in the mid-twentieth century brought to a high development and purity the abstract color explorations of the early moderns. Just as in the work of Josef Albers, color interaction is a main concern for Rothko's *Orange, Red and Yellow*, except that the large scale of the painting and the intense fields of pure color have a powerful psychological effect on the viewer; afterimages of complementary color in the retina are an important component of the experience of Rothko's paintings.

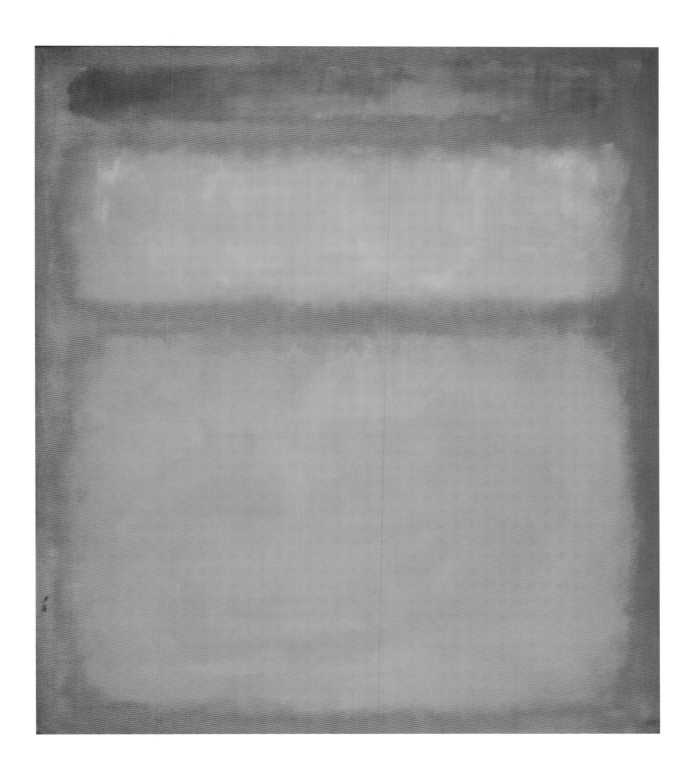

MODERN COLOR AS
PSYCHOLOGICAL EXPRESSION

Color can be seen as a language through the ages. Whether symbolic in medieval painting or observational in the plein air tradition, color is used to make statements in much the same way as we do with words. The use of color to describe psychological, social, and moral concepts is very ancient in most cultures, especially the West.

Modern painters attempted to separate colors from the older social and religious languages seen in much of European painting from the Romans to the Renaissance,

and use them to describe the experiences and emotional states of modern human beings. Pablo Picasso's Blue Period and Edvard Munch's use of red, yellow, and black are both examples of the modern modifications of an ancient language. Like the abstraction of color, color "moods" became a topic in their own right and entered the language of modern painting.

From the late-nineteenth century on, color has been examined as a vehicle for psychological expression and analysis. Partly through the work of psychoanalysts Sigmund Freud and Carl Jung, as well as through the efforts of many poets and Symbolist painters, color developed a very clear psychological language in the modern world.

The assertions that colors had feeling associated with them in an intrinsic emotional manner, devoid of earlier theological or societal constraints, became a tool for painters. For example, blue was associated with coolness and calm. It also could be associated with sadness and depression. Yellow was associated with warmth and life, or a "sunny" mood. Acid yellows, on the other hand, were described as evoking feelings of jealousy or toxicity. Scarlet, previously the color of faith and wealth, became one of the vehicles for descriptions of passion, rage, and lifeblood.

Color became not only a tool for painters but also part of a common spoken vernacular language of everyday life in describing one's feelings. Interpretation of color in dreams has become one of the tools used by psychologists. Painting one's dreams, in turn, has entered the toolbox of approaches for painters in the modern era. As in the other aesthetic approaches discussed here, psychological elements of color often coexisted in the same painting side by side with other artistic elements and styles.

Color takes on a spiritual quality in Dessner's paintings. A sense of deep atmosphere is at the same time right up on the picture plane. Recalling Mark Rothko's deeply moving color statements, Dessner's color creates a sense that something more and unseen is present just beyond the haze of his richly scumbled colors.

An important American colorist, Osborne integrates abstraction and observation much in the same way as Richard Diebenkorn. The difference is in her choice of more organic shapes and forms, as opposed to Diebenkorn's hard geometry; however, both artists use a broad range of shapes and constructions. *Delos* contains a rhythmic compositional movement as well as rich colors that can be seen as spatial as well as flat. The tension between depth and the flat surface of the canvas, or picture plane, has been an important concern in abstract and semiabstract paintings.

Painting from Photographs

One of the great aesthetic arguments of the modern era has been between those who accept using photography as a resource, or even a guide, in painting and those who stand steadfastly against this.

As soon as photography was invented in 1825, painters began to use this novel invention in the service of painting. Painters thought of photographs much in the same way as they thought of sketches or drawings of a subject—as largely an *aide-mémoire*. Important painters like Jean-Auguste-Dominique Ingres, Thomas Eakins, Edgar Degas, and Paul Cézanne referred to photographs for information on composition, shapes, and anatomy.

Color photography, not invented until 1861, would eventually become just another tool for the painter like the camera obscura had been for Renaissance painters. The idea was not to paint directly from the photograph but to use it as a notation or a guide. The photograph provided factual information about a scene or a structure, which could then be interpreted by the painter.

Painters who work too closely from black-and-white photographs often incorporate the optical effects provided by the camera, chiefly the monocular, or flat, feeling of the photograph. Copying the photograph too closely results in a loss of the sense of form that results from observing nature and utilizing traditional methods of drawing and painting to create illusions of color, form, and depth. Many students who faithfully "copy" a photograph are shocked to find that the resulting drawing or painting is, again, flat and lifeless.

The same is true when a color photograph is used too closely. Depending on how the subject of the photograph is lit, color in a photo tends to be monochrome or tonal or flat. All this can help the painter organize masses of color or tone; however, the color photograph doesn't fully describe the color variants in the subject as filtered through the human eye and the responsiveness of the painter to the subject. The illusions of life learned from observational drawing and painting must be added to the work lest it appear too like a photograph—in other words, too flat and monotonous.

Photography can be an excellent aid or a hindrance to painters, depending on how it is used. A deciding factor in this discussion is the set of goals in the individual painter's work. For a painter focusing on interpretive observation, photographs might not only be unnecessary but a considerable obstacle. For the painter who strives to integrate many elements, such as in a large-scale multi-figure painting, photo reference might be of great help.

Some aesthetics, like those used by photo-realist painters in the 1960s, absolutely require photo reference, both in color and otherwise. The decision to use or not use photography as an aid in painting must result from a serious examination of painters' goals, tools, and skills in the making of their art.

Vincent Desiderio, *Cockaigne*, 1993–2003, oil on canvas, 111⅞ x 153⅜ inches (284.1 x 389.5 cm). Courtesy of Marlborough Gallery, New York

In addition to the intensity and complexity of this painting, color is lovingly represented throughout the hundreds of postcards of paintings collected by the artist. The overall cool tone of the color in the composition organizes the many varieties of color in the small images.

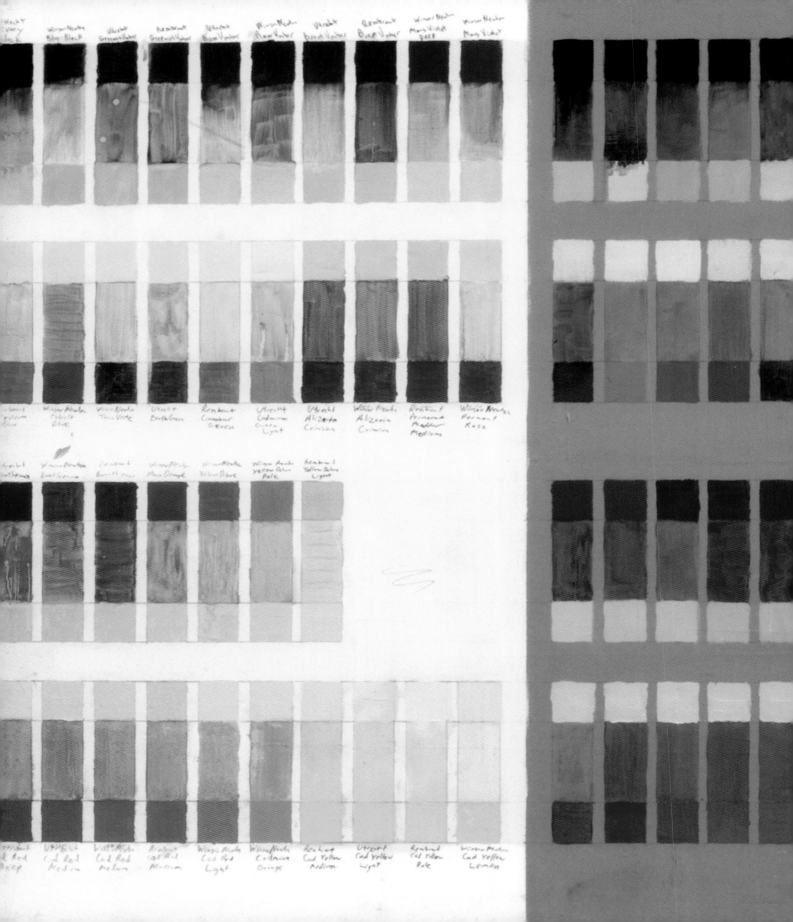

Color Exercises: Identifying & Understanding Color

This section deals with color exercises designed to build awareness of essential concepts of color identity, temperature, and tonal gradations. All are very practical and have a long history in the mechanics of understanding color in painting. Consideration of color wheels, the spatial illusions of color (what creates depth versus what looks flat), neutrals, color and value, limited palettes, and color mixing will also all enrich the painter's experience of color.

This color chart shows original tube colors, transparent versions of each, and tints of each on three different grounds. Having a chart like this available as you work will facilitate color selection as you develop a painting.

COLOR IDENTITY TEST

In this student color chart, the student has shown the tube color in the top chips (or squares), the transparent version of each color directly below that, and a tint of each color below that.

The color identity test, or color tint test, reveals the most basic nature of tube colors through examination of their body color, transparency, and tint. These explorations, combined with the neutrals exercise and the shades and values exercise, provide the basis for understanding the practical uses of color in painting and its relationship to drawing, form, and structure.

You can use canvas, canvas board, or other gessoed surfaces for these tests. The surface can be white, but trying the test mixtures on toned surfaces, or on a variety of ground colors, is very instructive. In addition to the basic color identity/tint exercise, try another in which you make more than one value of each tint. This variety of values shows how a color changes from a light tint to a darker one. Many students combine several exercises on the same surface.

Have one surface for mixing and another for laying out the results of the color test. You can start with a limited number of colors or put out all the colors you own. Decide on the arrangement before actually laying down the paints on the surface. You can organize colors by hue groups (all the reds, all the yellows, and so on), or you can lay them out according to earth-color or prismatic-color groups. The arrangement should make sense and be consistent.

Once you decide on your colors and arrangement, place a swatch or sample of each tube color on the test surface in the order you want them. This swatch ideally should be a thick "chip" of oil paint. Some students grid their swatches out carefully with masking tape, and others place the colors as a thick, loose brushstroke. Either is fine as long as the color sample is thick and clearly placed.

After all colors have been placed, drag out a bit of each swatch with a little linseed oil. This swatch is called a "transparency." Do this in turn for all the colors on your test surface. You should now have two rows of colors: one row of thick samples of tube color and one swatch of each that is transparent.

Next, mix a light tint from each color, making sure to clean your brush thoroughly between each mixture. These tints should be no darker than 2 or 3 on a value scale of 1 to 10—with 1 being the lightest, or pure white, and 10 being the darkest. To do this, have a lot of white (titanium white) available on your mixing surface. Put down each tint of color mixed with white as a thick chip of color. The result should now be three rows of colors laid out neatly next to one another: The first row shows the color from each tube. The second row shows the transparency of each color. The third row is a tint of each color.

Compare the qualities of each. You will see that the "identity" or "flavor" of each tint is quite different from the next in temperature, intensity, and hue (or family). Furthermore, the tints *force the color* in one another. For example, a tint of

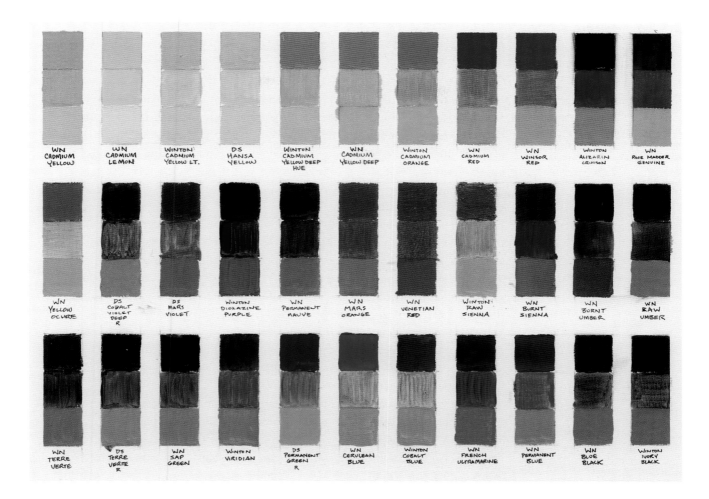

WN CADMIUM YELLOW	WN CADMIUM LEMON	WINTON CADMIUM YELLOW LT.	DS HANSA YELLOW	WINTON CADMIUM YELLOW DEEP HUE	WN CADMIUM YELLOW DEEP	WINTON CADMIUM ORANGE	WN CADMIUM RED	WN WINSOR RED	WINTON ALIZARIN CRIMSON	WN ROSE MADDER GENUINE
WN YELLOW OCHRE	DS COBALT VIOLET DEEP R	DS MARS VIOLET	WINTON DIOXAZINE PURPLE	WN PERMANENT MAUVE	WN MARS ORANGE	WN VENETIAN RED	WINTON RAW SIENNA	WN BURNT SIENNA	WN BURNT UMBER	WN RAW UMBER
WN TERRE VERTE	DS TERRE VERTE R	WN SAP GREEN	WINTON VIRIDIAN	DS PERMANENT GREEN R	WN CERULEAN BLUE	WINTON COBALT BLUE	WN FRENCH ULTRAMARINE	WN PERMANENT BLUE	WN BLUE BLACK	WINTON IVORY BLACK

burnt sienna, which looks like a yellow-pink beige, causes an Indian red tint to look lavender by comparison.

Each color in your paint box has a very specific quality, or flavor. This is important to recognize—just as learning the flavors of each herb and spice makes all the difference in cooking. Through seeing the tints of each color, you begin to understand the true nature of each tube color and how to make choices about when to use each one. The transparent version of each color shows that when a color is made transparent through the addition of oil or medium, the transparency is more hot in temperature or more vibrant in intensity. The colors right out of the tube can be deceptive. They may generally seem to have some kind of color quality, such as red or brown, but the pigment's true nature only comes out when seen in the transparent and the light tints. The light tint is the most crucial of all for beginning to understand the nature and use of your tube colors.

COLOR WHEELS

A color wheel is usually organized around a triad of colors that is most commonly red, yellow, and blue—in other words, the subtractive *primary colors*. Color wheels often also include the *secondary colors* of violet, orange, and green, which are made from the intermixing of the primaries (red + yellow = orange, blue + yellow = green, blue + red = violet). Additional gradations on a color wheel can include *tertiary colors* made from breakdowns of the secondary colors (red-orange, yellow-orange, blue-green, yellow-green, and so on).

Though theoretically all colors can be mixed from a red, a yellow, and a blue, for practical purposes, decisions have to be made as to which red, which yellow, and which blue. Artists are dependant on pigments rather than the pure theories of primaries. Each artists' pigment in a triad has a differing hue, value, chromatic intensity, and temperature depending on the tube paint used. These properties result in great variety of primary relationships and secondary and tertiary mixtures. For example, a triad of cadmium yellow pale, cadmium red light, and ultramarine blue will have very different results from one of lemon yellow, cadmium red medium, and cobalt blue. Another triad of yellow ochre, ivory black, and Venetian red will create the earth palette color wheel. Many historic palettes include a warm and cool version of each color to maximize mixing opportunities.

The number of color wheels, based on the great variety of colors on the market, is almost infinite. The primary colors of red, yellow, and blue can still theoretically mix many colors, but for the painter's purposes, this simple concept is limited in reality. Some artists suggest that cobalt blue, cadmium yellow light, and cadmium red medium are close to pure primaries. The difficulty is that recipes are variable among manufacturers of oil paints.

Color wheels can be larger or smaller depending of the number of colors included—for example, through the addition of a tint of each color or shades of each color. Note that some tube colors are so dark that it's useful to make tints of them first and then add them to the wheel. Their darkness makes it difficult to see their "flavor" very well, and they will darken other colors on your wheel when mixed with them.

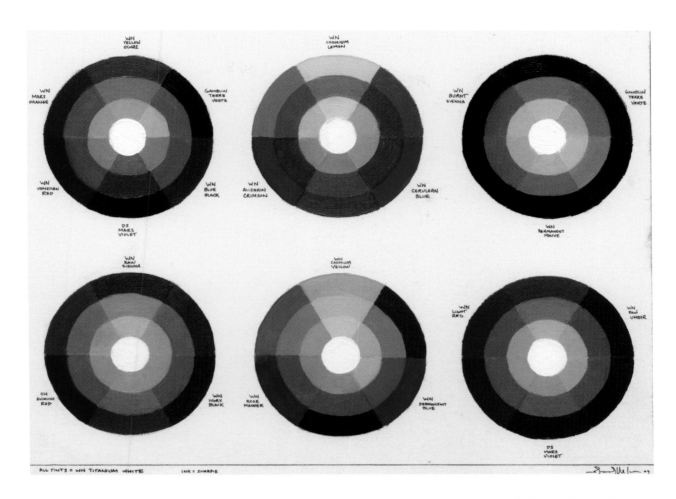

This student color wheel chart shows different triads. Color wheels can be made of as many colors as there are tube pigments. Which red, which yellow, which blue should be used? The reality for painters is that we are dependent on pigments, not just the theories of colors. Experimenting with many color wheels and many primary triads is important and closer to the truth for painters. Courtesy of David Wilson

Color Wheel Suggestions

Try several triads of prismatic colors, making tints of each color used or mixed to see their true hues and chromatic flavors.

Also, make shades of each one. For example, try triads of earth colors—say, yellow ochre (for yellow), earth red (for red), and black (which in this exercise acts as blue). Also make tints. Note that a cool earth black mixed with an earth red can create surprisingly beautiful purples and lavenders. You can also try mixed triads between earth and prismatic colors, such as ultramarine blue, burnt sienna, and raw umber. Extend your color wheel with the intermixing of secondary colors to create neutrals. The practical application of this exercise is an understanding of color intensities, temperatures, hues, and complements.

This color wheel in a nineteenth-century color manual, much as devised by Sir Isaac Newton, presents the primary, secondary, and tertiary mixtures. The colored dots in the center of the wheel point to the important primaries (red, yellow, and blue) and the secondaries (violet, orange, and green). The understanding and use of the color wheel today is much as it has been for the last several centuries. It is a practical thing and meant to help the student understand basic color mixtures and interactions.

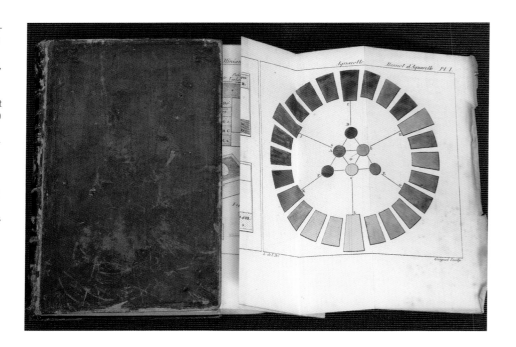

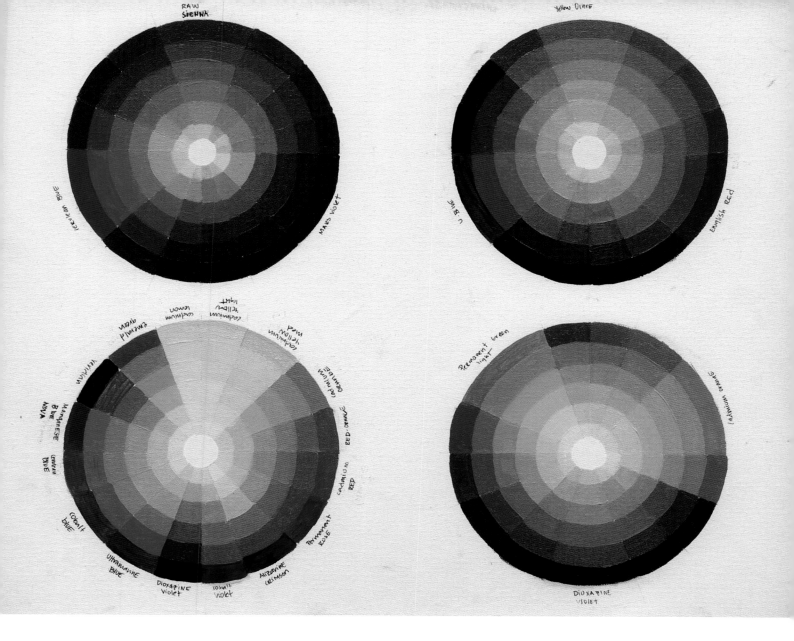

In making a color wheel as an exercise, there is no definitive orientation for the wheel. The more important point is to show and understand the flow of colors as they mix from one to the next. So for example, the tertiary colors (yellow-orange, yellow-green, red-orange, red-violet, blue-violet, and blue-green) are dependent on the placement of the other colors (the primaries and secondaries). Courtesy of Mercedes Bon-Cardona

MIXING NEUTRALS

This student mixing chart shows neutral gradations of various pairs of colors. Courtesy of David Wilson

Neutralizing a color means reducing its chroma (color saturation or brightness). Colors also have inherent properties of being neutral or bright relative to one another. One way to create a neutral is to mix one color with another that is already neutral by comparison to the first—for example, mixing burnt sienna (neutral) with cadmium red light (bright).

Or mix a color with its complement (the color that falls opposite it on the color wheel)—for example, red and green or orange and violet. The colors can be from either the prismatic or the earth palette or a combination of the two. As with the color tint test, have a mixing surface with the colors placed on it and a display surface for laying out the final mixtures, or chips, of paint. Make a tint of each color on your mixing surface (you will need a large amount of each). The mixtures should be a value of 2 to 3 on the value scale (as described for the color tint test). On your display surface, lay out a thick chip of one of the tints. Mix another chip with some of its opposite color tint added and place it in a row next to the previous chip. Keep doing this until the final color is almost purely the opposite of the color you started with.

What you should see on the display surface is a row of tints of equal value that go from a pure color through a range of tints that gradually become less saturated or more neutral. The original, pure tint will become duller (more neutral) with each addition.

At some point, the chips will be so balanced that the color is neither one nor the other. This chip is what we would classically call *mud*, a color that's over-mixed with its complement or is too neutral to have a color identity. (Note that adding excessive amounts of white to an already neutral or muddy color will only make it muddier or chalkier.) As you continue, the color picks up a quality of the opposite hue until it reaches a purity of that opposite color. The two pure tints should occupy opposite ends of the row. A minimum of eight to ten chips will be needed to see the effects of this exercise.

A classic version of this exercise would be done with tints of red and green, but this beautiful exercise can be done with an infinite variety of combinations. In addition to using complements, you can try neutralizing a bright or pure color by adding other "neutralizing agents," such as a gray, an umber, or a black. This can be done with tints of pure colors, as well as the pure versions themselves.

A great variety of neutrals can be observed through this exercise. And note that the tints of these resulting neutrals usually better show the true nature, or flavor, of the neutral mixtures. The practical application of this exercise in painting is being able to develop form through the use of a variety of brights and neutrals (or cools).

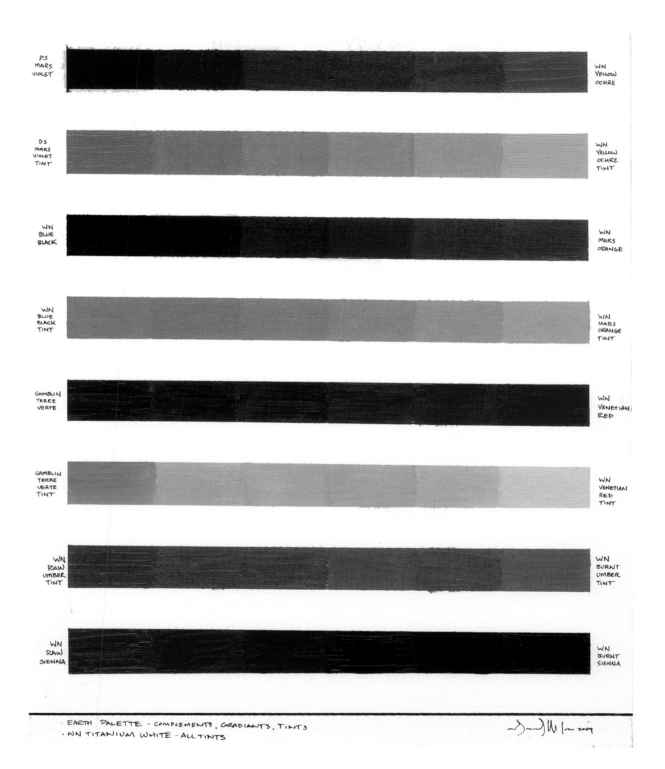

PS
MARS
VIOLET

WN
YELLOW
OCHRE

DS
MARS
VIOLET
TINT

WN
YELLOW
OCHRE
TINT

WN
BLUE
BLACK

WN
MARS
ORANGE

WN
BLUE
BLACK
TINT

WN
MARS
ORANGE
TINT

GAMBLIN
TERRE
VERTE

WN
VENETIAN
RED

GAMBLIN
TERRE
VERTE
TINT

WN
VENETIAN
RED
TINT

WN
RAW
UMBER
TINT

WN
BURNT
UMBER
TINT

WN
RAW
SIENNA

WN
BURNT
SIENNA

· EARTH PALETTE - COMPLEMENTS, GRADIANTS, TINTS
· WN TITANIUM WHITE - ALL TINTS

MIXING TINTS AND SHADES

Colors can be made lighter or darker in a variety of ways to get a number of tints (light mixtures) and shades (darker mixtures). One way to lighten a color is to add white. A paradox is that while white can lighten a color, after a point, it also reduces the chromatic intensity of a color. White can make already neutral or muddy colors "chalky." Another way to lighten a color is to add a lighter color to it (for example, add Naples yellow to yellow ochre). To darken a color, add black or a darker color (for example, adding burnt umber or black to cadmium red).

In the abstract, colors can be lightened or darkened in very simple ways. In actual painting, the subject, its light source, and its relationship to other colors is crucial in the decisions concerning lightening or darkening color. For example, if you want to lighten a bright red like cadmium red used in painting an apple and the light on the subject is warm, it would be better to add orange or yellow first. This will cause the chromatic intensity, or saturation, to remain intact. The final highlight on the apple might actually be a pale yellow-pink rather than white, if the light source is a warm spotlight. Lightening with white can create a cool pink rather than the effect of warm light on a red surface.

If the light on the subject is cool, as from cool ambient daylight, adding white might be the right choice, since the gradual addition of white cools or neutralizes the saturation of the red. The actual final light highlight might be a cool lavender-blue, since the ambient light is cool, bluish daylight. As always, it's the relationships and understanding of the colors that count.

To better understand the formation of tints and shades, make a value-gradation scale from white to black. Ten to twelve chips should be sufficient. Then choose a color, and make a gradation chart from lightest to darkest following your steps for the white-to-black gradation. The color, as it comes out of the tube, needs to be placed next to its value marker on the white-to-black value scale. Add white in steps to the tube color to make tints until a step of pure white is achieved. Add black, umbers, or darker colors (such as a dark blue or red) in steps from the tube color to achieve shades until a step of pure black is achieved.

You'll notice that the original tube color falls in different places on the gradation chart. This is because the tube colors begin at a great variety of value gradations. For a pale yellow tube color, only one or two steps with white might be needed to achieve pure white. For a darker color, four or five steps might be needed to get to white. The same is true for the dark gradations.

And again, this exercise can be done using a great variety of hues to lighten or darken a tube color. The practical application of this exercise is an understanding of colors as values.

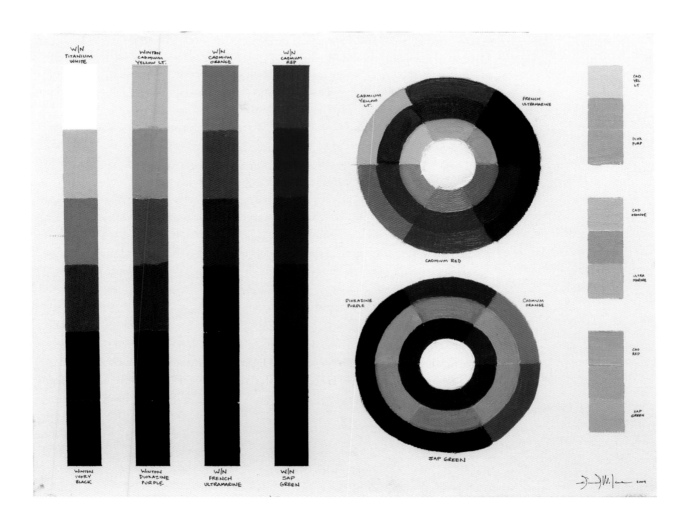

This student color chart shows color tone gradations matching a gray scale, color wheels, and neutrals made through the use of complements. Each "test" shows a different effect and range of tones and color saturations. Courtesy of David Wilson

COLOR CONTRAST

The consideration of color contrast can take several useful forms: contrast of hues, contrast of temperatures, contrast of complements, contrast of values, contrast of opaque to translucent to transparent, and contrast of edges. The consideration of these color contrasts can be seen as an abstract or academic exercise but is most useful for the development of painting skill and one's aesthetic choices.

A still life may need to consider contrast in all of the areas listed above, while a completely flat color abstraction might only be concerned with one or two from the list. The more varied the painting, the greater the number of color contrast elements needed.

The practical application of the exercises described here is a maximizing or minimizing of chromatic intensity or relationships of colors by placing them next to one another. For example, a lackluster portrait with a range of colors that seem okay will benefit from the placement of a few discreet touches of colors of greater contrast in the light and shadow areas. The result is much more alive and vibrant.

Try a series of small paintings in which (1) the hues (reds, yellows, blues) are intensified and played off one another strongly, (2) the temperature changes between light and dark are dramatized, (3) the painting is composed of strong complementary colors, (4) the values of colors are dramatized, (5) the three densities of opaque, translucent, and transparent are played off one another, and (6) the edges of the brushstrokes are strongly stated to create depth (sharper, clearer edges advance; softer, fuzzier edges recede). An easy subject is a small still life setup of one or two objects, like a pear and an apple. Use the same subject for each of the variations, and then compare and analyze the results.

This exercise shows blocks of primary, secondary, complementary, and neutral color interactions.

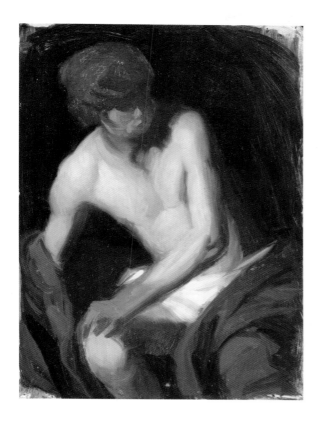

COPYING COLOR

An important method of learning color, or any other element of painting, is to do a copy of a masterwork. Copies fall into two categories: a sketch copy and an exact copy. The sketch copy simulates the surface effect of a painting by matching its general colors, tones, and forms. This can be done in a loose, alla prima manner with a simple, classic palette. The color sketch copy is one skin of paint and matches the color intensities, temperature, shapes, composition, and tonal gradations of the original.

An exact copy follows the complete process that the original painter might have used in painting the masterwork. Research must be done on the materials, palette, underpainting, and so on. The intent is to experience the original process of layering and to emulate all aspects of the original, from its underpainting to its exact surface features, whether it is a direct painting or a layered painting. In both cases, the copy can be smaller than the original or be a fragment of the masterwork. Sketch copies can be done from photo reproductions, but to do an exact copy, some time must be spent with the original in a museum for the purposes of understanding the methods used. Overall, the copying process is very beneficial to one's experience and knowledge.

A comparison of a sketch copy (of Caravaggio's *St. John the Baptist*) and an exact copy (of Velázquez's *Lady in Black*), both by Arthur DeCosta, shows the distinct difference between the two, with the exact copy yielding a result that is more "finished" in appearance. The sketch copy is looser and more generalized than its original.

COLOR AND DISABILITY

My own struggles in school led me to believe that I would never understand color or be a colorist in my painting. The fact of the matter was that I simply hadn't learned the concepts yet or had enough guided instruction or practice. But color in painting eventually became one of my greatest pleasures. Many artists experience visual difficulties that go beyond simply struggling with the craft and creativity of painting. The majority of students and painters I know have described struggling with color and being often frustrated and bewildered by it. But this is very different from having actual visual losses and/or diagnosable difficulties in seeing color.

Color blindness of various types is not uncommon among art students. Many times, students are afraid to bring up the subject with a teacher or feel that it is their personal problem to be dealt with alone. Some students have never been diagnosed, and the difficulty becomes apparent in beginning painting classes. Difficulties and frustrations with color can even lead a person who loves painting to give it up unnecessarily.

Often, when diagnosed, the complex nature of the individual difficulty is not clarified enough. For artists, a clear and accurate visual and verbal analysis of the individual problem is needed.

As we age, our eyes can present challenges to seeing color and detail. Cataracts, "floaters," eye pressure, infections, exposure to toxic fumes and sprayable art materials, and the like can all gradually affect what we see and how we see it. Still other artists may have impairment or complete blindness in one eye and not the other.

This has been a special interest of mine, and I've recorded many cases over the years. Based on working with many students who have visual impairments in over thirty years of teaching painting, I've made a few observations and formulated "work-arounds" and suggestions. What follows is based on those experiences.

When art students are diagnosed with color blindness as children or teenagers in elementary or high school, they may feel that they cannot work with or understand color. Many of these early diagnoses are a kind of blanket statement, and they don't account for the many forms color blindness may take in a visually sensitive young person. It's important to have a more precise description from the afflicted of what actually can and can't be seen.

One student told me that he couldn't see reds. He said he could tell a color was red but could not distinguish the subtleties of the hue, value, or chroma of the red. We discovered in class, after some trial and error, that he could distinguish the reds from one another if they were touching one another or in close proximity. We worked out a way for him to compare reds while painting so that he could match the correct red in the subject by having other red samples available to hold up and compare.

Artists with Visual Impairments

Sometimes, artists' visual difficulties lead them to create a whole body of work based on the evolution of their ability to see—or not see—color. A famous example is the late work of Claude Monet (page 156). Diagnosed with cataracts, Monet continued to paint without treatment. His color seemed to brighten in some hue groups and become duller in others. The overall effect of his late paintings is almost closer to abstract expressionism than to impressionism. The impressive fact is that he did continue to paint in spite of his growing disability. Many other well-known artists suffered from often catastrophic visual problems. For example, Mary Cassatt, who was diabetic, had cataracts and ultimately went blind. Edgar Degas lost central vision in one eye in his thirties and in the other later in life.

Of course, this wasn't foolproof, but the student's ability to describe reds improved along with his confidence.

Another student could see a full range of colors, but the neutrals dropped out and could not be accurately distinguished. We came to this conclusion after trial and error by verbally describing colors and their bright-to-neutral variations. To help the student, who could see that the colors were dulled but could not accurately describe them, we employed some of the ideas from the neutrals mixing exercise described on page 148. The student was able to make appropriate neutrals from the bright colors by using concepts of how to "dull" a color and could still have it be closely related to the original bright color. The student had to become more aware of the mixing process and focus on the relationships of color.

One adult student of mine was so color impaired that he couldn't "see" high-chroma colors of any kind. To him, colors looked soft and muted, more like earth colors. Yet, he could see tonality very well. We worked out a way of painting for him that was essentially very tonal and employed the earth palette as his main color list. Even though he could not see bright colors or describe them very well, his painting became a very beautiful example of rich, earth-based, tonal aesthetics.

Another student I knew produced very beautiful and subtle landscapes and still lifes. Seemingly, he had no difficulties with any of the formal elements of painting. After graduation, he revealed to me that he was blind in one eye and compensated by using the rules of drawing and painting to create a full range of atmospheric and perspective effects. Rather than do a kind of painting that reflected his "monocular" vision (such as abstraction), he was determined to compensate by becoming an expert in the optical rules of painting.

While most of the color-impaired students with whom I've worked have been male, some have been female. One young woman had great difficulty in distinguishing blues from one another. Changes in temperature were also difficult to assess. Her color ability in other hue areas was accurate. Like the student previously mentioned who had difficulties with red, we worked out a system of comparisons and verbal descriptions that worked well for her in most situations. Even glasses can be a problem for painters; bifocals and trifocals can be difficult to work with in the complex world of visual analysis and color.

In general, it's very important to get regular eye exams and wear appropriate glasses if needed. Take proper precautions when using art materials that could affect the eyes. And *do not be afraid* to discuss visual difficulties with a trusted art instructor.

Claude Monet, *Water Lilies*, c. 1914–1917, oil on canvas, 65⅜ x 56 inches (166.1 x 142.2 cm). Fine Arts Museums of San Francisco, Museum purchase, Mildred Anna Williams Collection, 1973.3

After 1914, Monet increasingly experienced reduced vision from cataracts. Some works show a departure from the earlier precision of his brush-strokes and drawing. As his difficulties progressed, colors became distorted and unclear or muddy.

In this late Monet, done between 1914 and 1917, the color has become less complex and the drawing more general-ized than in earlier works. Within a few years, many late Monet paintings appeared muddy and virtually abstract. Surgery late in life did, however, restore some of the artist's lost abilities.

THE EVOLUTION OF TEACHING COLOR

Color has been taught in a variety of ways in the last 150 years. Inherited from older academies of art, which first appeared in Italy in the mid-sixteenth century, methods of teaching painting and drawing provided the foundation for art education in the modern era of the nineteenth century. Academic schools in Europe, such as the

École des Beaux-Arts in France and the Pennsylvania Academy of the Fine Arts (PAFA) in the United States, originally used very formalized, traditional methods to teach color, which they inherited from older academies and studio practices of painters. Those schools have since incorporated a complete range of modern concepts and methods to add to their pedagogical heritage.

Since most color training in painting began with understanding monochrome and tonal color, exercises designed to clarify those concepts were how students started their studies. Paintings in black in white, monochrome color studies, and tinting engravings with watercolors to understand tonality came first. Making copies of appropriate masterworks and, later, life studies of the model organized the experience of color. Students then expanded their color repertoire by studying with individual painter-instructors and learning their methods and aesthetics. In France, the classes of Jean-Léon Gérôme at the École des Beaux-Arts were extremely popular. His classroom exercises and personal aesthetics were very accessible and useful for students. He was one of the most popular instructors of his day.

In the United States, Thomas Eakins at PAFA had immense influence on

young painters. His strongly tonal and naturalistic approaches, learned largely in Europe from Gérôme and Spanish baroque paintings, presented a simple yet clear vision of color in painting.

With the growing influence of impressionism, by the turn of the century, school curricula incorporated impressionist concepts and goals into their teaching strategies, alongside older concepts. University art departments and art schools in America were often fertile ground for the exploration of new ideas in the realm of teaching art. New concepts were put forward by great artist-teachers like Arthur Wesley Dow at Columbia University in New York and Arthur Carles at PAFA in Philadelphia. These innovative instructors introduced modern ideas of color usage and design into the curricula of their schools. The more abstract concepts of color interaction put forth by Josef Albers at the Bauhaus School in Germany became a norm in American art training by the 1960s.

Teaching color since World War II in the United States has followed either highly structured design- and abstract-based structures or laissez-faire, experiential guidelines. Color instruction was presented as either a set of abstract exercises in two-dimensional design classes or a personal exploration heavily influenced by impressionist color ideas in painting classrooms.

Individual instructor-painters, such as Authur DeCosta at PAFA or Hilton Brown at the University of Delaware, have attempted to build a bridge between theory and practice in real and meaningful ways for their students. These instructors would connect the past with the present through demonstrations of not only theoretical ideas in color but also usable painting techniques and the history of those techniques.

A comprehensive program for the teaching of color can be constructed by a teacher. The concepts and demonstrations in this book and other texts concerning the history of color can be presented alongside practical exercises and demonstrations. Guided classroom assignments, master copies, life paintings, and so forth will bridge the gap for students between concept and practice. Teachers of color should not be either laissez-faire or fearful guides, afraid to interrupt the creativity of their students with too much information. Students of painting will use the ideas, make choices, and eventually grow into mature and knowledgeable painters following their own vision.

William Bouguereau, *The Bathers*, 1884, oil on canvas, 79 x 50¾ inches (200.7 x 128.9 cm). A. A. Munger Collection 1901.458. The Art Institute of Chicago. Photography © The Art Institute of Chicago

Highly regarded as a closed form academic master, Bouguereau is an influence today in the renaissance of academic realist painting. His working methods evolved from the "academie" and the "equisse," both painting study methods used at the École des Beaux-Arts in Paris: A closed-form drawing and brown underpainting were placed on a light-toned ground. Masses of local opaque color were scumbled into the underpainting, both in lights and darks. Surface blending, opaque development of lights, and transparent details finished the work, along with an occasional local glaze. Bouguereau's color tends to be tonal and monochrome but with lighter luminous opaque shadows than most of his tonal colleagues.

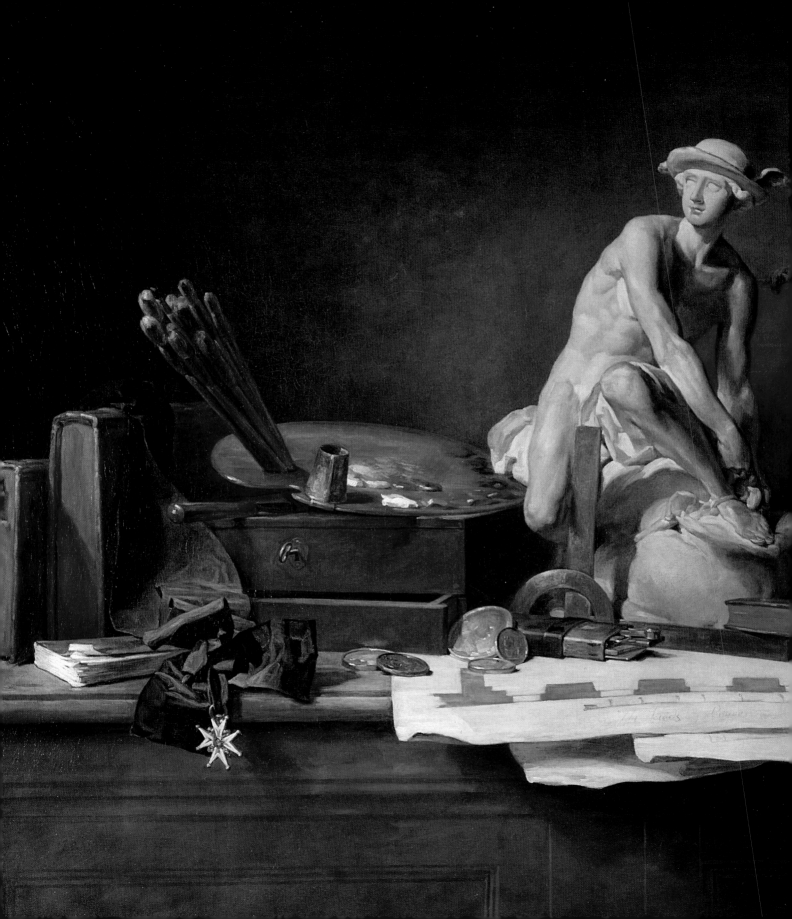

SIX

Painting Demonstrations: Major Methods & Practices

The student of color can learn a huge amount and gain more color confidence quickly by doing exercises that illustrate and clarify the various color concepts. The demonstrations in this chapter are meant to be simple exercises students or painters of any level can follow to increase their knowledge. They are not an exhaustive representation of all the many color concepts but rather are illustrations of core or basic ones. This is especially important also for art teachers, who can then introduce color concepts to their students with more confidence.

Jean-Baptiste-Siméon Chardin, *The Attributes of the Arts and the Rewards Which Are Accorded Them*, 1766, oil on canvas, 44½ x 57¼ inches (113 x 145.4 cm). Minneapolis Institute of Arts, Minneapolis, Minnesota, USA. The William Hood Dunwoody Fund. Photo: Erich Lessing / Art Resource, NY

Chardin is a prime example of the observational painter of the eighteenth century. His elegant still lifes and portraits provided guidance for modern observational painting and color. Tonal in nature, Chardin's colors grade through simple value scales and temperature changes. In this painting, bright touches of

reds, as well as light and dark touches, move the eye through the composition and organize the image.

161

NORTHERN RENAISSANCE (SIXTEENTH CENTURY)

Closed-form layered approaches are typical of Northern Renaissance painting well into the sixteenth century. A refined drawing is placed on a gesso panel (usually white), and a highly developed underpainting is completed before any color is added. The underpainting provides a complete image of the form and structure of the painting from the beginning.

Color is added in layers, first with a velatura to establish the light area and optical grays or neutrals in the shadows. In some cases, the velatura is tinted the desired color of the complexion, and in others, it is white, providing a grisaille effect to be glazed later. In either case, the translucent velatura creates the light mass of the skin and allows the tones of the underpainting to show through in the shadows. The shadows in this first layer often have a grayish or very neutral quality, created by the brown underpainting showing through the milky velatura. A glaze can later darken shadows.

In the case of a colored first layer, in-painting (the addition of opaque touches to enhance form and complexity) is done to further develop subtleties of the form in the face. The same is done in the clothing and background. In the grisaille form, in-painting is also done to further develop smaller forms in the grisaille with white and grays, and then when dry, a glaze is laid over the skin to tint the whole area. In both types, glazes are used to deepen shadows and tints or color areas in the light.

Linear details are added at the end with a pointed brush dipped in a dark color to reaffirm the drawing and clarify details. In some cases, highlights and other opaque details are also added as a last touch of refinement to the face or other details of the portrait. Color is achieved through the tinted velaturas and through rich single glazes added at the end to complete the tonality and color of the subject.

Giovanni Bellini, *Madonna of the Meadow*, c. 1500, oil and egg on synthetic panel, transferred from wood, 26½ x 34 inches (67.3 x 86.4 cm). National Gallery, London, Great Britain. © National Gallery, London / Art Resource, NY

A masterpiece of early sixteenth-century Italian painting, *Madonna of the Meadow* uses a highly developed closed-form underpainting in earth colors as a base for the final glazes in the Madonna's clothing and the sky behind her. True to layered painting of the period, flesh tones are built using a velatura over the underpainting. Surface details and highlights are added at the end.

Demonstration

Each layer in this whole process must be dry before the next layer can be developed. Some examples from the Northern Renaissance period use a "hatched" oil drawing (a fine, closed-form line drawing done in oil over a chalk drawing in which the form and shading is developed with small lines, or "hatch" marks, conforming to the contours and direction of the light). Some very early works have ink or egg tempera underpaintings done in the same manner with oil paint layers on top to complete the painting. The mediums for the underpainting were light and thin, being only linseed oil and a touch of paint thinner. Sometimes varnishes were added for quicker drying.

In my copy of Hans Memling's *Portrait of a Man* from 1470 (in the Frick Collection), the underpainting is established first as a fine, closed-form drawing in chalk. The drawing is then "fixed" by a complete brush drawing in umber oil paint over the original drawing. Shadows, also rendered in umber oil paint, are delicately brushed into the oil drawing to add form. The light mass is brushed in with white. This provides the interactive layer for the velatura and glaze to follow. The background landscape is developed in the same manner. The sky is almost pure white. The final effect of this stage is a fine, light-and-dark grisaille in white and umber.

A velatura (a thin, translucent layer) made with white and tinted with burnt sienna is brushed over the whole face. Where the tinted velatura falls over the white, light underpainting area, the skin assumes the proper complexion tint and value. Where it falls over shadows and darks, optical neutrals and grays are created. The velatura mixture is thinned a bit with linseed oil and paint thinner—just enough to create translucency but not enough to make the paint runny.

The background landscape is developed, and a glaze of pure ultramarine blue is placed over the sky. Transparent sap green and transparent yellow are brushed over the land. Opaque touches of color with white and burnt sienna are used to modulate facial structure, and opaque mixtures of ultramarine blue and white flesh out the distance in the landscape and sky.

Details are added in the face and landscape. Fine linear accents, details, and highlights are added to face, hair, and land. The garment is glazed with burnt sienna and black, with darker details added in the same colors.

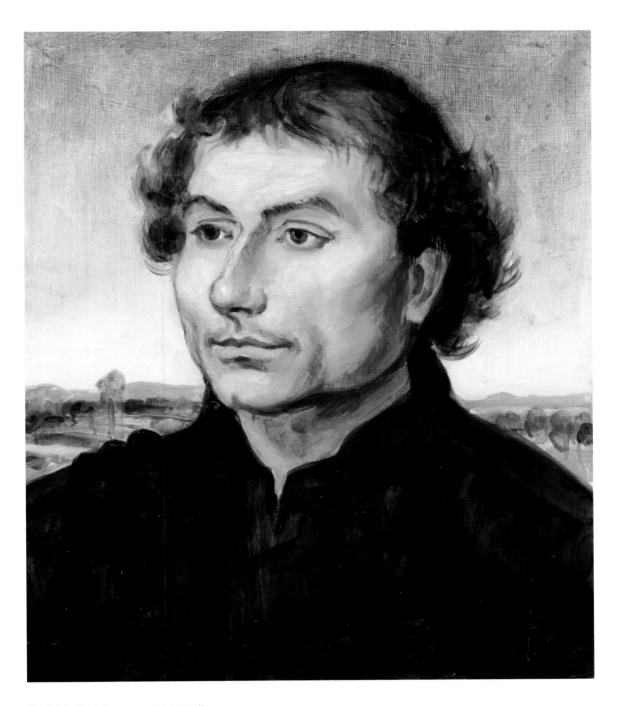

The finished painting presents an overall quality of refinement, subtlety, and closed-form effects. At the same time, the sense of atmosphere is very strong.

SEVENTEENTH-CENTURY TONAL PAINTING

This gentle painting exhibits Rembrandt's skill as both a tonal painter and a master of alla prima brushwork. The color gradates simply up and down a tonal scale from lighter and warmer to darker and duller, with bright touches enlivening the color in the face, hands, and reflected lights.

Usually starting with an open-form, atmospheric, loose, transparent-brown placement drawing, opaque color is laid in to develop the forms. Often, some of the original transparent underpainting shows through in the shadows. And Rembrandt occasionally finished a formal work with local glazes over a background, a piece of clothing, or a shadow.

RIGHT: **Christina Weaver**, *Portrait of Pieter van den Broecke (after Frans Hals)*, oil on board, 20 x 16 inches (50.8 x 40.6 cm). Courtesy of the artist

In copying Hals's painting, Weaver examined the relationships of light and shade and of color gradations in that context. Hals was known for his rich tonalities, and his color grades from light to dark, brighter to duller (grays and browns). Hals often used greenish-gray touches in the shadows to provide some color contrast.

Open-form methods used by baroque painters became very common in the seventeenth century alongside the more closed-form types used by classicists. The closed-form methods illustrated in the previous demonstration continued to be used, although they evolved to exhibit softer and more atmospheric qualities, as in the work of classicist painters like Nicolas Poussin.

Open-form, tonal, and atmospheric painters, such as Frans Hals and Rembrandt, used direct, alla prima brushwork to mass in their forms. Their underpaintings were often little more than broad brushstrokes to describe the basic shapes and movements of forms. Of course, some painters drew more at the beginning, while others were more casual.

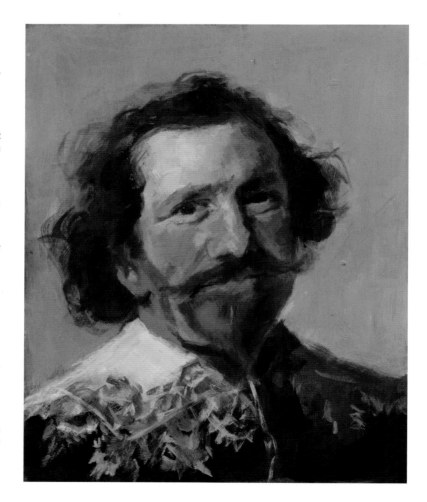

Demonstration

Unlike the refined underpaintings of the early Northern and Italian Renaissance painters (who set the complete drawing at the beginning), baroque tonal, open-form painters allowed the forms to evolve to a finish in the top layer. The focus was on atmosphere, tonality, and strength of form and character in the painting.

The refinement of forms through smaller brushstrokes and the details were established gradually, with the lightest lights, darkest darks, and details added at the end. Much of the color in these paintings is opaque and applied directly to the painting, though hints of transparent shadow masses sometimes show through. This is often true in the work of Rubens, for example. The use of a finishing single glaze to add brilliance to a fabric or landscape or to deepen shadows was not uncommon.

Arthur DeCosta copied an anonymous seventeenth-century portrait for this color demonstration executed in the tonal style of that time. Working in oil on gessoed water-color paper, he began with an underdrawing in red chalk on a pinkish-beige middle-toned ground. For accuracy, the drawing was traced from a reproduction and transferred to the canvas. A brown brush drawing was then placed over the chalk to fix and darken the placement drawing. This was typical of seventeenth-century practice.

The next stage shows the first blocking-in of thin, generalized color over the underpainting to mass the lights and darks. Opaque paint is used in the light mass and translucent scumbled color is placed in the shadows.

Dark touches of details are added in the eyes, nose, mouth, and hair. More definite planes of opaque color are added in the warm light and neutral shadow masses.

The finished portrait reveals added final details and adjustments of color in the background: The textures of the hair, eyes, and collar have been finished. The background has been cooled with raw umber and white, which causes the head to advance and the background to recede. The cool background also sets up a warm/cool temperature interaction with the head.

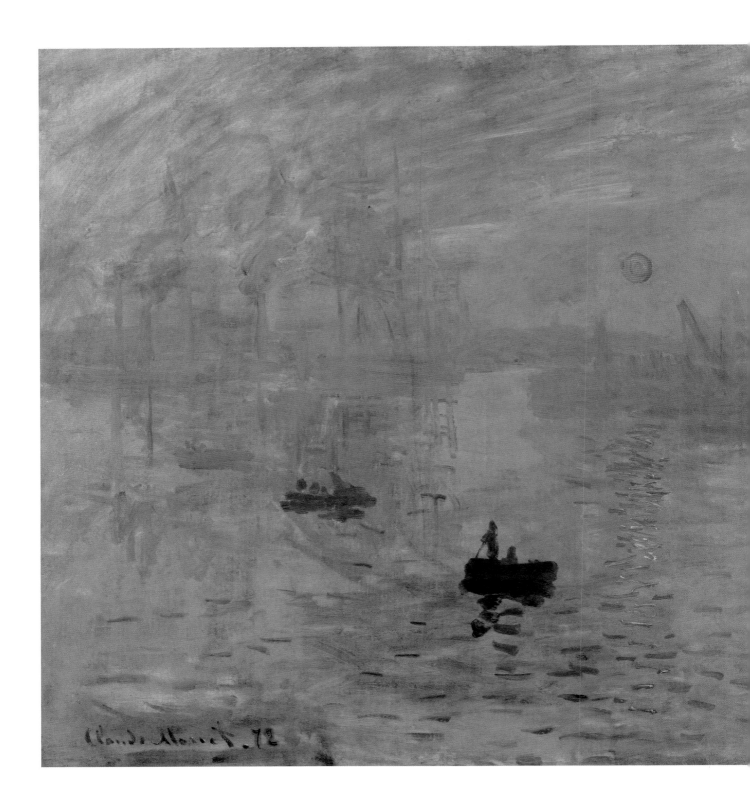

IMPRESSIONISM

Impressionism as an approach to painting can be one of the most varied and confusing of the modern color concepts. What we call *impressionism* embodies not only a number of color theories and layering approaches to paint but also a great variety of aesthetic choices.

In the strict sense, the ideas of Michel Eugène Chevreul and the work of Édouard Manet, Claude Monet, Pierre-Auguste Renoir, and others of the French impressionist group who exhibited together in 1874 usually are pointed to as defining impressionism and its approaches. The actual range of the concept includes plein air painters, outdoor as well as studio painters, and tonalists as well as colorists. Photographs were also used by many impressionist painters as reference.

Painters in many countries subscribed to the romance and freedom of impressionism. The Macchiaioli in Italy, northern light painters in Scandinavia, and tonalists in the United States were some of the many influenced by the movement. For some, optically mixed spots of color created atmospheric effects of light. An example of this is Monet's *Haystacks* series. For others, it was simply the alla prima brushwork and casual subject matter that were most appealing. Examples of this approach are seen in the Pennsylvania impressionists. Still others used traditional approaches, even in closed-form structures, but added cool, reflective effects of daylight, soft tones, and brushwork to their figures, such as American painter Daniel Ridgway Knight, who exhibited in Paris.

Influences in the evolution of impressionism are varied, including the sketches of English landscape painter John Constable, the alla prima studies of the École des Beaux-Arts curriculum, the paintings of such French painters as Camille Corot and

Claude Monet, *Impression, Sunrise*, 1872, oil on canvas, $18^{15}/_{16}$ x $24^{13}/_{16}$ inches (48 x 63 cm). Musée Marmottan-Claude Monet, Paris, France. Photo: Erich Lessing / Art Resource, NY

Whether or not the label *impressionist* derives from the title of this painting (as commonly thought), *Impression, Sunrise* is a work that defines both the aesthetic and technical approaches of impressionist painting. Large areas of thin washes of color create the basic organizing underlayer of color. Opaque touches of light and dark color and warm and cool color are scattered over the surface of the canvas to suggest forms, atmosphere, and depth. An overall sketchy quality is reminiscent of the preparatory studies of most painters of the period. Highly prized by the impressionist painters for its responsiveness, this "unfinished" quality drew the wrath of art critics.

As in *Impression, Sunrise*, suggestions of sparkling light, shade, and color changes in *La Grenouillère* are created through touches of transparent and opaque paint. More drawing and tonality are employed in this painting than in other impressionist works, which suggests that, though it might have been worked on out of doors, it was probably finished in the studio. Many impressionist paintings were works "of the studio," based on sketches or having been started en plein air and them brought into the studio.

Eugène Delacroix, and Barbizon landscape sketches. Other influences or characteristics affecting the development of impressionism were a preference for casual subjects, the inspiration and design conventions provided by Japanese prints, and photography and its use as a reference, among others.

To simplify, we could look at three basic characteristics of color and paint quality that are common in the great variety of impressionist approaches: (1) an emphasis on the color of the available light source and the color of the ambient atmosphere, (2) a paint quality that's "sketchy" or at least evocative of atmosphere, and (3) a layering process that incorporates reflected atmospheric colors and an overall sense of atmosphere enwrapping the subject.

The color of the light source is crucial. For example, direct sunlight or lamplight will generally be warm and rely on the cadmiums or warm earth colors for their temperature in the general light mass. Cool directional light, like that from north-facing windows or the light of an overcast day, will rely generally on earth colors, especially the cool ones, in describing the light masses. Highlights will generally be the color of the light source. The highlight on a red apple under a lamp will be a light, warm pinkish-yellow. The color of the same highlight under cool daylight will look bluish. Neither highlight will be merely white or just a lighter version of the apple's color.

Whether created by small, loose strokes of color or by solid masses of color and tone, reflections in the shadow mass will depend on the ambient light around the subject as well as on the other objects near the subject. If the ambient light is warm, the reflections will tend to be warm. If the ambient light is cool, they will tend to be cool.

Finally, a clear mass of light or shadow on the subject may not be present if the subject is in a general ambient surround of light that has no strong sense of direction. In this case, the overall tonality of the subject or a scene may appear to be evenly middle tone. There will still be lighter and darker areas, but the shapes and masses of the subject will seem more even, thus minimizing contrasts of tone in the subject. Contrasts may depend entirely on color and temperature changes. Where there is a strong sense of light and shade, these masses must be described first, with reflections and color modifications added later.

In summary, the approaches used by impressionist painters vary tremendously from more solid, traditional and tonal methods using masses of color and value to more optically complex processes involving dots and small strokes of color that optically mix on the canvas. In all, the color of the light and that of the ambient atmosphere is very important.

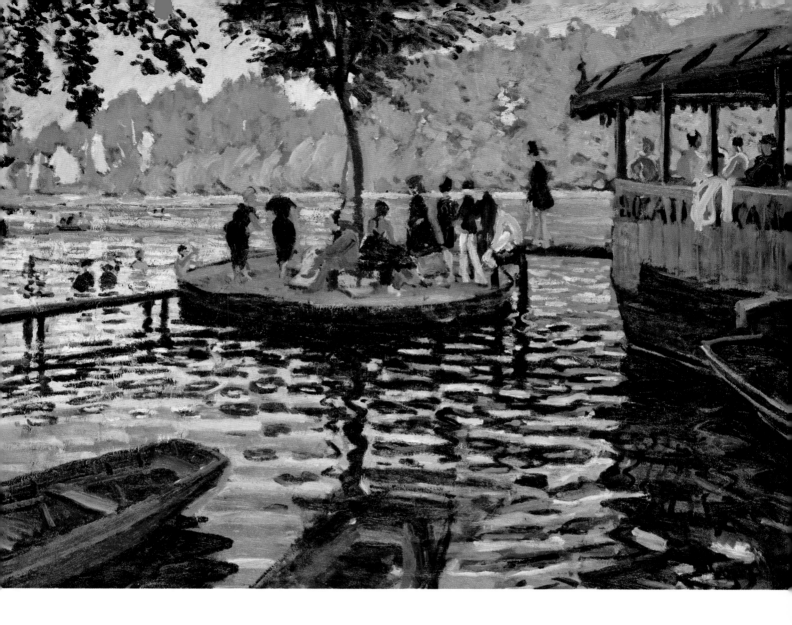

POINTILLISM

The subtle beauty of this small study derives from the very close touches of opaque paint and the thoughtful modulation of color changes. Layers of colored dots create settings for other color layers to come. The cool atmosphere color, described by the haze of gray-blue color dots, unifies the mass of the figure's body and connects her to the darker background.

The color theories of Michel Eugène Chevreul (1786–1889), and others who wrote about the optical mixing of colors and the contrast of colors, produced a second generation of impressionists, who explored color in increasingly formal and abstract manners. Georges Seurat, Paul Signac, and others in France created a pure form of color interaction and optical mixing in their painting called pointillism. Employing small, dense dots or short strokes of paint, these painters created a haze or mist of individual colors that optically mixed to show masses and forms when the viewer stepped back from the painting. This was not a new concept, optical mixing having been used by previous impressionists, but the pointillist painters formalized the approach conceptually and abstractly.

Other painters emerging at this time were also exploring the formal aspects of color, application of paint, and form development. Vincent van Gogh, Paul Gauguin, and Paul Cézanne were developing individual and highly conceptualized approaches to describing an image.

Pointillism had an enormous impact on painters in France, to the degree that most of the painters of the 1880s and 1890s went through a pointillist phase on their way to developing a mature style. Many pointillist painters used a limited palette of triads of red, yellow, and blue plus white. Dots or small strokes of these colors—either pure or mixed—would be constructed on the canvas to create masses of color (that were actually the optically mixed conglomerate of many small touches of color). For example, a purple area would be made by placing red and blue dots in close proximity. If the resulting purple needed to be modified or softened, dots of a yellow or a color mixed with white would be introduced. The color of the enwrapping atmosphere would be dotted throughout in varying amounts to unify the illusion of air and light in the painting.

Some painters who used pointillist methods, such as Pissarro, worked closely from nature and mixed colors from a purely prismatic palette. Other pointillists used a full classic palette that included earth colors and diverse mixtures. Still others, such as Signac, incorporated strong design and stylistic concerns. The very abstract and conceptual use of color seen in pointillism moved color one step closer to complete abstraction by the end of the nineteenth century.

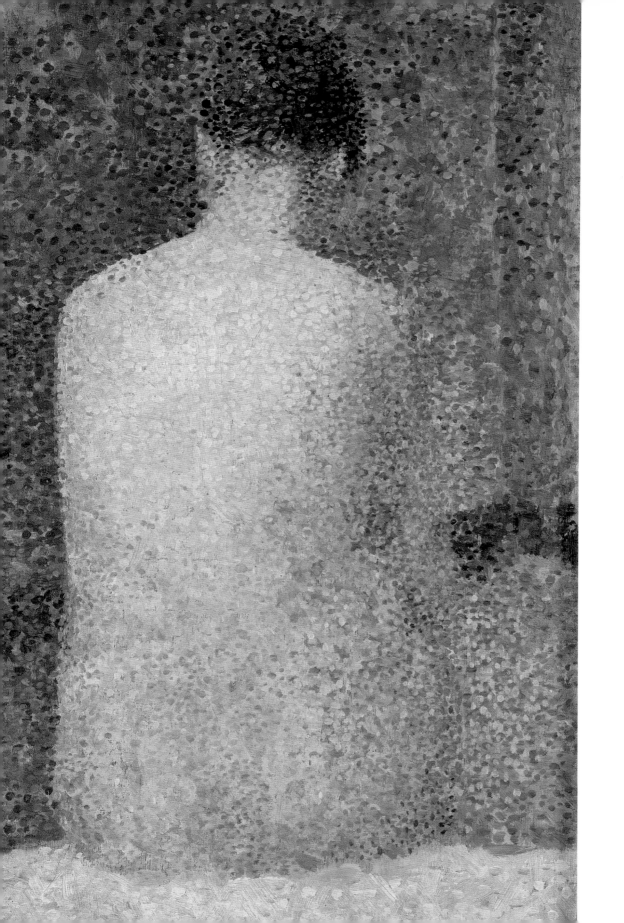

Demonstration

The image on page 175 is the source for this pointillism demonstration. No lines will be used, and the paint is entirely opaque. The ground is white. When copying a pointillist work, it's wise to choose a brush that will make marks that are the same size as those in the original. In this small sketch copy, I used a larger brush than Seurat's for the purpose of generalizing the color effect and simplifying the sketch-copy process. The larger the brush, the more generalized and rough the image. The smaller the brush, the more refined the result can be.

This first layer can begin either with a description of the positive shapes (the objects) or be a general haze of atmosphere created by dots over the whole canvas into which one can develop the subjects. There's nothing wrong with sketching out the objects and composition with drawing materials, as long as that doesn't interfere with the colored spots and diminish the integrity of the pointillist approach. Usually, there is no evidence of any solid lines in pointillist paintings.

Local color dots are placed to describe the generalities of color in each area. Note that the white ground still shows through, which supports the sense of atmosphere and color interaction. Spots mixed with ultramarine blue and white are used for the general placement of shape and background, spots of burnt sienna mixed with white describe the basic color of the figure, and spots of cobalt violet mixed with white are added into the shadow area.

Additional color dots are placed. These add variety to the color areas and help form the volume of the model. The warm spots create a strong optical description of the solid body being in the foreground while the darker, cooler background recedes.

The finished painting has the addition of dark touches in the model's hair, in the creases of her body, and in the darkest parts of her shadow. Touches of green made from a mixture of yellow ochre, ultramarine blue, and white in the background on the right further develop the sense of optically mixed neutrals and a cool, receding background. These move the model's tones and form away from us into the shadows. Touches of blue spots of atmosphere color are also placed in the figure. This links her to the atmosphere. These finishing color spots, made of dark blues and purples, create a sense of drawing and completion of the form. They are similar to the finishing accents of detail and edges that would be placed in any figurative painting that is concerned with form and atmosphere. The overall effect is colorful and has a completely open-form sensibility.

EXPRESSIONISM AND ABSTRACTION

Josef Albers, *Homage to the Square*, 1964, oil on Masonite, 18 x 18 inches (45.7 x 45.7 cm). The Josef and Anni Foundation, Bethany, CT, USA. © 2010 The Josef and Anni Albers Foundation / Artists Rights Society (ARS), New York. Photo: Albers Foundation / Art Resource, NY

Albers did hundreds of variations in his explorations of abstract color interaction, both in his paintings and in sets of lithographs. *Homage to the Square* is one of his most well-known series of works. Subtle color shifts between light and dark and warm and cool can be seen in this fine example.

For painters and students of painting, the years between 1900 and World War I can be both exciting and very confusing visually. A great variety of painting approaches and "-isms" proliferated. For our purposes, two stand out as immediately important: a type of French expressionism called fauvism and early abstraction.

The fauves ("wild beasts"), as named by critics of the time, attempted to simplify how they saw and described color. Still using recognizable and often mundane subjects (still lifes, portraits, and landscapes), these painters distilled the color they saw to pure interpretations of hues and intensities. The complex mixtures of halftones and neutrals of the academics were seen as inhibiting of the color experience. Impressionism and pointillism were also seen as too indirect. In an attempt to have an innocent eye, these painters would interpret the colors they saw in as pure a manner as possible.

For example, if the complexion of a model was ruddy, they might make it bright red. If a shadow was bluish, they might interpret it as pure blue or purple. If a reflection was greenish, a cadmium green might be used. Color complements were often used to create a strong chromatic effect in these paintings. This abstracting or simplifying of color created paintings of great vibrancy and strength of expression, while at the same time moving them one more step toward pure abstraction of color.

The complete abstraction of color as a primary focus for painters involved a number of factors. The subject (a still life, landscape, and so on) was left behind, and the focus of the painting was color in and of itself. Also, the structures of colors and their interactions, intellectual or perceptual, became paramount. Abstract color could now be contemplated and enjoyed for its own sake, rather than as a part of a larger construct of image, narrative, perspective, atmosphere, or tonality. The purity of the experience of color was much talked and written about.

Painters such as Wassily Kandinsky and Franz Marc pursued a path of purity and passion in the area of color. Many painters from the 1880s to the 1920s could be seen to evolve as they matured through stages in their work from academic painting through an impressionist phase, a pointillist phase, a fauvist period, and arriving at pure

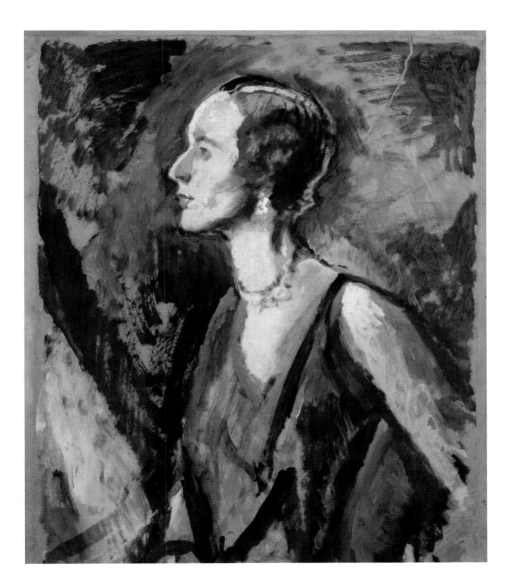

Adolphe Borie, *Portrait of a Woman*, c. 1920, 24 x 18 inches (60.9 x 45.7 cm). Courtesy of the Pennsylvania Academy of the Fine Arts, Philadelphia

Many painters exploring abstraction in the first quarter of the twentieth century put together elements of many aesthetics. For example, some used very bright color while others used limited or neutral palettes.

Some wove realistic drawing into otherwise abstract compositions. In these explorations or "journeys," there is as much diversity and variety as there was in impressionism. Borie is a good example of this. Here, he combines a somewhat realistic portrait with abstract shapes and brushwork and a neutral limited palette (black, red, blue, yellow, and white) on a middletone brown ground. The idea that modernist and expressionist paintings are all concerned with bright color and complete abstraction is a misunderstanding of the actual journey of these artists.

abstraction of color. An example would be the Dutch-born painter Piet Mondrian. His early and student work reflects his academic training and the influence of impressionism. His landscapes can be seen to evolve through several simplifying and abstracting stages, until he arrived at the color-block abstractions for which is he largely known.

Abstract colorist painters explored everything from the psychological and emotional impact of color to its simple decorative possibilities. Whatever the direction or inspiration, the abstraction of color entered the language of painting as a powerful, almost primal force. The early modern abstract painters of the first two decades of the twentieth century laid the groundwork for all the abstract colorist painters up to the present.

Wolf Kahn, *Riverview in Pink Oil*, 1992, oil on canvas, 27 x 29 inches (68.5 x 73.6 cm). The Dr. Donald L. and Dorothy Jacobs Collection at Georgetown College, Georgetown, KY. Courtesy of the artist

Landscape is a point of departure for explorations of the moods and formal interactions of color in Kahn's paintings. Highly chromatic secondary colors are built in scumbled layers with opaque touches on top.

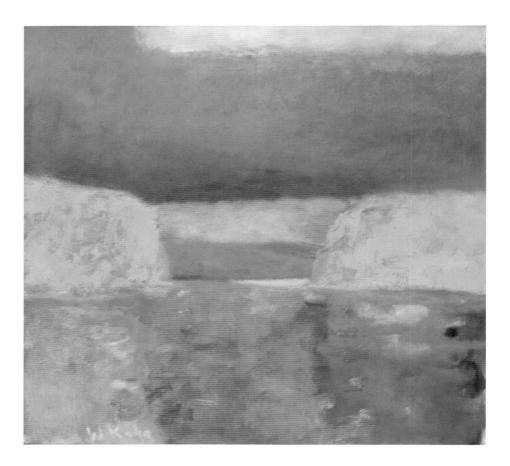

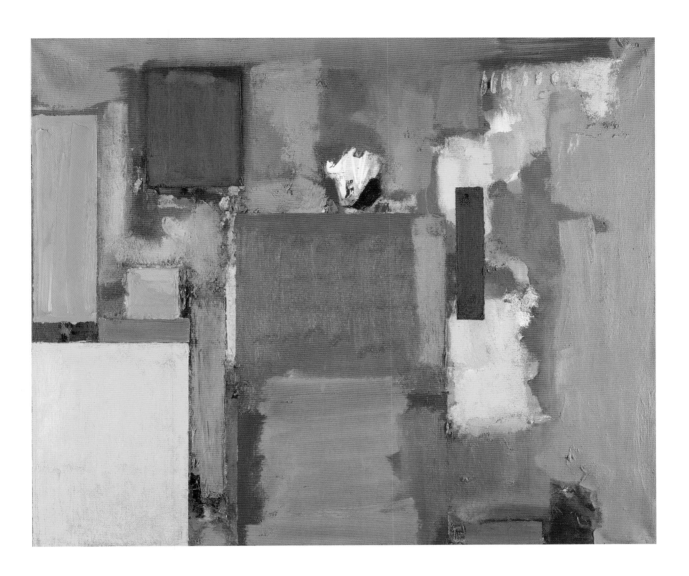

Hans Hofmann, *The Golden Wall*, 1961, oil on canvas, 60 x 72¼ inches (152.4 x 183.5 cm). Mr. & Mrs. Frank G. Logan Purchase Prize Fund 1962.775. Permission of The Art Institute of Chicago. Photography © The Art Institute of Chicago. © 2010 Renate, Hans & Maria Hofmann Trust / Artists Rights Society (ARS), New York

A defining influence in abstract expressionism, Hofmann integrates bold brushwork with simple primary and secondary color interactions. Generally open form, he adds the occasional closed-form shape for emphasis and contrast. Like many of his peers, Hofmann's work flows through various periods of exploration and experimentation. He was an important teacher, both in Germany before World War II and later in the United States.

Demonstration

As previously mentioned, copying masterworks is one of the best ways to understand the aesthetics, theories, and craft of these paintings. Sketch copies done on a small scale will quickly enhance a student's knowledge, understanding, and confidence. *Madame Matisse (the Green Stripe)*, done in 1905 by Henri Matisse, was my basis for this fauvist demonstration. It was done from a reproduction and follows the working methods and palette of Matisse.

To begin, a loose ultramarine blue-and-white drawing places the image on a white ground.

Prismatic color masses of both opaque and transparent consistencies are scumbled in with a thin medium mixture of linseed oil and paint thinner. Fauvist aesthetics often called for keeping the color as pure and direct from the tube as possible. Ultramarine blue, cadmium red, cadmium yellow light, cadmium green, and cobalt violet were used. Except in the skin of the face, no white was used. The white canvas coming through the scumbled colors creates a sense of light. Most of the colors at this stage are middle values.

Deeper or brighter interpretations of the observed color are placed opaquely. Darker and thicker versions of the colors are placed. Thicker, pure ultramarine blue darkens the hair. Thicker mixtures of ultramarine blue and cadmium green provide darker drawing touches in the face and clothing. The reflected greens in the center of the face are pure cadmium green light.

The painting is finished with strong touches in reds, greens, and blues. The overall effect of fauvist color is one of immediacy and boldness of color interpretation.

GRISAILLE AND GLAZING METHODS

Mark Bockrath, Pre-Raphaelite copy, c. 1990, oil on canvas, 14 x 11 inches (35.5 x 27.9 cm). Collection of the author

The grisaille underpainting in ivory black and white (below) sets up the base for glazing with one skin of glaze color in each area (opposite).

Grisailles develop the form of the subject with the intention of developing color through a thin skin of glaze over each local area. The grisaille provides the drawing and the basic form of light masses and dark masses. The light mass is usually exceptionally light so that it can be darkened to the right value by the appropriate glaze. The white of the light paint "shines" through the glaze, creating the correct balance of light and color in the final surface.

Grisailles are typically done using white and black oil paint, mixed in gradations where needed. A grisaille is distinguishable from a "painting in grays" (discussed in an earlier section), which matches all the tones of a subject directly by gradations of paint mixtures ranging from near white in highlights to middle tones to darks. Paintings in grays are simply the image done without color as tonal gradations. A true grisaille is part of a specific layering process and exhibits extremes of light and darks.

Both open-form and closed-form painters have used true grisailles. El Greco massed his forms in black and white in a bravura manner, for example. Each color was one thin glaze color over the local areas of his forms. Occasionally, there was some overpaint applied in the form of details or adjustments. French nineteenth-century painter Ingres also employed grisailles, over which he applied velaturas and glazes to tint and develop the grisaille. He used glazes in both open and closed forms not only to tint bright areas but also to modify and tone shadows.

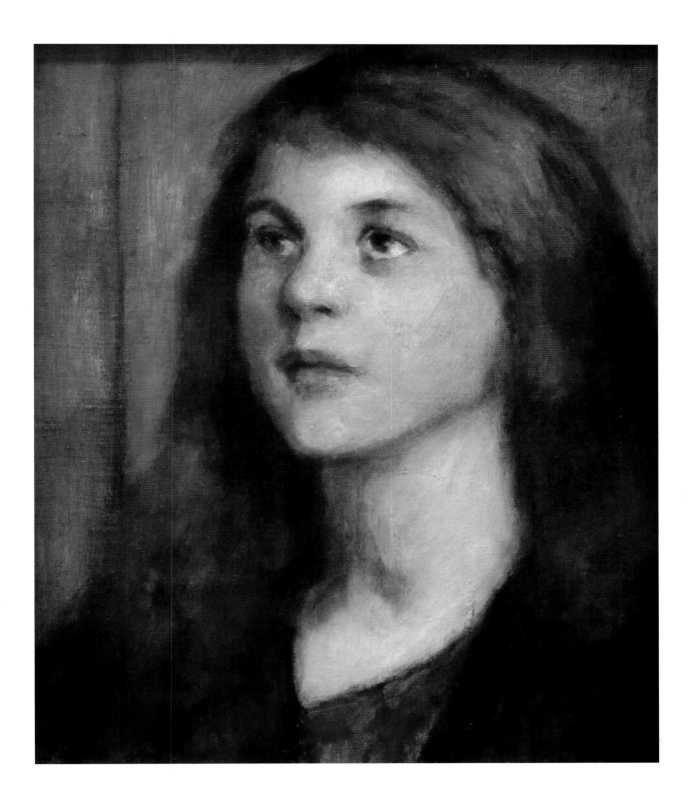

Demonstration

Regardless of the grisaille style, it is important to remember that the layering is very crucial and follows practical principles. Finishing glazes were usually single skins, and velaturas were also usually single layers.

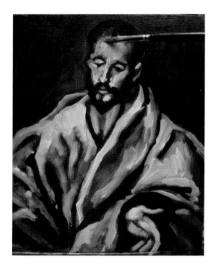 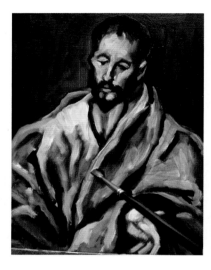 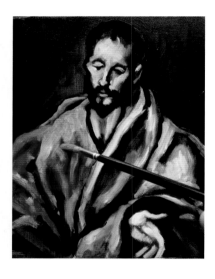

El Greco's *Portrait of St. James the Less* was the source for this grisaille and glazing demonstration. My underpainting was placed on a dark-brown ground. Over a loose chalk sketch, I then used dark umber to place the drawing. (Black can also be used for this.) The forms are developed in black and white oil paint directly, with little or no medium added. The result is an open-form grisaille.

Over the dry grisaille, one skin of transparent color can be placed over each color area. Here, I brush transparent burnt sienna thinned with linseed oil and a touch of paint thinner over the face to begin the glazing and finishing process.

Transparent ultramarine blue is brushed over the robe on the right. The underpainted forms in the grisaille create the structure of the robe and the blue provides the color of the garment.

Final glazing of the garments is done with permanent rose. Simple, large blocks of glaze are typical of El Greco and most glaze techniques.

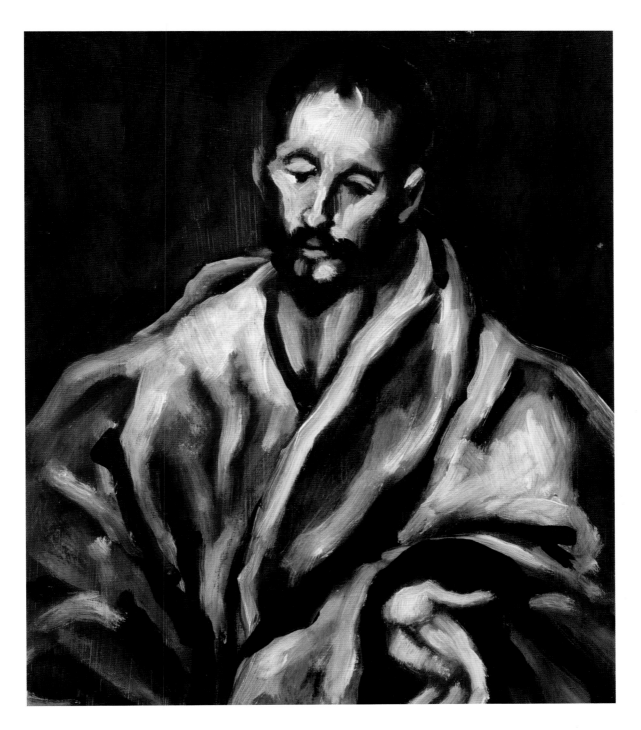

The finished work is one of strength of form
and luminosity of color.

DIRECT SKETCH METHOD

An important form of both study and information-gathering since the seventeenth century has been the direct sketch, which shows observations of natural light, tone, and color. Also, since the early-nineteenth century, the "sketch" has been elevated to the status of "complete painting" through the contributions of the impressionists. For example, the outdoor sketches of English eighteenth-century painter John Constable are highly prized today, even though they were considered merely "notes" in his own time.

Very common in the nineteenth century, the direct sketch was used to describe a scene en plein air; to study relationships of color, light, and tone in a subject; and as a preparatory study for larger finished studio works. Such paintings were usually small and were considered "studies" not to be taken seriously as finished paintings. Color masses were matched directly, with a scale—from bright, light, and warm to darker, more neutral, and cooler—organizing the principles of the color. Monochrome tonal color was most typical of these early sketches.

Demonstration

Direct sketch studies were done by open- and closed-form painters alike. Portrait, landscape, and still life painters (and even painters of historical scenes) all used the direct sketch as a preparatory study. Small alla prima paintings of this type became the basis for impressionism as well as much of direct painting today.

In this copy of John Constable, the placement of the composition is sketched in loosely in burnt umber on a middle-tone, warm-gray ground. Color is thinned a bit with linseed oil and paint thinner. Upper layers are denser, with paint and a touch of oil as needed.

Color masses are placed, creating an arrangement of tonal masses and the illusion of depth, near to far. The pigments used in this example (green earth, burnt umber, yellow ochre, ivory black, ultramarine blue, and flake white) reflect a typical landscaping palette of the eighteenth century.

Details are placed using darker darks and opaque warm touches in the lights. Some of the transparent underdrawing remains, which adds to the sense of form.

This is the direct sketch finished as an impressionist painting, with reflected blues, greens, and purples added to the dark areas. Impressionist paintings were often only one step away from earlier observational and tonal paintings in their structure and color usage.

FURTHER READING

Alla Prima: A Contemporary Guide to Traditional Direct Painting by Al Gury (Watson-Guptill Publications)

The Artist's Craft: A History of Tools, Techniques, and Materials by James Ayers (HarperCollins)

The Artist's Handbook of Materials and Techniques by Ralph Mayer

The Art of Painting by Leonardo da Vinci

The Art Spirit by Robert Henri (Basic Books)

Bright Earth: Art and the Invention of Color by Philip Ball (University of Chicago Press)

Color: A Natural History of the Palette by Victoria Finlay (Random House Trade Paperbacks)

Color and Culture: Practice and Meaning from Antiquity to Abstraction by John Gage (University of California Press)

A Color Notation by Albert H. Munsell

Color Space and Its Divisions: Color Order from Antiquity to the Present by Rolf G. Kuehni (Wiley)

Colors: The Story of Dyes and Pigments by Guineau Delamare and Ber Francois (Harry N. Abrams, Inc.)

The Elements of Color by Johannes Itten (Wiley)

Flemish Painting by Jacques Lassaigne, translated by Stuart Gilbert (Skira)

History of Color in Painting with New Principles of Color Expression by Faber Birren (Van Nostrand Reinhold)

Interaction of Color by Josef Albers (Yale University Press)

Modern Chromatics: Students' Textbook of Color with Applications to Art and History by Ogden N. Rood (Van Nostrand Reinhold)

On Colors (De Coloribus) by Aristotle

Optiks by Sir Isaac Newton (Prometheus Books)

Primary Sources: Selected Writings on Color from Aristotle to Albers edited by Patricia Sloane (Design Press)

The Principles of Harmony and Contrast of Colors and Their Application to the Arts (1855) by Michel Eugene Chevreul (Kessinger Publishing)

The Search for the Real by Hans Hofmann (The M.I.T. Press)

Techniques of the Impressionists by Anthea Callen (Chartwell Books)

Thomas Sully 1783-1872: Hints to Young Painters, a Historic Treatise on the Color, Expression and Painting Techniques of American Artists of the Colonial and Federal Period by Thomas Sully (Reinhold Publishing Corporation)

Vasari on Technique by Georgio Vasari (Dover Publications)

INDEX